LEONARDO
A PORTRAIT OF THE RENAISSANCE MAN

LEONARDO

A PORTRAIT OF THE RENAISSANCE MAN

ROGER WHITING

THE WELLFLEET PRESS
WELLFLEET

A QUARTO BOOK
Published by Wellfleet Press
110 Enterprise Avenue
Secaucus, New Jersey 07094

ISBN 1-55521-796-6

This book was designed and produced by
Quarto Publishing plc
The Old Brewery, 6 Blundell Street,
London N7 9BH

Senior Editor Hazel Harrison
Editor Susan Berry
Designer Bill Mason
Picture Manager Sarah Risley
Picture Researcher Bridget Harney
Art Director Moira Clinch
Art Editor Philip Gilderdale
Publishing Director Janet Slingsby

Typeset by En to En, Tunbridge Wells

Manufactured in Hong Kong by
Regent Publishing Services Ltd

Printed in Hong Kong by
Leefung Asco Printers Ltd

CONTENTS

INTRODUCTION

I have been asked to write this introduction to *Leonardo* because its author, Roger Whiting, died in the course of the book's preparation. Though he was able to complete the manuscript, he sadly did not have the opportunity of seeing the final, finished result, complete with illustrations. I think it would have pleased him.

When Roger Whiting started his research for the book, the first issue he was determined to tackle was the sheer uniqueness of Leonardo, both as a man and in terms of his breadth of creative activity and achievement. He wanted to show today's readers what it is that makes Leonardo stand out as the quintessential representative of Renaissance civilization – a civilization filled with figures who not only played a major part in its making but also had a profound influence on the shaping of subsequent history. This was no easy undertaking. As Jacob Burkhardt commented in his seminal *Civilization of the Renaissance in Italy*, published more than a century ago, the subject matter was "as wide as an ocean". Yet Burkhardt also realized that no subject defied further analysis. For him, the Italian Renaissance could still be studied with advantage from "the most varied points of view". This was a feeling Roger Whiting shared, as this, his last book, shows.

Leonardo is an eloquent testimony both to its complex subject and the new perspectives that continue to illuminate his achievements. Roger Whiting begins with Leonardo's life, seen against the background of the social and historical events of his times, and continues with a chronological examination of his work as a draughtsman, painter and sculptor. He then assesses Leonardo's work as anatomist, scientist and botanist, concluding by introducing some aspects of Leonardo's interests that may be relatively unfamiliar to many, showing how, for a substantial part of his working life, Leonardo was involved in military and civil engineering projects, as opposed to purely artistic pursuits.

Roger Whiting clearly demonstrates that Leonardo's view of the world was holistic – that he saw the world as a single entity, all parts of which fitted together, as if in a machine. Thus each individual working of nature is mirrored by another, whether it be the flow of water, the sap rising in a tree or the pumping of the human heart.

He shows that Leonardo had an insatiable desire to understand the world around him and the place of humanity within it, and believed that the knowledge he sought could only be gained through direct experience. It was not enough to reason that human beings existed because blood appeared to flow through their veins; he wanted to know how the veins transported their precious life-giving force and how humans finally aged and decayed. To this end, he embarked on a systematic process of dissection and personal observation, making careful drawings which he surrounded with explanatory text.

Though nature and the depiction of a real world had long interested Italian Renaissance artists, what distinguishes Leonardo from his contemporaries is this sheer breadth of enquiry. There were also fascinating variations in the way he worked. At one moment, for instance, he was making painstakingly intricate studies of plants in silverpoint for such paintings as the *Virgin of the Rocks*; at another, he was producing intensely vivid portrait heads in broad chalk strokes in preparation for *The Last Supper*. Such drawings could well stand on their own as finished works. In contrast, however, other pages of Leonardo's sketchbooks are filled with a virtual frenzy of proposals (anticipating the final designs for such projects as the Milan equestrian statues and the various studies of the Holy Family) which are almost unintelligible because of the random superimposing of one idea upon another.

Leonardo, in sum, emerges as the supremely energetic entrepreneurial spirit of his times, continually questioning and experimenting. Roger Whiting fully illustrates this prowess, but, more than this, he shows how Leonardo's work still influences us – this was his special legacy.

The book is rich in illustration, in breadth of coverage and, most importantly, in quotation, with many extracts from Leonardo's own writings to reveal the complex workings of his mind. It demonstrates to the full Leonardo's unique and lasting position in social, cultural, artistic and scientific history.

Dr Anabel Thomas lectures in Renaissance art at Cambridge University.

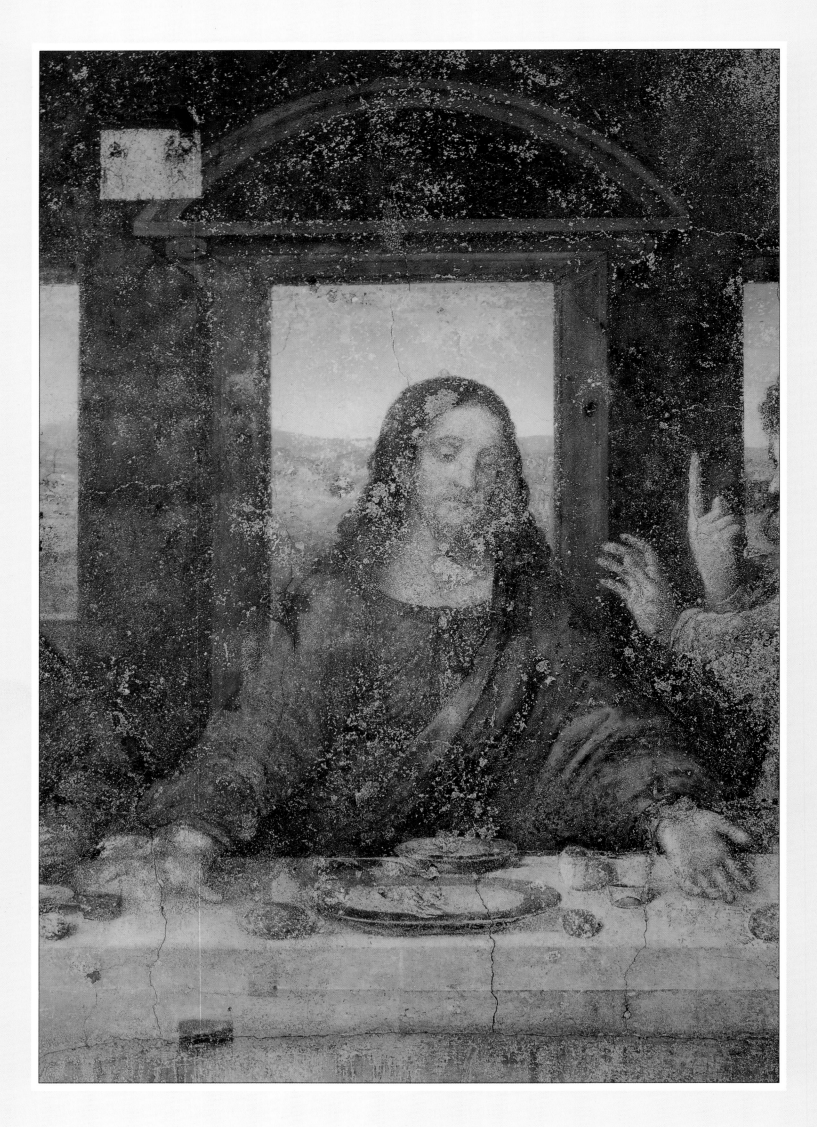

THE RENAISSANCE MAN

HEAD OF CHRIST
c 1495-7

Detail from *The Last Supper*. Leonardo based the apostles on actual
people – he would pursue anyone whose face he found interesting –
but he had great difficulty finding a 'sacred countenance' for Christ's
face. It has been suggested that he left it deliberately vague.

THE RENAISSANCE MAN

<p style="text-align:center">═══════════════════════════════</p>

Castiglione's words about Leonardo da Vinci give us a flavour of his breadth of mind. 'One of the finest painters of the world, neglecting [his] rare talent, set himself to learn philosophy, in which he produced such strange concepts and fanciful revelations.'

They also express some disapproval, and Castiglione was not alone among Leonardo's contemporaries in deploring his apparent squandering of his talents. Giorgio Vasari, Leonardo's first biographer (two editions, 1550 and 1568), who argued that Leonardo had laid the foundations for the ultimate period of Italian artistic achievement, was irritated by his non-artistic activities. 'He was a man of regal spirit and tremendous breadth of mind' but 'he was always setting himself to learn many things only to abandon them almost immediately . . . He would have made great advances in knowledge and in the foundations of learning had he not been of such a various and changeable nature.'

Too young to have known Leonardo personally, Vasari drew only on secondary sources, and therefore cannot be taken as a wholly reliable historian. A distinguished Milanese cleric, Giovanni Ambrogio Mazenta, spoke of the 'many machines depicted in [his] books, that have been put to use in the region of Milan, like weirs, locks and gates, mostly invented by Leonardo.' Twentieth-century engineers and physicists have found that many of his calculations are still valid, and a number of modern working models have been made based on his drawings. If some of the latter lack engineering precision, they still possess a marked degree of originality of concept.

As an artist, Leonardo shared the summit of the High Renaissance with Michelangelo, Raphael and Titian, though they were slightly younger than him. Yet as the centuries passed, while their great works of art were constantly praised, Leonardo's genius has been given full justice only with the relatively recent rediscovery of many of his notebooks. The first transcriptions of his scientific notes were published in 1797. Between 1881 and 1901 some of his notebooks, drawings and anatomical studies were published as his work became more appreciated. Milan's Scientific and Technical Museum, opened in 1952, soon included 'Leonardo da Vinci' in its title, crediting him with the invention of a large range of technical gadgets. Though in 1964, Bertrand Gille, author of *The Renaissance Engineers* (1966), had claimed that most of Leonardo's devices were not original, the discovery in 1965 of a further 700 pages of Leonardo's archives in Milan swung the pendulum back. Gradually the full scope of his works has become apparent, as each publication has brought to light something new.

Besides some 25 known paintings (of which about 10 remain today), it is supposed that Leonardo left behind at least 10,000 pages of manuscripts – maybe more – of which 7000 have been found to date. All his musical compositions have been lost, and only fragments of his writings on the theory, practice and study of music now remain.

Much of what he wrote he had hoped one day to publish, but today his archives are scattered across the world, offering researchers a vast but rather inaccessible store of information. Francesco Melzi, a pupil of

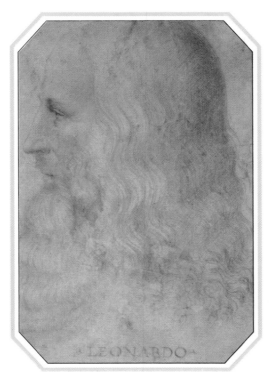

PORTRAIT OF LEONARDO DA VINCI
c 1519

This drawing by an unknown artist was used as the basis for later
portraits of Leonardo.

Leonardo's, who inherited 25 paintings, 1000 drawings and 10,000
pages of manuscript, simply kept them as relics, although he edited a
version of the *Treatise on Painting* (now kept as the *Codex Urbinas* in the
Vatican). The Melzi family's lack of interest led to the various volumes
being widely dispersed. Even worse, when Pompeo Leoni, who died in
1608, secured seven of them, he cut out and rearranged them into sub-
ject albums, disrupting their original order and concealing the reverse
sides of the pages by glueing them down. Two, the *Madrid Codices*,
which he gave to the King of Spain, were only rediscovered in 1965 and
published in 1975.

 In the 17th century the Earl of Arundel acquired another two – now
housed at the Royal Gallery, Windsor (*Codex Leoni*), and the British
Library (*Codex Arundel*). In or around 1762 the surgeon William Hunter
saw the anatomical drawings in the royal collection, and reported, 'I
am fully persuaded that Leonardo was the best Anatomist, at that time,
in the world.' Unfortunately, Leonardo died before he could publish
them. Thirteen volumes (including the 1750-sheet *Codex Atlanticus*)
were given to the Ambrosian Library, Milan. Others vanished in the
17th century. The *Treatise on the Nature and Movement of Water*, in fifteen
books, was found in a Rome market, and re-sold in 1717 to a nineteen-
year-old tourist, the future Earl of Leicester. Today they are known as
the *Codex Hammer*, or *Leicester Codex*, of Holkham Hall and the Los
Angeles County Museum. The Victoria and Albert Museum, London,
holds the *Codex Forster*, the Bibliothèque de l'Institut de France, Paris,
has the *Manuscripts A–M*, the Biblioteca Nacional, Madrid, holds
Manuscripts I–II, while the *Codex Trivulziano* is in the Biblioteca
Trivulziana, Milan, and the *Codex on the Flight of Birds (Codex Turin)* is in
the Royal Library, Turin. It is a mark of Leonardo's breadth of inquiry
that any assessment of his archives today requires so many specialist
scholars to evaluate his contribution to their particular disciplines.

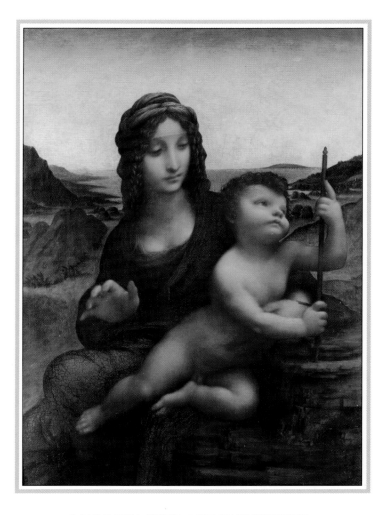

MADONNA WITH THE YARNWINDER
c 1501

The skilfully interlocked figures form a complex 'activity' pose, with
one part of the body turning and bending upon another.

ART AND SCIENCE

For Leonardo, there could be no art without science. According to him,
failure to realize this fundamental truth would result in painters being
ranked as mere craftsmen. Not only did he insist that an artist should
possess a sound knowledge of the laws of nature, but that he should
also use scientific methods to reproduce three-dimensional images on
two-dimensional surfaces. Then he could aspire to rival God himself as
the Creator of nature in his paintings and sculptures.

As an engineer, Leonardo worked on the latest destructive weapons
and defence systems of the day, content to take the money available for
such work. He also pioneered work on accurate mapping techniques
and devised canal projects and irrigation systems. He invented a wide
variety of practical machinery, both for making tools and carrying out
different tasks. Occasionally he went well beyond the limit of contemp-
porary scientific knowledge as, for example, when he tried to devise a
flying machine. However, his botanical investigations into plant growth
were sound, and centuries ahead of his time.

Leonardo endeavoured to create a scientifically organized body of
knowledge based on what was known in his day. His methods and con-
cepts were essentially visual, and he did not make the distinction
between 'experience' and 'experiment' that scientists make today. He

set out to fuse the ancient concepts of the *macrocosm* of the world with the *microcosm* of man, the latter reflecting the former. He accepted Plato's argument (4th century BC) that the world consisted of four elements (earth, water, air and fire), with four powers (movement, weight, force and impact). These elements resulted in the four humours of man – earthly melancholia, airy sanguinity, fiery choleric and watery phlegmaticism.

In or around 1492, Leonardo wrote:

> Man has been called by the ancients a lesser world, and certainly the award of this name is well deserved, because, in as much as man is composed of earth, water, air and fire, the body of the earth is similar; just as man has in himself bones, the supports and armature for his flesh, the world has the rocks, the supports of the earth; just as man has in himself the lake of the blood, in which the lungs increase and decrease while breathing, the body of the earth has its oceanic seas, which likewise increase and decrease every six hours with the breathing of the world; just as from the said lake veins originate, which proceed to ramify throughout the human body, the oceanic seas fill the body of the earth with infinite veins of water; the nerves are lacking in the body of the earth – they are not there because nerves are made for the purpose of movement, and the world, being perpetually immobile, does not need movement, and, not needing movement, the nerves are not necessary. But in all other respects they are very similar.

When he wrote on anatomy and geography, he drew on this analogy, using phrases such as 'the veins of water' and 'the breathing of this terrestrial machine'. The idea that the veins in the earth through which water flowed were similar to human blood circulation was as old as Seneca, and was still held by Leonardo's contemporaries. For Leonardo the subject lay at the very heart of his vision of life's principles. The universal laws of function and form which govern the world, the *macrocosm*, must also control man, the *microcosm*. Since this control arose from 'necessity', the analogy of the relationship came within the realms of scientific investigation. His unique contribution was to present the analogy in such a visual way. His series of images of nature and man illustrate their shared vitality of form and motion; no other artist has portrayed this analogy so vividly. His drawings of the landscape, rocks and water demonstrate this superbly, and his painting of the pregnant *Mona Lisa* (see page 51), seated before a background of active geological change, portrays the relationship to perfection. Leonardo saw painting as the supreme art, because it gave permanence to something that was essentially transitory – the very powers of Nature herself.

This all-embracing vision came together for him in about 1508, as he pursued the subjects of anatomy and physical geography. His work on topography and water courses around Florence provided him with the evidence he needed of the vital role played by water in shaping the

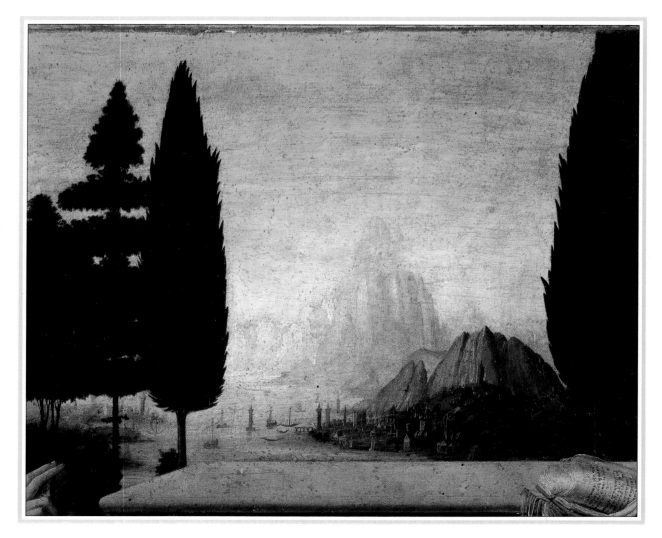

DETAIL OF THE ANNUNCIATION
c 1473

Leonardo's fascination with rock forms and other natural features
can be seen here. The complete painting is shown on page 34.

landscape over the centuries, and led him to far ranging speculations
about the causes of tides and the origins of mountain springs and the
sources of fossils.

Yet the more he investigated the more he realized there were
problems with the *microcosm–macrocosm* analogy. Why was it that while
the 'veins' of the earth were forever being widened by the flow of water,
those of the body were thickened by age, 'so much that the walls
become closed and allow no passage for the blood'. Also, 'the origin of
the sea is contrary to the origin of the blood, since the sea receives into
itself all the veins which are caused solely by water vapours raised into
the air; but the sea of blood is the cause of all the veins.' Although he
had come to recognize these problems, he failed to resolve them before
his death.

For Leonardo a fifth, spiritual, essence was necessary to shape the
growth and movements of the world's elements, just as the soul was
necessary for the body, as 'powers' and 'bodies' were all transient in
nature. This 'spirit' was the basic unit of his physical world-system,
making it unique. Yet he was far from 20th-century materialistic
atomism, describing force as a 'spiritual power . . . because in force
there is an active incorporeal life'. 'All natural powers are pyramidal
because they can grow from nothing to infinite greatness by equal
degrees. And by similar degrees, they decrease to infinity by

diminution ending in nothing. Therefore nothingness borders on infinity.'

For Leonardo science was man's extension of nature. 'Nature is concerned only with the production of simple things, but man, from these simple things, produces an infinity of compounds.' Thus man carries on where nature leaves off. He recognized that unbridled imagination could lead to the unworkable 'fantastic' (monsters, for example), while imagination, guided by 'experience', would produce practical results and machinery. From his tutor, Verrocchio, he learned the five simple mechanisms of the ancients – the wheel, lever, pulley, wedge and screw – the components of all machinery until the beginning of the 19th century. 'Science is the knowledge of things which are possible', he concluded.

Had his *Treatise on Anatomy*, begun in 1489, been published, it would have contributed to the advance of medical science, not only in the field of dissection and analysis, but also in relating man to the time and space of the universe in which he lived. It embodied growth, emotion, perception and action – the complete picture of man, the living organism, in an ever-moving universe. It was far more than just an anatomical textbook. Leonardo was the first man to draw dissected bodies accurately and systematically in three dimensions, making a supreme contribution to medical knowledge.

He was a scientist attracted by all branches of knowledge. He questioned everything. Indeed, 'I question' is the most frequent phrase to be found in his notebooks and he questioned himself most of all, accepting nothing blindly. Consequently he re-opened all the statements made by his predecessors. He believed direct experimentation was essential in the search for knowledge, anticipating the approach of Galileo and Bacon. 'Those who want to experiment without possessing some scientific knowledge are like navigators who set sail without a rudder or a compass and who are never sure where they are going.' This outlook explains the enormous range and quantity of his studies, sketches, and calculations.

LEONARDO'S ITALY

To understand fully Leonardo's achievement, it is important to know something of the world in which he lived. Italy during the period of the Renaissance was divided amongst small, quarrelsome states, which suffered from internal instability caused by rival factions amongst powerful families and by external rivalry with neighbouring states over boundaries or trade matters. The city-state of Florence followed the pattern. Powerful merchant families had built up the city's wealth and ruled over the city within a republican constitution. By the 15th century, the most powerful and wealthy family were the Medicis, and for nearly 150 years they dominated the city's politics and banking,

arranging marriages for their children amongst the ducal and princely families of Italy. Much of their wealth was used to patronize artists, architects and scholars, and this goes some way to explaining the concentration of talent in Florence at this time. This period saw sporadic fighting between Florence and Pisa over the control of the River Arno's access to the sea. Like many other Italian states, Florence did not conscript her own citizens into the army, but hired the services of mercenaries with their formidable captains, the *condottieri.*

Milan was Florence's most dangerous enemy since there was a long fluid boundary between them and an aggressive ruler could easily destroy the frail peace that existed between the two states. At this time in Europe war was the expected state of affairs – peace was something to be prayed for. Milan was ruled autocratically by the Visconti dukes until the middle of the 15th century, at which point power slipped into the hands of the Sforza *condottieri* family. The Sforzas used the state's power and wealth to attempt to dominate Italian politics and to gain acclaim for the patronage of the great artists of the day.

Venice, the great trading republic, dominated the Adriatic and came into conflict with Milan on her western boundary which made it necessary for Milan to enter alliances with some of the smaller states, such as Ferrara and Mantua, on her southern boundary. Across central Italy, successive popes were beginning to expand their control over lands beyond the original St Peter's Patrimony based on Rome, and, in doing so, came increasingly to act like secular princes in their attempts to maintain and extend their territories into the Romagna and the Marches. The kingdom based on Naples was territorially the largest in Italy, but it had none of the trading wealth or productive lands of the northern states and by the 15th century it was ruled by a branch of the Spanish Aragonese royal family.

Into this world of shifting alliances and rivalry came the French in 1494. The French king, Charles VIII, was by then in a strong enough position to extend his lands and occupy his nobles in warfare. He revived an ancient claim to the kingdom of Naples, and marched through Italy with the largest army seen since Roman times, having secured diplomatic acquiescence from Milan, Florence and the Papacy. Naples responded by calling on its Spanish cousins for help. This external invasion upset the precarious balance in Italy, and, within a year, Italy became a battlefield for the contending ambitions of France and Spain. When Charles VIII died four years later, his successor Louis XII revived a dynastic claim to Milan, which led to the defeat and death of Ludovico Sforza (for whom Leonardo had designed a range of weaponry). Louis' successor Francis I had mixed fortunes from 1515 onwards, and for a while his most distinguished achievement seemed to be to persuade Leonardo to come to France. The wars continued for the next forty years at varying levels of intensity, with the result that Italy lost some of her cultural dynamism to her conquerors and impoverishment took its toll. It was into this background of political instability and personal possibility that Leonardo was born.

DESIGN FOR CANALS, TUNNELS AND ARCADES
c 1488

Arcaded walkways and service canals.

LEONARDO'S LIFE

The illegitimate son of a lawyer, Ser Piero, and a young peasant girl of 'good blood', called Caterina, Leonardo da Vinci had no formal education, but this did not prevent him becoming a 'universal genius'. He was born in April, 1452, in the village of Anchiano, near Vinci, among the hills to the west of Florence. From the age of five to fourteen, he lived with his father, who was by then married, not to Caterina but to another teenager. When Leonardo was seventeen, his father secured for him an apprenticeship in the workshop of Andrea Verrocchio, considered not only the finest painter, sculptor and goldsmith of his day, but a man well versed in geometry, anatomy and the new science of perspective. No better teacher could have been found to lead Leonardo's youthful studies.

Verrocchio's senior pupils, many of whom were destined to be noted artists, did a considerable amount of the work on his paintings, enabling his studio to take on a wide range of commissions. Leonardo was only twenty-three when he was given the kneeling angel to complete in Verrocchio's *Baptism of Christ*. Although Leonardo learned much from Verrocchio, a strict taskmaster, he also taught himself a great deal, acquiring a vision of art as a rational pursuit based upon certain mathematical principles. At the age of twenty, he was enough of an artist in his own right to be admitted into the Company of St Luke, the Florentine guild of artists.

Leonardo had a warm nature and a gentle character; he loved animals and was a vegetarian. Unlike many of his contemporaries, he led a

sober life. He drank with moderation and rose early (woken by his home-made water-powered alarm clock!). Otherwise, his virtues and vices were largely those of his age. While generous to others, he was highly economical, noting down everything he spent. He managed to avoid political and religious controversy in an age that was riven by it. As far as his education went, he countered the charge that he lacked 'book learning' by pointing out that, while others obtained their knowledge second-hand, he obtained his first-hand, by 'experience'. By contemporary standards he was no scholar, as his ignorance of Latin deprived him of much classical knowledge. This must have been a source of frustration, as he was occasionally driven to translations of classical treatises on scientific subjects rather then being able to read the originals.

His life was one of contrasts; by day he moved in courtly circles, but by night he was pursuing his search for knowledge, dissecting corpses in the hospital mortuary. From the example of a fellow-illegitimate, Leon Battista Alberti (1404-72), another noted painter, sculptor, architect, composer, mathematician and inventor, Leonardo realized that a combination of pursuits was possible, particularly when motivated by the desire to find the meaning of life. Throughout his life, Leonardo seized whatever opportunities came his way to continue his wide-ranging studies: he would work at a subject for a year or two, and then return to it a few years later when another opportunity arose.

In 1482 he left Florence for Milan where the Sforza court offered opportunities beyond painting. Once there he secured a salaried appointment from Ludovico il Moro Sforza, Duke of Milan. All too often his widespread interests caused him to run into difficulties in fulfilling contracts on time, making the support of a sympathic patron a necessity.

Until that time, he had largely concentrated on painting, but in Milan his role widened. From 1482 to 1500 he was engrossed in the canalization of rivers, the construction of engines of war, the architecture of civil buildings and churches, as well as music and theatrical costuming. After a few years he succeeded in establishing himself among the influential – an achievement considering his lack of formal education.

Following the French invasion of 1499, Leonardo moved around for some time. He then worked (in 1502) as a military engineer for Cesare Borgia, who led the papal armies against the French, and in 1503 for Florence in its war against Pisa, before beginning the *Battle of Anghiari* fresco for the Republic of Florence. After the failure of his flying machine experiments, he went to Milan to design a residence for the French governor, Charles d'Amboise. In 1507, this led to his becoming painter and engineer to Louis XII in France, before returning to Milan in 1508 while the French remained there. Late in 1513, he settled at the Belvedere Palace, Rome, under the patronage of Giuliano de Medici, Pope Leo X's brother. Here he studied optics, mirrors, mechanics, geometry, and anatomy, while planning the draining of the Pontine

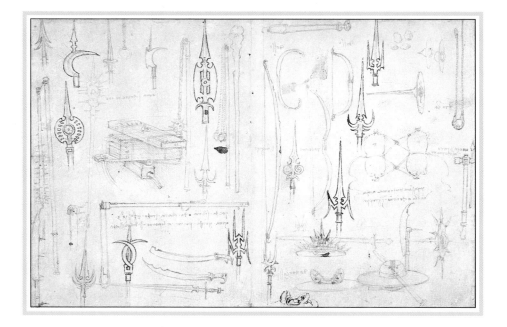

WEAPONS AND SHIELDS
c 1487-8

A selection of weaponry drawn from ancient sources such as Pliny
and Vitruvius.

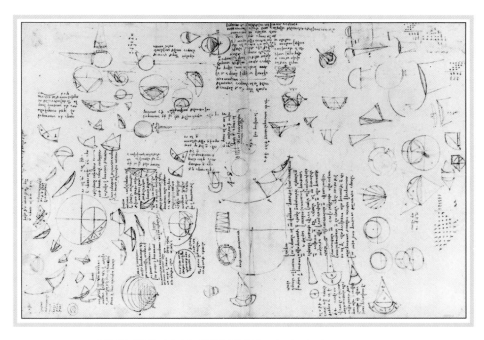

GEOMETRICAL INVESTIGATIONS OF AREAS
c 1508-9

Leonardo described his calculations thus: 'On the night of St
Andrew I reached the end of squaring the circle; and at the end of
the light of the candle, of the night and of the paper on which I was
writing, it was completed.'

marshes. In 1515, he lost two patrons when Giuliano left to marry and Louis XII died. After a spell designing the new Medici palace in Florence, he accepted Francis I's patronage and left for France to redesign Romorantin as a royal residence. He died on 2nd May, 1519, aged sixty-seven, insisting in his will on nine high and ninety low masses in four churches, so implying an almost royal status for himself.

While his movements and his employers are reasonably well documented, Leonardo's private life remains an unknown quantity, as he left almost no trace of it. 'The events of my life are my thoughts', he once wrote. It is known that he was an accomplished horseman and admirable lute-player and was also something of a dandy, apparently delighting in a short rose-coloured cloak that drew attention. He was a markedly handsome young man, with blond hair and piercing blue eyes. He was also fastidious about his appearance, with a strong dislike of getting paint in his nails. A glimpse into his privacy came in 1476, when he and three others were anonymously accused of homosexual activity with a teenage male prostitute. Though conditionally discharged, they were soon re-charged and again conditionally released. The crime was widespread in Florence, and homosexuality not at all unusual. Leonardo saw homosexual love as more spiritual than heterosexual love, and although psychologists think Leonardo was homosexual, it is more likely that he was bisexual. However, a chance meeting in 1490 led him to adopt a pretty ten-year-old peasant boy who proved to be a thief and liar. The fact that Leonardo stood by him, meeting all his extravagant demands, provides an insight into his inner emotions.

For Leonardo, women displayed an ideal beauty in a somewhat remote way, which contrasts with his view of their function: his unflattering frontal depiction of female genitalia is almost aggressive. Possibly, while drawing it, he was reminded of when he 'came to the entrance of a great cavern, in front of which I remained for a while, amazed and uncomprehending such a thing . . . There immediately arose in me two feelings – fear and desire – fear of the menacing, dark cavity, and desire to see if there was anything miraculous within.'

THE ASSESSMENT OF A GENIUS

Leonardo is all too frequently regarded as a painter of genius while his scientific achievements are ignored. To understand him, it is essential to try to appreciate the unity of his creative intellect, his principles, the development of his thought and his working style.

Within the last decade, scholars have published a range of detailed studies on every aspect of his work. These publications have proved that there were few fields of knowledge in which he had not only carried out research but had also added immensely to that knowledge. Anatomy, physiology, mechanics, optics and botany all exercised his mind.

STUDY OF BALANCES

Leonardo drew on classical and medieval scientific proportional
formulas, and restated the law to the heaviness of weights relating to
the length of arms supporting them. Today the science of weights is
called statics.

Leonardo's notebook jottings give a clue to his mind. 'Tell me if
anything was ever done?'; 'Every obstacle yields to effort'; 'Let your
work be such that after death you become an image of immortality.'
Wedded as he was to the pursuit of truth, his mental energy proved
boundless. In pursuing the laws of nature, the artist had to have a
universal approach, an all-pervading interest in life. This led the Swiss
historian, Jacob Burckhardt, in his *Civilization of the Italian Renaissance*
(1860) to award Leonardo the somewhat extravagant title of the
'universal man'.

Sometimes frustrated by his own lack of understanding during his
research, Leonardo would drop a subject, only to return to it
subsequently. Total understanding was his ideal – an ideal he
inevitably found beyond him. His refusal to compromise – indeed his
inability to do so – was a direct product of his restless creative
imagination (his *fantasia*). That fantasia drove him on to more and yet
more investigations. His reading shows his insatiable need for fresh
fields to explore. For Leonardo, all aspects of knowledge had to serve
each other.

> They say that knowledge born of experience is mechanical but that
> knowledge born and ending in the mind is scientific, and that
> knowledge born in science and ending in manual operations is
> semi-mechanical, but to me it appears that those sciences are vain
> and full of error that have not been born of experience, mother of
> every certainty, and which do not likewise end in experience; that is
> to say those that have neither at their beginning, middle nor end
> passed through any of the five senses.

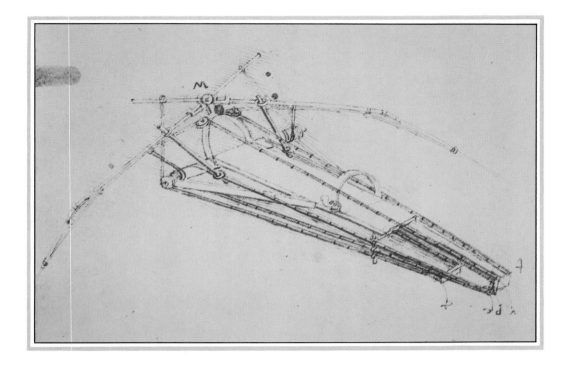

DESIGN FOR A FLYING MACHINE
c 1488

The wings were made of a network of wooden nerves and a coating
of cloth, onto which was glued a layer of feathers.

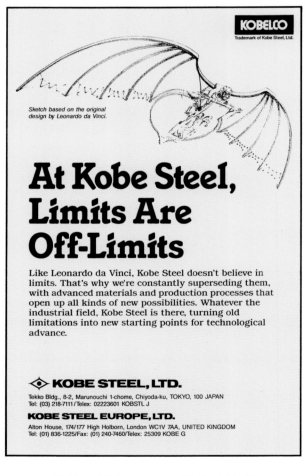

KOBE STEEL ADVERTISEMENT

This advertisement is clear evidence of Leonardo's power as a
household name. His flying machine did not fulfil its function, but
his ideas will always appeal to promoters of innovatory technology.

LEONARDO'S LEGACY

Leonardo is often portrayed as a genius unconstrained by convention, the pioneer of aeroplanes, submarines and tanks. Though he does not cover the subject of making moving pictures, some of his sequences of drawings come near to it – as with the man using the sledgehammer, with the movement of water and the flight of birds. His architectural designs were so systematized that they foreshadowed computer-aided architectural textbooks on shape and space layout. (W.J. Mitchell used one of them in his *Computer-Aided Architectural Design*, in 1977.)

Despite his own progressively scientific approach to life, Leonardo retained a great respect for nature, and foresaw man's technological misuse of the world's ecology. His 'prophecy', entitled 'The Cruelty of Man', blamed mankind for the evils of society, the destruction of nature's gifts and beauty.

> Creatures will be seen on the earth who will always be fighting amongst themselves with considerable damage and frequent deaths on each side. There will be no limit to their wickedness; we shall see great areas of trees in the wide forests throughout the universe felled by their proud limbs, and when they are satiated with food, the nourishment of their desires will be to deal death and grief and toil and wars and fury to every living thing . . . Nothing will remain on the earth . . . that will not be pursued, carried off or destroyed, and those of one country expelled to another . . . The woods fall in ruin. The mountains are torn open in order to carry away the metals that are produced there. But how can I speak of anything more wicked than of those who raise hymns of praise to heaven for those who with great zeal have injured their country and the human race? O earth, what delays you in opening up and hurling them headlong into the deep fissures of your huge abysses and caverns?

Here was the first 'green' scientist and technologist. Alone among Renaissance men, he saw clearly the contradictions of the human condition that he himself embodied, for he both painted beauty and threatened its destruction by his military engineering – marvelling on the one hand at creation and, on the other, devising machinery that demanded metal and wood.

This 'father of the modern age', envisaging man as the master of nature and conqueror of the earth's resources, was not typical of his time. His rationalism and desire to limit himself to the possible are Renaissance based, but otherwise he was a modern man, ready for daring enterprises. His attempts to conquer flight and his eagerness to study the human body were way ahead of his time. City planners would benefit from studying his schemes for building and maintenance. Yet because he retained a taste for the fantastic, he also remains a man of the Middle Ages. In him, the rational and irrational

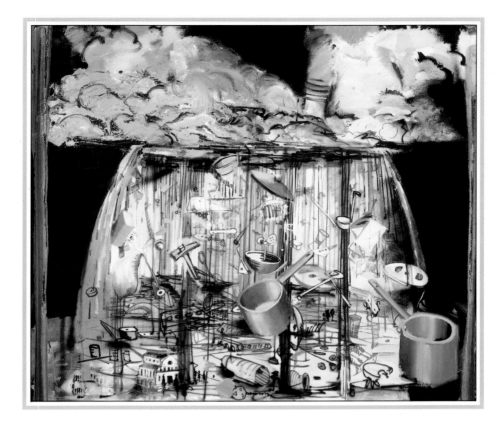

CLOUDBURST OF MATERIAL POSSESSIONS
Stephen Farthing, 1989

This humorous impression of a tempest of modern household
objects was based on Leonardo's painting of the same name, shown
on page 131.

THE MONA LISA SMILE

This is one of a set of ten Royal Mail greetings stamps issued in
1990, all showing well-known smiles.

go hand in hand, linked to an extraordinary visionary outlook that
distinguishes him as a genius.

He once wrote in deep humility and wisdom these words:

> Seeing that I can find no matter of much use or delight, because the
> men born before me have appropriated to themselves all the useful
> and necessary subjects, I shall do what the poor man does who
> comes last to the fair: since he cannot provide himself with any
> other stock he picks up all the things which the others had seen but
> rejected as of little value. These despised and rejected goods which
> were left behind by many buyers I shall load on my feeble donkey
> and shall carry not to big cities but to poor villages and distribute
> them, taking such a price as the wares may be worth.

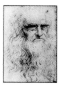

THE RENAISSANCE MAN

In 1987 William Emboden revived the speculation that Leonardo might have founded a *Leonardo da Vinci Accademia* to explore the frontiers of knowledge had he had time. Today, as scholars publish their findings, such an 'academy of Leonardo' is emerging. Three factors account for his scientific contributions being so long overlooked. First is the fact that only 7000 sheets of his manuscripts survive, perhaps as little as a third of all he wrote. Second, his 'laboratory' notes are now in confusion; his 'books' no longer exist. Third, they have suffered mutilation, being tied in bundles of loose sheets, or with pages torn out – a chronological chaos. His scientific work was never 'finished', for each 'solution' threw up fresh questions, indeed a glossary is needed to explain his vocabulary. His left-handed mirror-writing and lack of punctuation increase the problem. Also, by the time his contribution had come to light, scientific advance had taken over.

It is now clear that he did not herald a 'scientific revolution', because he failed to make a clear conceptual break with the natural law approach of medieval science. However, he did highlight its weaknesses, so indicating the need for a fresh approach. Technologically it is difficult to assess whether he produced real developments, as today's knowledge of medieval and Renaissance engineering is patchy. The complexity of his spacial visualization was ahead of its time, and his insistence on using 'experience' was significant. It is now accepted that his artistic work went beyond art itself to include a vision of the inter-relation of things. So ignorant of Leonardo's achievements have technological historians been that in 1950 Leonardo Olschki could write, 'Leonardo's technology still belongs to the traditional type of antiquity and the Middle Ages; it was highly developed craftsmanship, with no attempt to apply scientific principles . . . His scientific and technological work is little more than a mass of eloquent literary fragments and realistic drawings, of ingenious projects that would hardly have withstood a practical test'.

Computer graphics provide a new way of examining his work on the structural and geometrical order in nature – his 'visual science' – as they can build realistic images of how Leonardo saw the world beginning from geometrical and physical first principles. Today a computer graphics manual follows the same order of procedure as his *Treatise on Painting*'s instructions for painters.

> The first principle of the science of painting is the point, then comes the line, then the surface, and then the body bounded by a given surface . . . The second principle . . . is the shadow of the body which it represents . . . The science of painting includes all the colours of the surfaces, and the forms of the bodies bounded by them . . . this science is the mother of perspective, or visual lines . . . [leading to] another science, which includes shadow and light . . . a science capable of great development.

At last Leonardo is receiving the full recognition he deserves as a Renaissance genius.

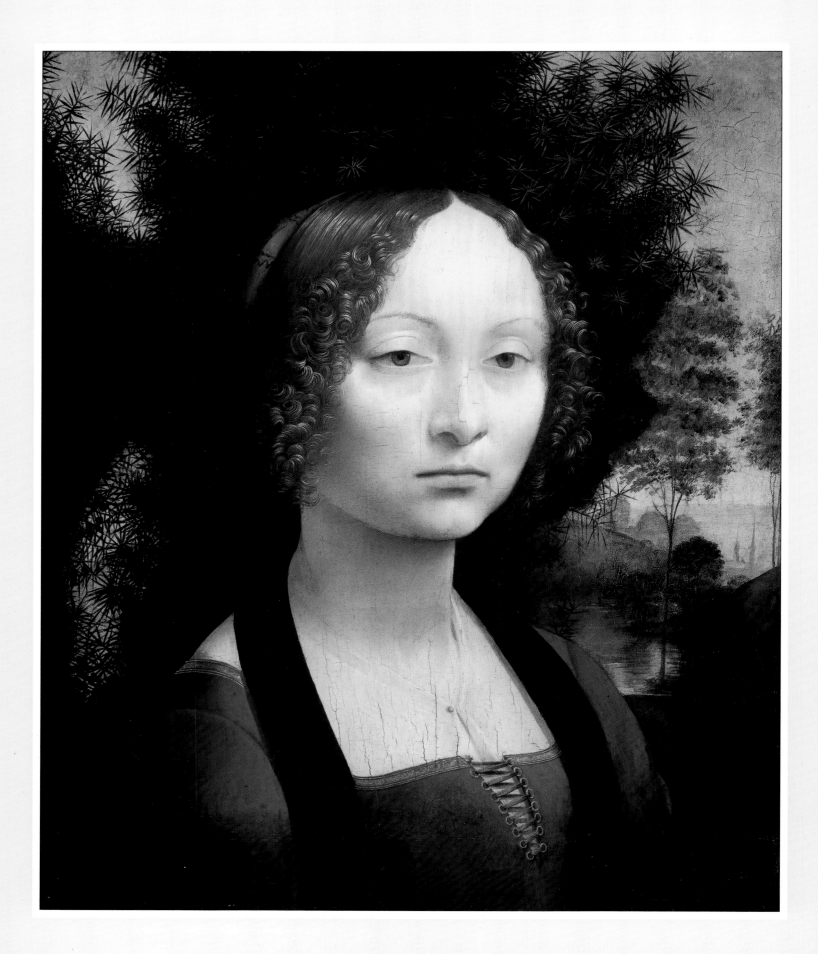

THE
EARLY
PAINTINGS

GINEVRA DE'BENCI
c 1474

The sitter for this portrait was a deeply religious and sensitive young
girl, and Leonardo portrayed her either shortly after her wedding to
a man twice her age, or in 1481. At the later date she was in self-
inflicted exile, recovering from a serious illness and tormented by an
ill-fated love affair.

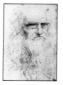

F or Leonardo, painting provided an eternal glimpse of what would otherwise so swiftly pass away.

> He who scorns painting loves neither philosophy nor nature . . . [for] painting . . . is the sole imitator of all the manifest works of nature . . . a subtle invention, which with philosophical and subtle speculation considers all manner of forms: sea, land, trees, animals, plants, flowers, all of which are enveloped in light and shade. Truly this is science, the legitimate daughter of nature, because painting is born of nature; but more correctly . . . the granddaughter of nature, because all visible things have been brought forth by nature and it is among these that painting is born. Therefore we may justly speak of it as the granddaughter of nature and as the kin of God.

Only of painting could he write, 'O marvellous science, you keep alive the transient beauty of mortals and you have given it greater permanence than in the works of nature, which continuously change over a period of time, leading remorselessly to old age.' In this art form man could be set in his correct relationship with the world. Gian Paolo Lomazzo, a perceptive painter, wrote in his massive book of 1584 on Leonardo, Raphael, Michelangelo, Titian and Farrari, 'It appeared that [Leonardo] trembled every time he sat down to paint, and therefore never finished anything he began, being so impressed by the grandeur of the art that he found errors in those things that appeared miraculous to others.'

Lomazzo realized that Leonardo and Michelangelo held widely diverging points of view, artistically speaking. For Leonardo, there is the sense of converging on the heart of the mystery to produce a concentration or crystallization; for Michelangelo there is no such path – he preferred to paint all mysteries, all history, heaven and hell. Leonardo's efforts are directed to an intense spirituality beyond the flesh, hence the mysterious faces of his female subjects, while Michelangelo's were directed towards a spirituality which includes the flesh and its delights.

TECHNIQUES OF A MASTER

> Have you never considered how the poets in composing their verses are not bothered to form beautiful letters nor do they worry whether they cross out any of their verses in remaking them better? Hence, painter, compose roughly the parts of your figures and attend first to the movements appropriate to the mental states of the creatures composing your narrative.

The bodily effects of the various 'mental states' of subjects had to be shown. Leonardo even attended executions to watch the facial expres-

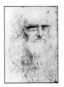
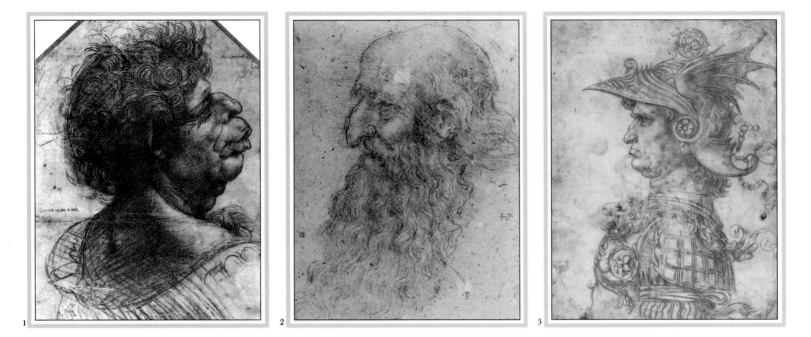

1 2 3

HUMAN PHYSIOGNOMY

'A Grotesque Head', *c* 1504, (1) an almost life-size work, is an
example of a typical 'character' drawing. It was pricked for transfer,
but its purpose is not known. 'Head of an Old Man', *c* 1514-15 (2) is
a black chalk drawing on coarse grey paper representing the ageing
of man. 'Bust of a Warrior' (3) is considerably earlier. It was done
c 1477, and is a metalpoint drawing done on paper with a tinted
chalky coating. The delicacy and precision of this technique gave
drawings almost the appearance of miniature paintings.

sions of the dying, 'the contractions of their eyebrows and the wrinkling
of their foreheads.'

'A good painter has two main objects to paint, man and the intention
of his soul; the former is easy, the latter hard as he has to represent it by
the attitude and movement of the limbs'. For Leonardo, actions or ges-
tures – body movements not involving a change of place – were the
moto actionale, behind which lay 'emotions of the soul', *moti mentali*,
which must be displayed too. To achieve sufficient range of emotion
and motion, he always did a range of drawings before beginning a
painting. He advised painters to carry notebooks with tinted (coated)
paper to ensure nothing would get erased.

In his essay 'On Shadow and Light' in the *Treatise on Painting*, he
examined the underlying optics of natural and artificial light by experi-
menting with lamps and objects. He noted how the shadows and their
rebounding effects changed as the lamps and objects were moved
around. He distinguished between primary and derivative shadows
(the former cast on the object itself and the latter cast behind it), the

LEDA AND THE SWAN

Leonardo made several sketches and two separate cartoons for the subject, one showing Leda standing and the other in a crouching position. Both cartoons and paintings are unfortunately lost, and only known to us through copies. Clearly, like all Leonardo's works, they were much admired by contemporaries. Raphael made a pen and ink study from the cartoon of the standing version during his stay in Florence in about 1506, and there are several copies of the painting.

According to Cassiano del Pozzo, who saw Leonardo's painting at Fontainebleau in 1625, the 'picture is in a bad state because it is done on three long panels, which have split apart and broken off a certain amount of paint.'

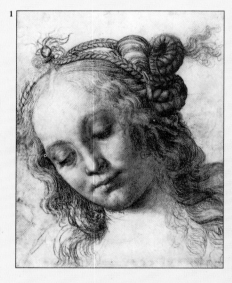

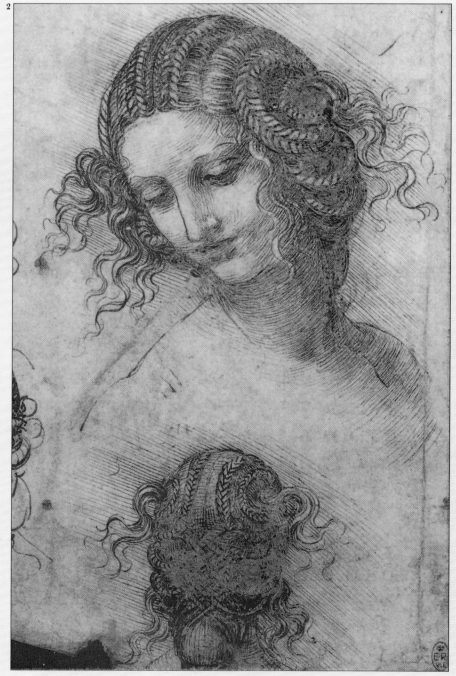

1 Verrocchio's black chalk, bistre and white drawing (*c* 1474) shows something of the skills he passed on to his pupils.

2 This study for Leda's head (*c* 1505-7) is an example of Leonardo's fascination with intricate and complex hair styles, which he inherited from Verrocchio.

5 Although Leonardo was finally to decide on a standing Leda, this drawing at Chatsworth of *c* 1505-7 shows how advanced the kneeling pose had become in his mind. The subject's fruitful liaison symbolized the union of humans with nature, underlined by the profusion of plants.

6 It was not until 1508, two or three years after this black chalk and pen and ink drawing was made, that Leonardo decided on a standing pose.

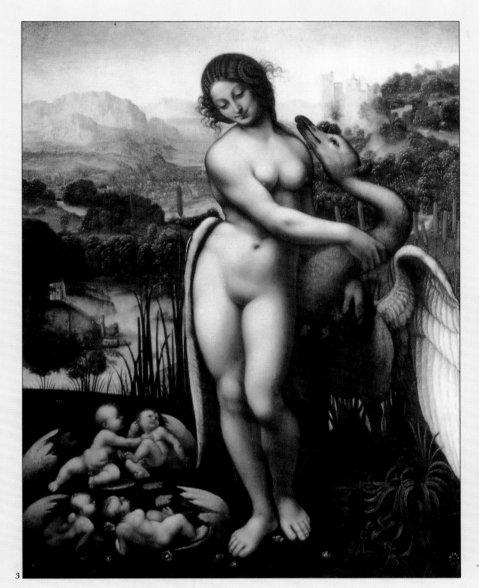

3 This version of the painting, in Wilton House, is probably the closest to the lost one. The union of Leda with the swan (Jupiter in one of his many disguises) was a pagan theme. The babies are Castor and Pollux, and Helen and Clytemnestra.

4 In this black chalk drawing of *c* 1505, Leonardo experimented with positions for Leda, showing her kneeling and twisting. The lines he preferred were drawn over in pen and ink.

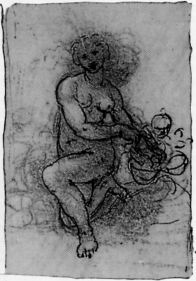

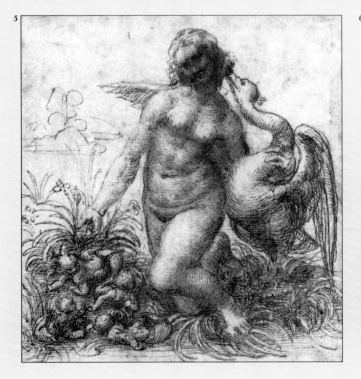

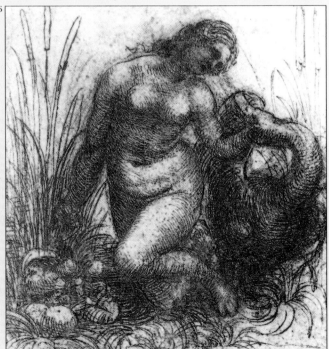

varying quality and strength of light, and the effects of shiny or dull surfaces. Today's computer graphic recreations, such as 'ray tracings' from light to object, echo his experiments.

He used high-quality Italian, and later French, paper. His earlier manuscripts have an elaborate spidery Gothic style, but later on they acquire a more orderly, 'classical' form. His early skull drawings were obsessively clear and neat. Faint preparatory underdrawings of black chalk or lead can be seen beneath the ink. Other drawings are more free, expressed with calligraphic sweeps of his pen. His 1478–81 studies for the *Virgin, Child and St John* and the *Virgin, Child and Cat* demonstrate a feeling of movement, the result of many varied pen strokes. While his earlier drawings are shaded and modelled in diagonal strokes (from top left to bottom right, natural to a left-handed person), his lines twenty years later follow the three-dimensional shape of the object depicted. This change enabled him to show the convexity of a cylinder by a series of parallel curved lines passing around the surface of the form, rather than simply by a group of straight lines running diagonally across it. He developed this sculptural style of drawing when he and Michelangelo were both in Florence.

His earliest drawings involve a delicate application of wash, rather than the use of hatching or shading lines. Thus, *A Lily, c* 1472–5, done in pen and ink, was washed over with black chalk. His later, more technical, drawings show the wash applied in a different way, drawn from his study of engineering treatises in which he used such methods, for example, in his *Scythed Chariot* and *Armoured Car*, as well as in his anatomical studies, such as the *Foetus in the Womb*. By then, in or around 1502, his handwriting was less orderly and his drawn pages were crammed with random series of images. Unfortunately the ink he used in later years was highly corrosive, especially on the more absorbent French paper.

He employed the favourite early Renaissance technique of metalpoint, which involved using a lead- or silver-tipped stylus for fine, delicate work. Many of his finest drawings until the early 1490s were in this medium, and ultra-violet photography has revealed many previously unknown metalpoint sketches in his notebooks.

From the 1480s, he preferred the then new drawing material, chalk, as it gave greater breadth and a more three-dimensional look to larger drawings. Its lighter touch was useful for more rapid work, as in the *Last Supper* and the *Battle of Anghiari*; *A Rearing Horse* is another excellent example. Kenneth Clark has described the *Last Supper*'s drawings as the first important Italian ones to be done in red chalk. A comparison of *A Rearing Horse* and *A Copse of Trees* shows Leonardo's varying use of this medium. Later on, in his *Deluge Drawings*, he preferred black chalk as it provided a means of expressing the swirling destructiveness of wind and water. It was also ideal for the elegant masquerade figures which he drew in preparation for theatrical entertainment. Lomazzo was probably correct in claiming in 1584 that Leonardo invented the pastel drawing technique.

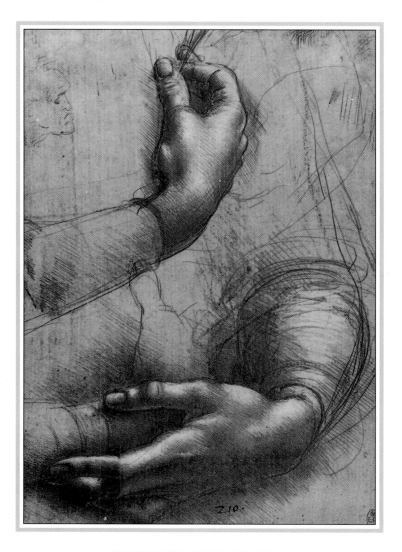

A STUDY OF ARMS AND HANDS
c 1474

Perhaps a study of Ginevra de'Benci's hands.

Convinced that a painter tended to paint all his figures alike, he called for 'variety in his figures, if the men are not all to appear brothers'. The idea that every painter paints himself was not uncommon in Leonardo's day. Many Renaissance painters created stylistic figures, and Leonardo himself succumbed at times. His advice was, 'Know that you must fight your utmost against the vice ... because the soul, mistress of your body, is that which makes your individual judgement; and she naturally delights in works similar to that which she made in the composition of your body.' No single norm of proportional beauty must be kept to, because 'the measurements of parts and their thicknesses vary greatly in nature, and you should vary them yourself.'

> O, anatomical painter, beware that the overtly strong indication of the bones, tendons and muscles does not cause you to become a wooden painter, with your wish that all your nudes should display their feelings ... [So] observe in what manner the muscles in old or lean persons cover or clothe the bones, and ... note the rule concerning the same muscles filling the spaces interposed between them, which are the muscles that never lose their appearance in any amount of fatness, and which are the muscles which lose the signs of their terminations with the least plumpness.

NEW SCIENTIFIC TECHNIQUES

Both as an artist and scientist, Leonardo realized by 1490 that the road to science was via the sense of sight. Alberti had laid down the optical truths of perspective, while Brunelleschi, the great Florentine architect, had created a new technique of reproducing three-dimensional images on two-dimensional surfaces. Leonardo developed a 'perspectograph', which allowed him to view an object through a hole in a square frame, steadied by one hand, while the other drew the projection of the object onto a glass pane. Using this revolutionary process, Leonardo could find a measurable relationship between an object and the image of it that he drew. With the outline providing a proportional linear perspective of the object, he could then work out how colours needed to be shaded to show perspective over distance. He found that these three kinds of perspective diminished with distance in 'pyramidal proportion'. Hence his law of linear perspective. 'The pyramid is the name applied to the lines, which, starting from the edges of the surface . . . converge from a distance and meet as a single point.' His pyramid of perspective could have many sides, its base formed by the edges of what was observed. Geometry, ever his prime mathematical interest, was thus brought into service.

By these means Leonardo was halfway to working out how to reduce size, colour and definition proportionally, with the prospect of depicting a three-dimensional reality on a two-dimensional plane. The ability to achieve an illusion of reality via painting was a great stimulus to him.

Leonardo's mathematical precision resulted in the geometric patterns which underpin his paintings, giving them harmony and order. Searching for a synthesis of all knowledge, he followed the hypothesis of the mathematician Fra Luca Pacioli's that geometrical patterns regulated the composition of painting. Using this hypothesis, Leonardo tabulated the proportions of the human body and made their geometrical patterns the backbone of his paintings. He based all composition on a harmonious scheme – be it radiation, arc, triangle, and so on. His orderly, precise mind left nothing to chance. Thus nature's generating forces took on a tangible form in a perspectival organization of space, which made use of curved lines to suggest continuous rotation, as of water or wind.

YOUTHFUL WORKS

The earliest surviving work of art by Leonardo is his drawing in the Uffizi Gallery of a landscape featuring Valdarno Castle. But more famous is his *Tuscan Landscape: The Feast of Our Lady of the Snows* inscribed with the date he drew it on, 5 August, 1473, though it shows a

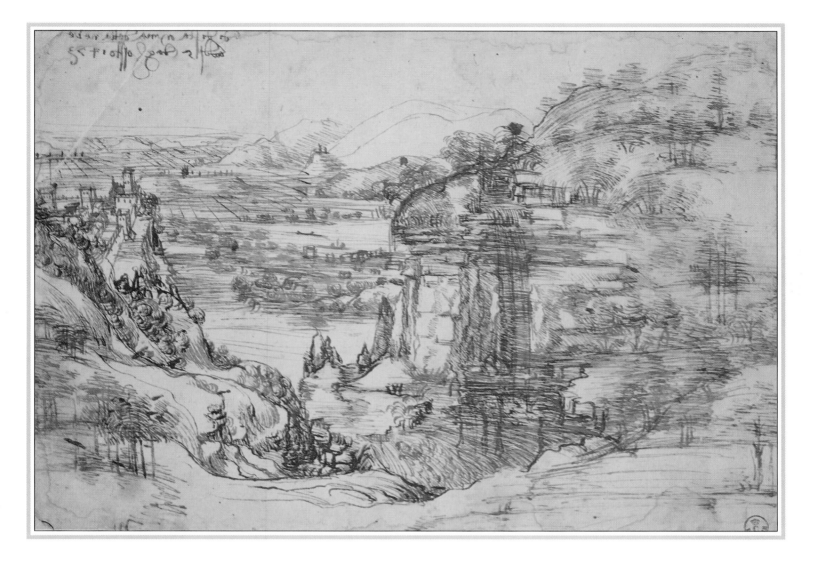

A TUSCAN LANDSCAPE

Inscribed 'The Feast of Our Lady of the Snows, 5 August, 1473', this
drawing is on yellow-tinted paper. Every contour, dip and fold of the
mountains and river valley is shown in sharp focus.

hot day, with the trees shimmering. Ludwig Heydenreich, a modern
Leonardo scholar, called it, 'the first true landscape in art', disregarding
the work of many Flemish, Italian and Chinese painters before
Leonardo's time. Leonardo's 'single line' ships resemble Chinese art,
while his trees, consisting of a vertical line and a splash of horizontal
lines forming ideograms, remind critics today of the work of the Japa-
nese artist, Toyo Sesshu (1420-1506).

Kenneth Clark maintains that his 'early pictures are less good than
we should expect them to be', and that only his *Ginevra de'Benci, c* 1474,
is wholly successful. It is unforgettable for the same reasons as the *Mona
Lisa*, both women being portrayed as proud, majestic, yet vulnerable.
(Like other Florentine women, Ginevra has shaved off her eyebrows
and eyelashes, so increasing her air of vulnerability.) Though Ginevra
called herself a 'mountain tiger', here her pale face, set against a juniper
tree (as its Latin name, *ginevro*, fitted her), seems somewhat stunned.
The directness of the painting suggests the work of youth. Contrast is to
be found between the sensual sheen of Genevra's silky hair and the sky
screen of juniper, between her filmy blouse and her black scarf (a sign
of faith and mortality), and between the lakeland's radiance and the
juniper. To achieve this effect in oil, Leonardo used a new Florentine

THE ANNUNCIATION

The painting was only firmly attributed to Leonardo in 1939; it had earlier been thought to be the work of Verrocchio (Leonardo's master) or Ghirlandaio, or possibly a joint effort of Leonardo and Lorenzo di Credi. Several Leonardo paintings were attributed to Credi and vice versa, which is not surprising: both artists were in Verrocchio's studio at the same time, as they were when this was painted, about 1473. Kenneth Clark says that Leonardo's early works 'are less good than one should expect them to be', and the picture is certainly stiffer and more stylized than his later works, but it is unusual in having an outdoor setting, and the angel's wing is clearly based on observation of a bird. The plants and flowers were probably also drawn from life, though none of Leonardo's plant studies can be positively linked with this work.

1 This drapery study for the painting is one of a few drawings which can be positively identified as the work of the youthful Leonardo.

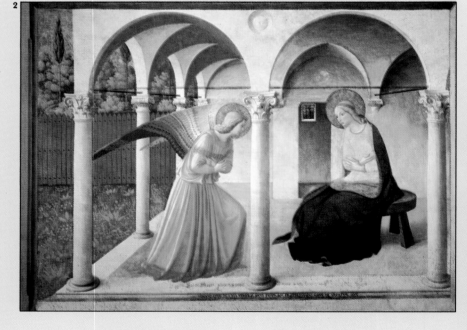

2 This version of the subject, by Fra Angelico, has a certain similarity to Leonardo's, but here Mary is indoors when the angel appears, a more traditional setting than Leonardo's outdoor one.

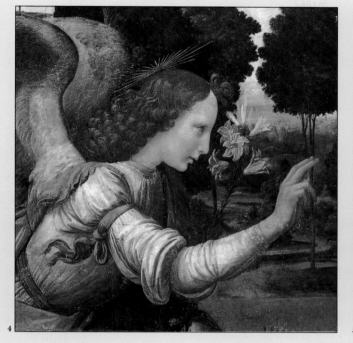

3 *The Annunciation* is painted on a wood panel, and is part oil and part tempera. The enclosed garden and the lily held by the angel both symbolize virginity.

4 The angel, holding a Madonna lily *(Lilium candidum),* has distinctly human features, contrasting with those of Leonardo's predecessors, with their ideal, superhuman qualities.

5 The marble sarcophagus was copied from Piero de Medici's tomb, which had been carved by Verrocchio.

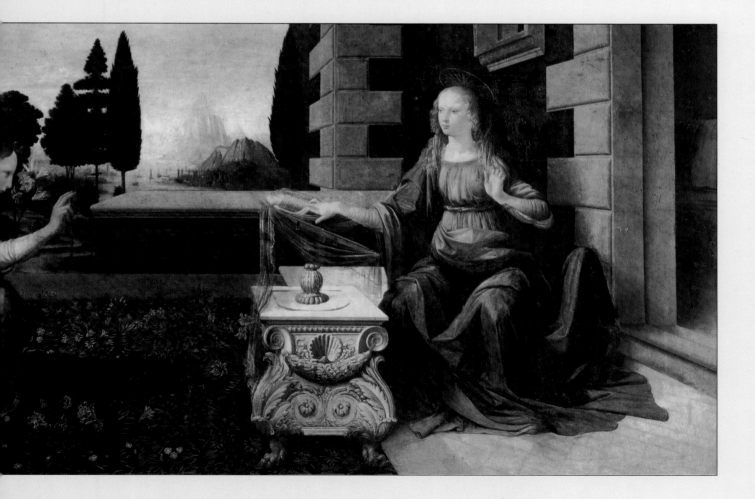

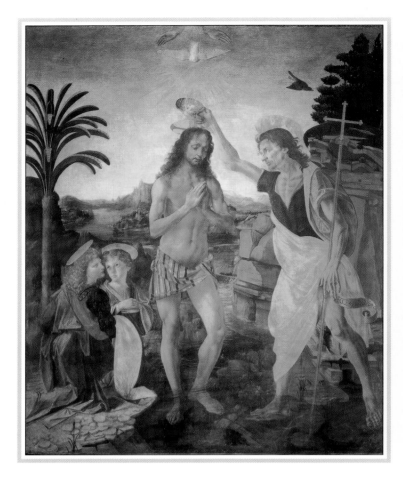
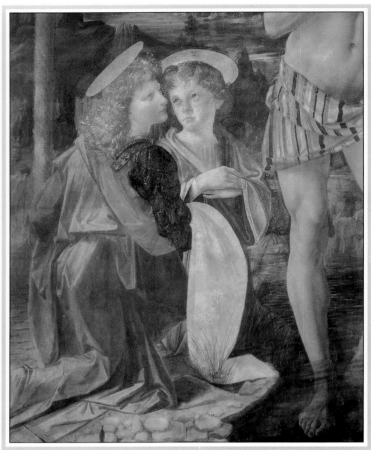

BAPTISM OF CHRIST
Verrocchio and his workshop
c 1470-6

The lefthand angel was almost certainly painted by Leonardo, the
first example of his individual skill. As can be seen in the detail
(above right), the angel shows a marked advance on the stiffly
detailed one in *The Annunciation*. The face has a delicate and
unearthly beauty.

technique, pressing his fingers into the wet paint to blur the precision of
his brush-drawn shapes.

Two *Annunciations* remain among his early works. The style of the
first, *c*1473 (now at the Uffizi) is contemporary, yet its setting is novel,
being out of doors, and with a sarcophagus dividing the composition.
The parts do not add up to a convincing whole, though it does convey a
strong sense of originality. The second *Annunciation* is in the Louvre, a
small painting intended to go below the altarpiece painted by Lorenzo
di Credi for Pistoia Cathedral. Several of Leonardo's paintings feature
angels, yet in Leonardo's day angelic art was dying from over-exposure.
The angels of power and urgency had been replaced by bevies of
handsome youths or girls, who simply added decoration and no more.
Yet angels, as celestial creatures akin to birds, fascinated him. He made
them into real beings, with impressively large feathered wings and with
their clothes blown by the wind. 'He often passed through places where
birds are sold', wrote Vasari, 'and took them out of their cages with his
hands, paying the vendors the price demanded, then let them fly away,
giving them back their lost freedom'. No doubt he also watched their
flight intensely.

In Verrocchio's *Baptism of Christ* the twenty-three-year-old Leonardo
painted the kneeling angel on the left. The foreshortened head, the

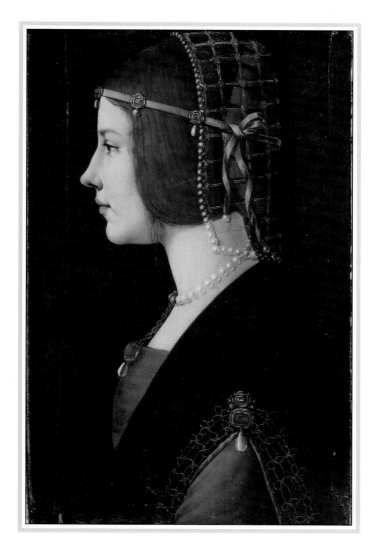

BEATRICE D'ESTE
1491

———

Leonardo was fascinated by Beatrice's features and her impudent
and wilful character. He also designed the costumes for her marriage
fête.

tumbling hair and the brightness of the angel's sweet eyes explain why
Vasari wrote (totally incorrectly in fact) that Verrocchio gave up
painting when he saw how the angel outshone his own work on the
picture. Besides this angel, the distant landscape and the water in the
foreground are in oils, while the rest is in tempera. Leonardo probably
did the oil sections.

From the spring of 1488, after he had been in Milan for around six
years, Leonardo became more of a public figure at the Duke's court,
doubtless painting some of the ladies there. His women have opulent
forms but young faces. Their eyes, which are either clear and luminous
or modestly lowered, added a sweet, sad grace to their virginal
expressions. He painted their hair, often elaborately dressed, in
meticulous detail. In 1495, he painted the *Lady with Ermine* – thought to
be the Duke's first mistress, Cecilia Gallerani, who acted as her lover's
adviser. (As the Greek for ermine is galee (γ α λ ε η) the title is a pun on
her name.) Here light and shade are supremely achieved. In 1491, when
he designed the costumes for the marriage fête of the young Beatrice
d'Este to the by then middle-aged Duke, Leonardo also painted
Beatrice decked in pearls and rubies. At the Sforza court, he painted
Bianca Maria, the sister of Gian Galeazzo, the twenty-two-year-old
bride of the Emperor Maximilian.

THE ADORATION OF THE MAGI

In 1481, while still in Florence, Leonardo agreed to do an altar-piece, entitled the *Adoration of the Magi*, for the church of San Donato a Scopeto. The contract demanded completion within two-and-a-half years, on penalty of forfeiting the fee, which was to be paid in property. Leonardo was even required to buy his own paint. When he left for Milan a year later the work was still unfinished, with only the brown underpainting complete. Yet Kenneth Clark has declared it, 'an overture to all Leonardo's work, full of themes which will recur'.

As he worked on the painting he turned an unflattering Joseph with a stick on the right of one drawing into a contemplative Joseph, and then finally into a 'philosopher-prophet' figure. The foreground figures in the earlier drawings are transformed into a dense crowd in the actual painting, while a deliberately pagan background for the old order gives way to the new order in the foreground. He convinces the viewer that those present, ranging from the joyful to the terrified, were staggered by the unprecendented event. He rejected the standardized presentation, as in Botticelli's *Adoration*, with its unmoved dignitaries assembled in order of rank, for a new vision of the mystery. Leaving the manger and animals behind, Mary has come into the open before a chaotic crowd in which the Magi are almost swamped. Yet there is unity and logic to be found in this new presentation, ranging from a balanced symmetry for ritual worship to a turbulence reflecting spiritual agitation. Perhaps the youths above Mary are angels, and the pressing group on the right are shepherds. Maybe even the handsome Leonardo himself appears as one of them. The fine facial expressions are certainly the result of his prolonged study of faces.

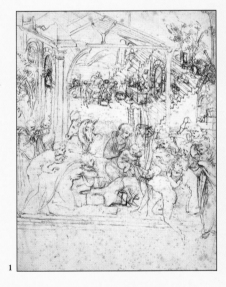

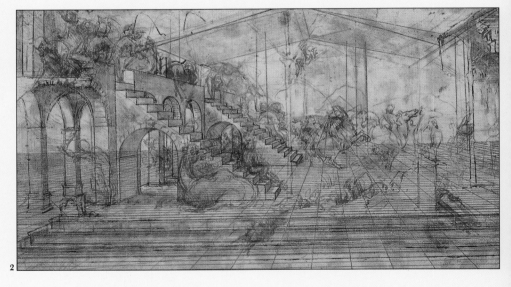

1 Leonardo's compositional studies show a range of different treatments. The ox and the ass were finally replaced by female observers, while the sketchy trumpeters to the right disappeared.

2 Leonardo's preliminary studies for *The Adoration* reflect his changing preoccupations. The drawings range from a study of the classical ruins to a camel, with background sketches perhaps exploring the theme of St George – or St Donato – and the dragon.

3 Domenico Ghirlandaio's *Adoration of the Magi* is a crowded scene, like Leonardo's, though less intensely concentrated on the Holy Family.

4 In Filippo Lippi's version of the same subject, the birth of the new order is symbolized by a stable in the ruins. Lippi painted this for the monks when Leonardo had failed to finish his.

5 In Leonardo's *Adoration*, the magi worship Christ at the 'altar' represented by the Virgin, the central group forming a balanced pyramid. The palm symbolizes victory.

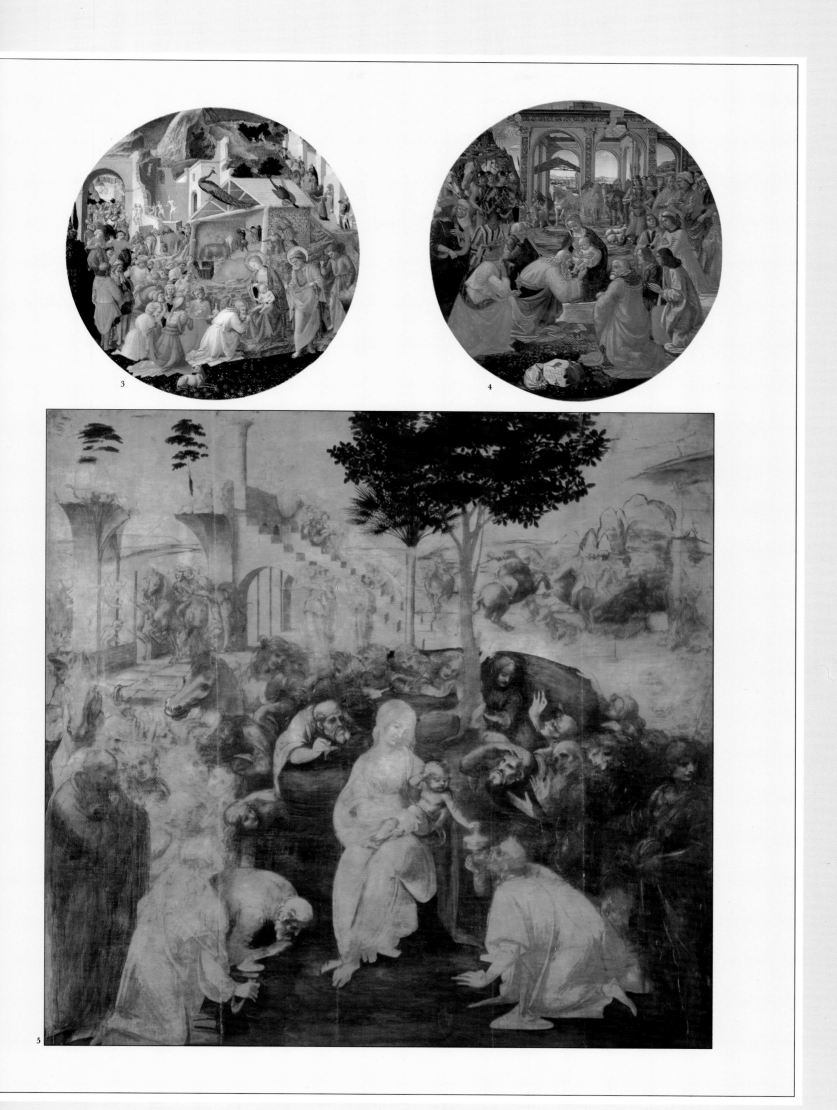

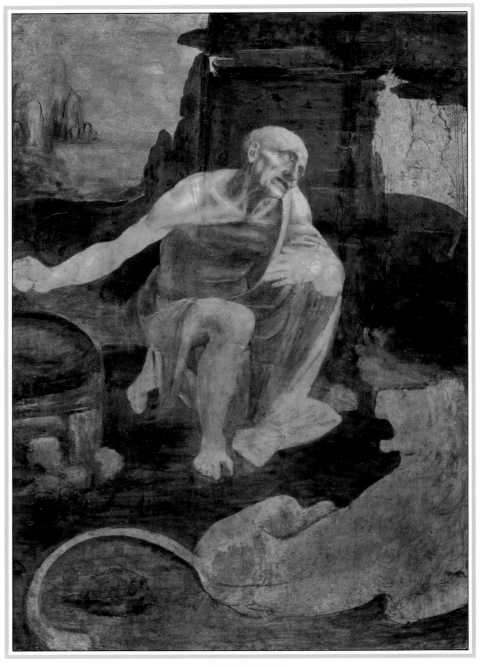

ST JEROME
c 1481
———

This unfinished painting was found in 1820 in a second-hand shop
in Rome, minus the saint's head, which was later found wedging a
cobbler's workbench.

ST JEROME IN THE DESERT
———

St Jerome in the Desert, 1482, a relatively early work of Leonardo's, is
striking for the sympathetic way it portrays an elderly man. Rarely does
he demonstrate his anatomical knowledge so well, for the saint's bones
and muscles are covered with only a thin layer of flesh, and the cheek
and neck muscles are accurately portrayed. The orange-yellow and
brown hues of the painting convey the glare of the desert, which por-
trays the almost naked and emaciated saint's isolation from the world.
Leonardo's most tragic work, it was done at a time when he referred to
his depression in his diary. 'Why do you suffer so?' is frequently to be
found in the margin of the *Codex Atlanticus*. 'I thought I was learning to
live; I was only learning to die.'

LEONARDO'S MADONNAS

Like most artists, the youthful Leonardo was fascinated by the image of the Virgin Mary. He often depicted her as a fragile adolescent girl, without the customary halo, playing with Jesus. All his Madonna figures have a special grace and sense of happy motherhood about them, doubtless reflecting his youthful appreciation of family life. The *Benois Madonna*, with its diagonal pose, is less formal than the *Madonna with Carnation*, representing the beginning to his break away from the traditions of the Verrocchio workshop. Everything is more unified: the light has a directional flow, and the draperies a rhythmic quality.

The *Madonna of the Cat (Virgin, Child and Cat) c* 1480-82, for which only the drawing remains, introduced a cat to recall a legend that one gave birth at the time Christ was born. Leonardo experimented with a series of drawings, showing a cat cuddled, stroked and half-choked, to ensure its presence reflected the emotional interplay of Mother and Child. Centuries later this flexible sketching became the norm, but it was unusual in Leonardo's time and accounts for the emotional and dynamic quality of his painting. Another painting of a Madonna, which has sometimes been attributed to Leonardo, is the *Litta Madonna*, which shows Mary suckling the Christ-child. It is named from its presence in the Litta house, Milan, before it was bought for the Hermitage Museum in Leningrad by Alexander II. It is so awkwardly composed, however, that it is probably not Leonardo's work.

On 25th April, 1483, Leonardo agreed to deliver an altarpiece for the new Chapel of the Conception in the Church of San Francesco, Milan, by 8th December that year. The de Predis brothers, contemporary artists, were commissioned to work on the side panels and the framework of the altarpiece was carved by Giacomo del Maino, so as to resemble a miniature temple. The lengthy complex contract was designed to ensure that the monks got the picture they wanted.

> Item, Our Lady is the centre: her mantle shall be of gold brocade and ultramarine blue. Item, her skirt shall be of gold brocade over crimson, in oil, varnished with fine lacquer ... Item, God the Father: his gown shall be of gold brocade and ultramarine blue. Item, the angels shall be gilded and their pleated skirts outlined in oil, in the Greek manner. Item, the mountains and rocks shall be worked in oil, in a colourful manner ...

Some changes were made, such as the omitting of an angel and the introduction of St John. In spite of two lengthy lawsuits and two paintings, recently discovered documents show the commissioned painting was in place by 18th August 1508, and the final payment being made in October of that year.

Today, the two versions of his famous *Virgin of the Rocks* still exist, one in London's National Gallery, the other in the Louvre. Probably Leonardo finished the first version by the early 1490s, with the second

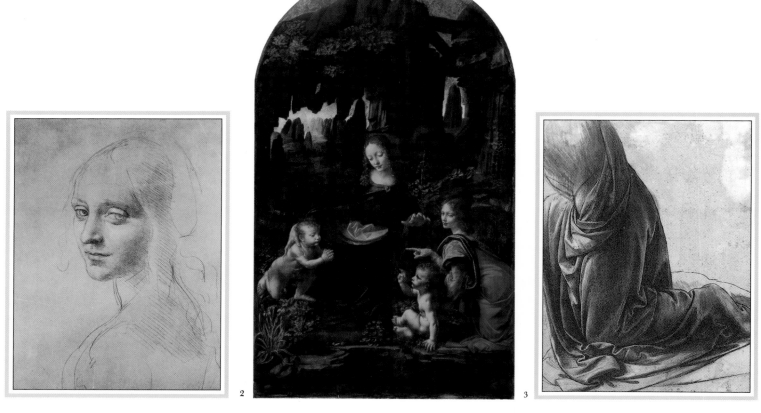

THE VIRGIN OF THE ROCKS

The study (1), in silverpoint on pinkish-brown paper, was done
c 1483 for the Paris version. There are considerable differences
between this, the Louvre version (2) and the London one (4), but
both show Leonardo's keen awareness of landscape elements and
effects of light. The drapery study (3) in black wash heightened with
white on pale blue paper, was made *c* 1496, probably for the London
version of the painting. In the London version (4), the rocky grotto-
like setting remains, linking the picture with the monks' chapel
where it was to hang.

completed by 1506 at the earliest. Of the two, the Louvre version
belongs, stylistically, to the 1480s, while the London one appears to be
of later origin. Critics continue to argue about which is the original.
Some say there is no proof that the Louvre version is earlier, but the
London painting, showing traces of work by the de Predis brothers, is
more likely to be later, especially as it is more mature and its light more
directional. The former is set in the autumn, with little sense of flowing
waters, while the latter brings the viewer closer to the figures, is bluer
and gives a sense of flowing waters.

As far as the subject of the painting is concerned, the immaculate
conception was a hotly debated topic in Leonardo's day. He had to
publicize that doctrine for his employers by conveying the power of
purity radiating from the Virgin. His approach to the subject was

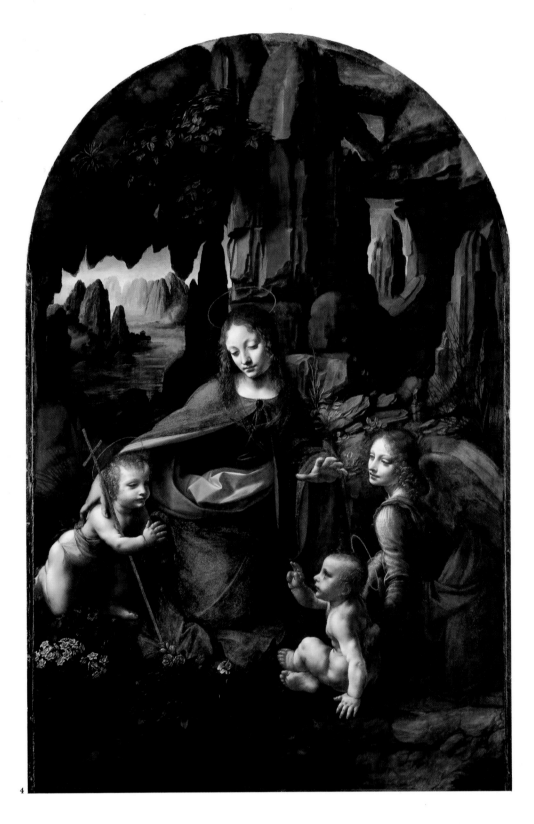

4

original, for he painted a timeless vision of a bustless Virgin proclaiming her purity amidst a landscape of phallic rocks and womb images. She can hardly have clambered over the rocks to the place where she is shown! The grotto setting was an ideal 'mirror image' for the monks' chapel, as it was built over catacombs; its candle-lit heavy gilt frame adds a misty golden atmosphere to the blue and gold apparition of Mary. It is Leonardo's most visionary painting, illustrating a popular 14th-century tale of Jesus meeting the infant John the Baptist in the care of Angel Uriel, as both fled to evade Herod's massacre of the innocents. Mary's arm draws John into the holy circle as he pays homage to Jesus, who blessed him and prophesied the Baptism – hence the foreground pool prominent in the Louvre painting. The sword-shaped iris leaves represent the sword of sorrow,

EARLY MADONNAS

The attribution of Leonardo's early paintings is very uncertain, and although he may have had a hand in all of these pictures it is unlikely that he was solely responsible for any, with the possible exception of *The Benois Madonna*. The Virgin and Child was a 'standard' theme of the time, and most pictures of this kind were produced in workshops under the supervision of the master. The large number of copies of *The Benois Madonna*, however, both Italian and Flemish, indicate that it was much admired, and was obviously not the work of a second-rate artist. Raphael used the figure of the Virgin for a painting of his own, of which the original is lost, and the same Christ-child (with a different Madonna) featured in several other paintings.

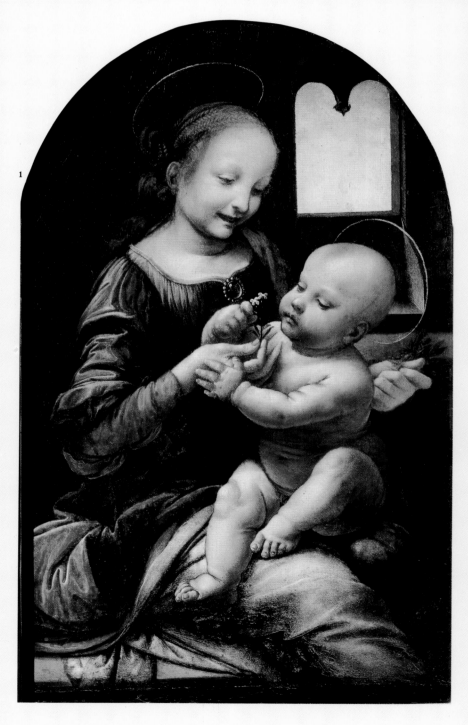

1 *The Benois Madonna* takes its name from a 19th-century artist, Léon Benois, who owned it until 1914. It was painted *c* 1480, and shows a revolution in Leonardo's style of drawing, anticipating his *St Anne, the Virgin, Child and Lamb.*

2 *The Madonna with the Carnation,* also known as the *Madonna with Child and Vase of Flowers,* was a product of the Verrocchio workshop, completed by Leonardo. Though the mountains are typical of his later work, it lacks his usual level of draughtsmanship.

3 As with *The Benois Madonna,* there are many replicas of this one, *The Litta Madonna* (*c* 1480), so it was obviously a famous composition. It is named after the Conte Litta of Milan, its owner until 1865.

4 A wonderfully dynamic sketch for *The Madonna, Child and Cat,* using a welter of alternative lines and positional changes. The original of the painting was lost, though there is a later version based on Leonardo's drawings.

5 The preliminary drawing for *The Litta Madonna* shows a marvellous combination of strength and delicacy. The stiffness of the painting, however, suggests that it was a product of Leonardo's workshop rather than his own hand.

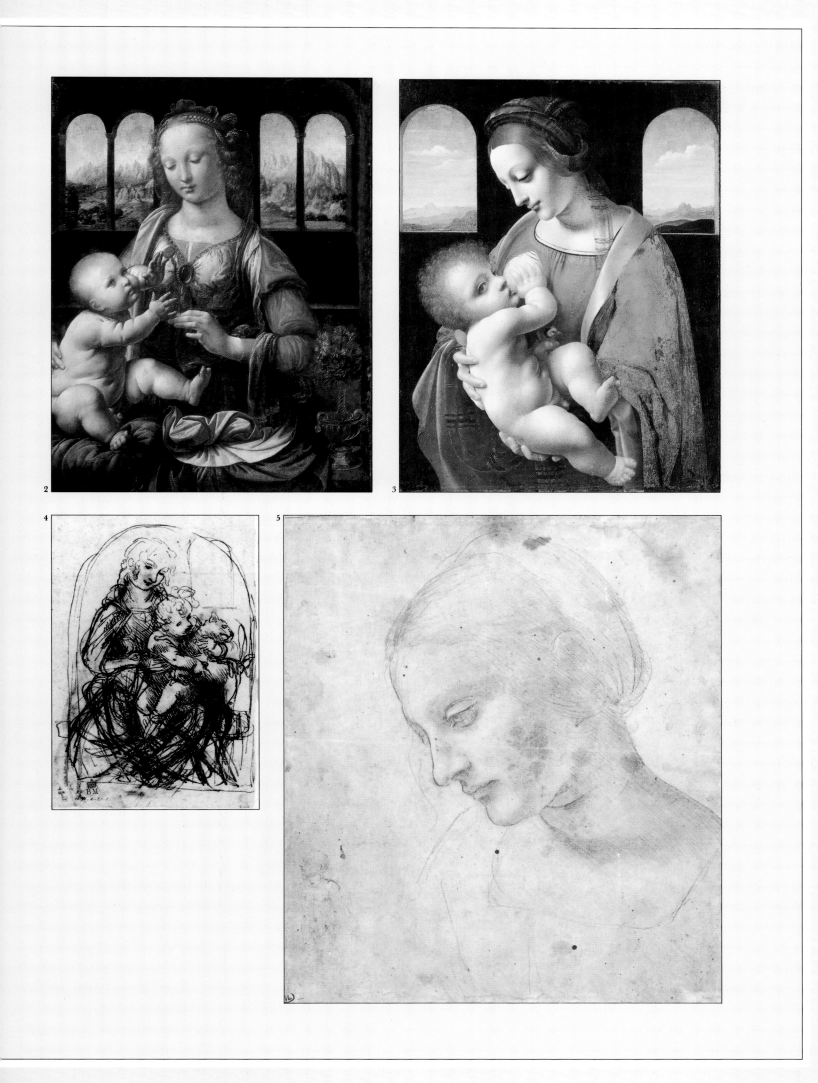

which was to pierce Mary's heart; the palm leaves are a Marian emblem and a symbol of victory, as in the *Adoration.*

Leonardo's lighting is novel, showing he had completely re-thought the traditional techniques of depicting light and shade to produce three-dimensional form. In his new system, tonal unity provides a foundation for pictorial structure. 'Shadow is of greater power than light, in that it can impede and entirely deprive bodies of light, and the light can never chase away all the shadows of bodies'. Shadow ultimately dominates colour, subordinating all hues to its darkness. 'The quality of colours will be ascertained by means of light, and it is to be judged that, where there is more light, the true quality of the illuminated colour will be seen.' The most brilliantly painted colour is kept for the most directly illuminated parts, while the shadowy unity is achieved by a subtle series of adjustments, as in the Virgin's clothes.

The way in which Leonardo created tonal modelling with his paints, before applying the major colours, shows how he valued a unified scheme of light and shade. He once wrote, 'The scientific and true principles of painting first establish what is a shaded body, and what is direct shadow, and what is light; what is darkness, light, colour, body, shape, position, distance, nearness, motion and rest'. The direction of light and shade are called *chiaroscuro.* This cannot be fully judged in this painting as he never finished it.

Leonardo called the individual colour of an object its 'perspective of colour', while the blurring of the definition of forms was, the 'perspective of disappearance'. He was alert to secondary light effects, as the Louvre version of the painting shows. Not until the 19th century was such elusiveness of visual phenomena depicted again and the Milanese would have seen nothing like the Louvre painting before.

ST ANNE, VIRGIN AND CHILD

In 1500 Leonardo returned to Florence following the French invasion of Milan the previous year. Seeking to re-establish himself as loyal to the Florentine Republic, he thought of using St Anne as a subject, as it was on her day in 1343 that Florence had risen against Walter of Brienne, a hated foreigner. He also did a drawing for his *Salvator Mundi,* which had close links with republican Florence as it was on St Salvatore's day that the Medici had been expelled in 1494.

He started slowly, judging by Fra Pietro da Nuvolara's note of April, 1501, to Isabella d'Este Marchesa of Mantua: Leonardo was reported 'to be leading a desultory and unsettled life, living from day to day . . . Since he has been in Florence . . . Leonardo has done only one unfinished sketch, of a Christ-child aged about one who, eluding his mother's arms, grasps a small lamb and seems to hug it to himself. He has done nothing else, except to put his hand occasionally to some portraits which two of his assistants were doing. But he is working hard

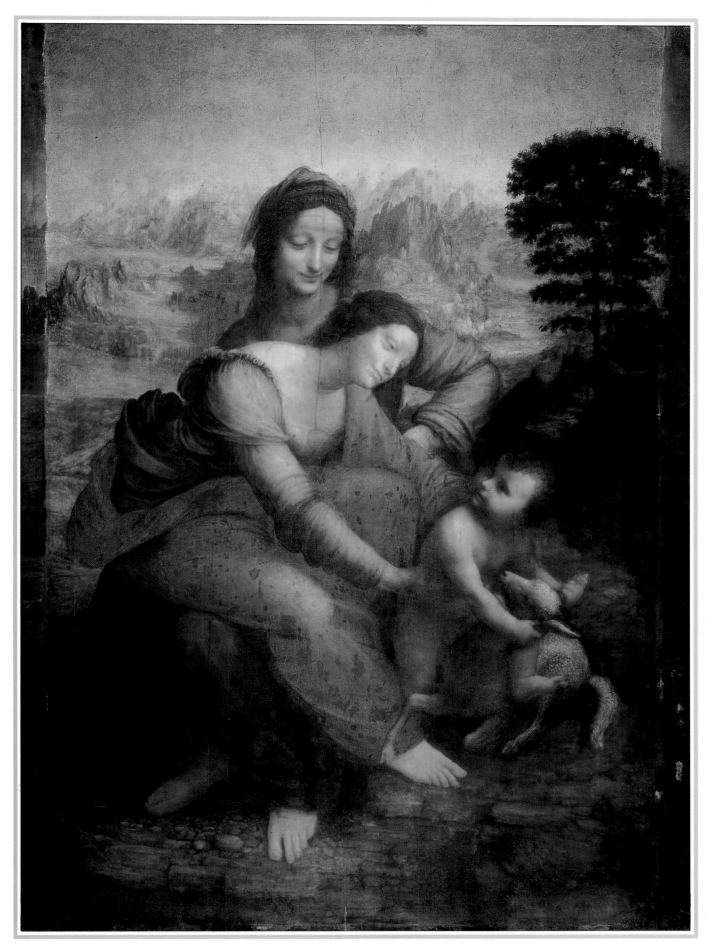

ST ANNE, THE VIRGIN, CHILD AND LAMB
c 1508

The delicate, vapour-veiled landscape with its distant mountains is
echoed by the sinuous quality of the women's flowing robes.

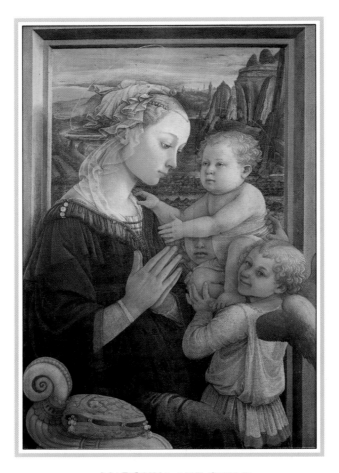

MADONNA AND CHILD
Filippo Lippi

Lippi's Madonna has a calm nobility, serene but altogether less
naturalistic than Leonardo's.

at geometry and is very impatient with the paintbrush.' Next day, he
added, 'In short, his mathematical experiments have distracted him so
much from painting that he can no longer stand the paintbrush.'

St Anne, Virgin, Child and Lamb, painted around 1508 or later, and
now in the Louvre, is in *sfumato* style, based on a cartoon of *Virgin and
Child with St Anne and St John*, now in London, which he did in 1508,
after an earlier one in 1501. Its rocky setting is reminiscent of the *Virgin
of the Rocks*, while its draperies are rock-like too. The drawing's soft
solidity draws the subjects together. The Christ-child precociously
reassures St John, as St Anne assures her daughter of God's protection.
In contrast, motion is the key to the painting. The variegated pebbles at
St Anne's feet in the painting are a typical Leonardo detail. Their
colours are brought out by artificial preparations Leonardo called
mistioni – the moistening of a series of 'small pipes in the manner of
goosequills', which, when pressed into different shapes, produced
different colour effects to guide the painter.

Vasari wrote that, 'men and women, young and old, continued for
two days to crowd into the room where it [the cartoon] was being
shown, as if attending a solemn festival.' Arguments still continue as to
whether there was possibly more than one cartoon, and, if so, which
one Vasari meant. When Cardinal Louis d'Aragon saw the painting in
the Chateau de Cloux, he preferred it to the *St John the Baptist* and the
Mona Lisa. The 5ft by 4ft (1.5 by 1.2m) panel was taken back to Italy,
and in 1630 was acquired by Richelieu. The story behind the picture is
that Filippino Lippi, 'the gentlest being that ever lived', had turned
down a commission to do an altar painting for the Fathers of the
Annunciation, suggesting that Leonardo was the greater artist.

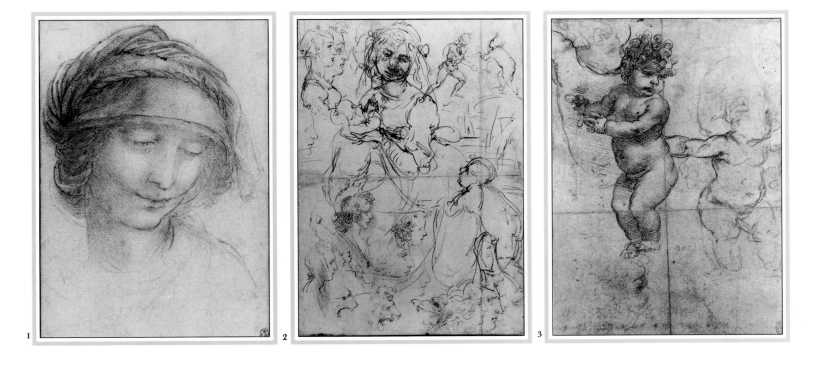

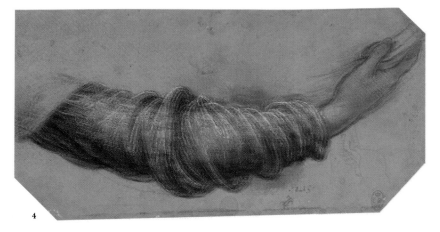

1 STUDY OF ST ANNE'S HEAD
c 1510

Kenneth Clark has said that this drawing has 'human mystery',
while the painting is more 'artificial', as it has lost something of the
drawing's freshness and humanity.

2 STUDIES FOR THE VIRGIN, CHILD, ST ANNE AND ST JOHN
c 1478-80

The main drawing shows the Virgin with Christ on her knee with St
John looking on from the right. Two permutations have been tried
for her head: in one she looks fondly at her son, and in the other
more assertively at St John.

3 STUDY OF THE CHRIST-CHILD

This study was probably made when Leonardo was changing the
Child's position from seated to a more active one.

4 DRAPERY STUDY

The hand is drawn in red chalk, which was gone over with pen,
while the drapery is in black chalk, pen and washes of black,
heightened with white.

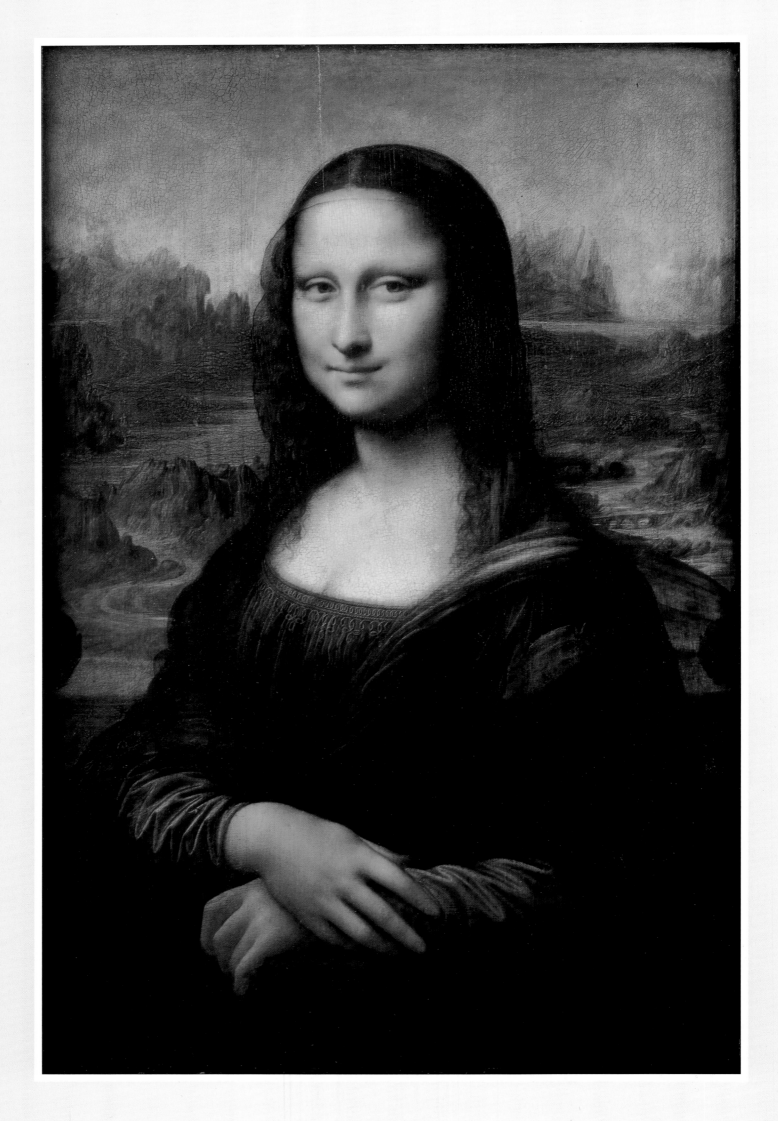

THE *MONA LISA* AND BEYOND

THE MONA LISA
c 1505-14
—————

The painting is a perfect visual expression of Leonardo's philosophy:
the image of the pregnant woman represents the microcosm, set
before the macrocosm of the ever-active world. Notice the cone-
shaped composition, achieved by including the hands.

T he dating of Leonardo's most famous painting is just one of the many arguments over it among the critics. While Kenneth Clark puts the date as around 1503 and Martin Kemp plumps for 1505-14, Robert Payne opts for 1498-9. Vasari indicated that the rich Florentine, Francesco del Giocondo, commissioned Leonardo to paint his twenty-six-year-old wife, Mona Lisa, or 'Madonna Lisa' in 1505. This comment apparently christened the portrait, though today Kemp still insists on calling it, *Portrait of a Lady on a Balcony*. 'But having worked at it for four years, he left it unfinished', complained Vasari, who probably had never seen the portrait. For example, he mistakenly said she had eyebrows, which she has not. He must have been describing a different painting, possibly following a confusion in his notes.

THE MONA LISA

But was Giocondo's wife the subject or was it a portrait of a mysterious Neapolitan lady, ordered by Giocondo, but hidden from his new bride of 1515, Philiberta of Savoy? Some assert that the Mona Lisa was Constanza d'Avalos, Duchess of Francavilla, 'in the beautiful black veil of a widow'. Payne refutes this on the grounds that, at thirty-eight, she would have been too old; he prefers the divinely beautiful Isabella of Aragon, and refers to two preliminary drawings done for the *Mona Lisa*, and the possibility of Leonardo drawing Isabella when she married in 1489 at the age of eighteen. Leonardo certainly saw her regularly, and painted her in *La Belle Ferronnière*. Here, Payne argues, the same face as the *Mona Lisa* is disguised by a different hair style. There is a noticeable similarity in the large, luminous eyes. If the *Mona Lisa* was painted in about 1498, it would fit into a sequence of three paintings of Isabella in the same attitude; as a teenage virgin, a woman of the world and a young widow. The dark veil in the *Mona Lisa* could possibly indicate a widow. Some have even wondered whether the face is that of a man in disguise.

Set in a truncated cone design achieved by the inclusion of the hands, the painting is bathed in a muted blue-green atmosphere, with a dream-like landscape of mountain peaks, water and mists. The face is deliberately ambiguous, the result of a series of tonal transitions which denote changes of contour, from curved hollow to soft prominence. With supreme delicacy Leonardo has built up a face from a series of translucent skins of paint. He has painted the equivalent of a mobile face, in which there is no single, fixed, definitive image. Each viewer finds something new in the expression.

The landscape too is a living, changing organism; mountains alter the river's course as their bases are eroded. The result is a masterpiece of the *sfumato* style, the blending of vague colours and shades to produce a misty appearance. The delicate streaks of paint in the drapery

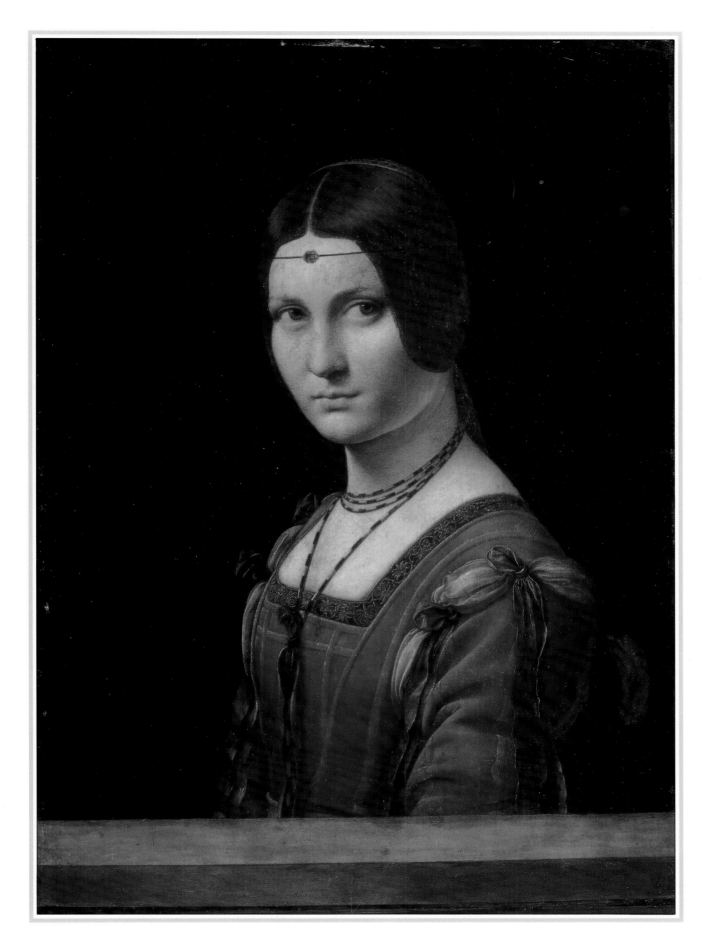

LA BELLE FERRONIERE

c 1495

———

The subject of this painting could be either Ludovico's second
mistress, Lucrezia Crivelli, or Isabella of Aragon. The *ferronière* is the
band around the brow, a common Lombard fashion.

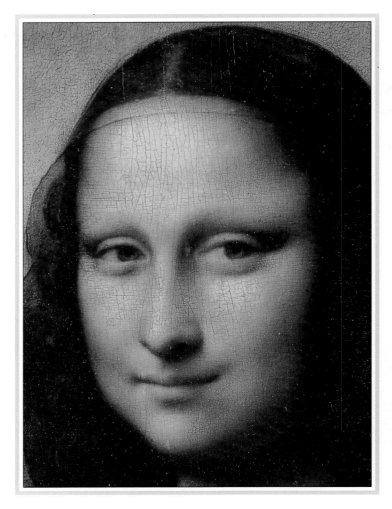 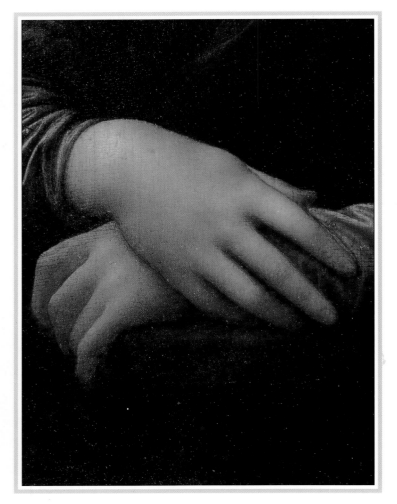

THE MONA LISA (DETAILS)

The famous smile does not seem to have come from the contraction
of facial muscles but from a kind of inner light that permeates the
sitter's whole being. The hands, an unusual inclusion in few
portraits of this period, are painted with breathtaking skill and delicacy.

and landscape underline the sense of identity between the background
and the foreground. Herein, for the critic Kenneth Keele, lies the clue
to the whole meaning of the painting: it is nothing less than the genesis
of the *macrocosm* and the *microcosm*, the birth of the world and mankind
in the womb of time. The background reflects Leonardo's theory about
genesis – that geologically the earth came out of the sea, leaving inland
seas, which eventually found their way via narrow gorges and riverbeds
back to the sea. In the foreground the woman, pregnant, awaits the
birth of an infant from the waters of the womb. Keele reinforces the
argument by saying that at the time he painted her, Leonardo was dis-
secting the pregnant uterus and drawing babes in the womb. This
theory is enforced by the subject's lack of jewelry, when compared to
the ladies painted by Pollaiuolo, Botticelli, Titian and Raphael. While
their paintings are highly ornate, Leonardo's is the very essence of sim-
plicity. Yet, when compared with the pregnant *Isabella d'Este*, the *Mona
Lisa* has the same rounded face and figure, and the same graceful
clasped hands. Her hair, cascading like the water, is smooth, and lightly
covered with a black veil.

Vasari recorded that Leonardo 'while painting her, had singers and
bellringers and buffoons to keep her cheerful and to dispel that gloom
that is often present in the paintings of portraits – and in this one of
Leonardo's there was so pleasant a smile that it was more divine than
human to behold'. Above all the smiles on his subjects' faces reflect the

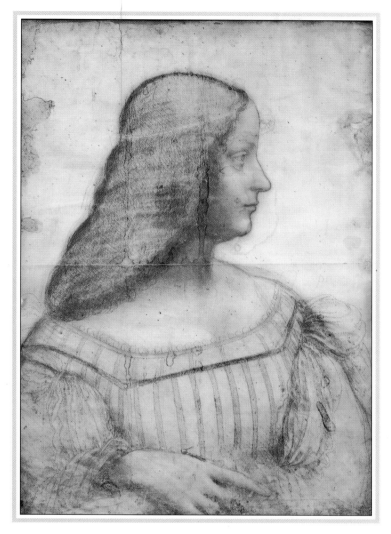

ISABELLA D'ESTE

This is Leonardo's only surviving pastel. Like the *Mona Lisa*, the
sitter is pregnant, and wears no jewellery.

eternal mystery – of sensuality, of the human spirit and things beyond
– which so enthralled him as an artist. The *Mona Lisa* enthralled others
too – on Leonardo's death, Francis I bought the painting for 4000
ducats.

Today it is difficult to decide how close to view the *Mona Lisa*; close-
up, the painting is a myriad of fine cracks, while at a distance – the face
dissolves into *chiaroscuro*. The colours are much altered by time from the
original, for once the sky was a clearer blue, the brown eyes were aglow
and the gown a rich green silk, making the subject stand out boldly
from the background. In 1928 Walter Pater, the eminent Victorian
scholar, regarded her as the embodiment of an ancient earth goddess.
'She is older than the rocks among which she sits; like the vampire, she
has been dead many times, and learned the secrets of the grave; and
has been a diver in deep seas, and kept their fallen day about her.' This
prompted Kenneth Clark to call her 'worldly, watchful and well-
satisfied', reducing her in Payne's opinion to 'bourgeois insignificance'.
However, Lord Clark once saw the painting in the sunlight, a chance
denied to others, and noted a wonderful transformation. 'The presence
that rises before one, so much larger and more majestical than one had
imagined, is no longer a diver in deep seas. In the sunshine something
of the warm life which Vasari admired comes back to her, and tinges
her cheeks and lips, and we can understand how he saw her as being
primarily a masterpiece of naturalism.'

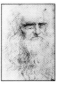

THE SALA DELLE ASSE

In the late 1490s Leonardo was allowed to decorate the Sala delle Asse (the 'room of the tower' or the 'room of the wooden boards') in the northern tower of the Sforza Castle, Milan. He had been given this for his own use, and to gain access to it, he had a bridge, complete with a classical *loggia* (or galleried arcade), built over the moat.

Enough of the room's vault decoration has survived various over-paintings to provide an impression of what he achieved. Eighteen trees are depicted branching over the room, including two that have been skilfully 'trained' to encircle the two windows. In the centre of the ceiling trees from each corner of the room and the centre of each wall meet together, while intermediary trees ramify around. Thus the trunks appear as columns supporting the roof, their roots pushing their way out of rocky strata, while the branches provide a complex late Gothic tracery. A gold cord wanders through the intertwined branches in a series of geometric arabesques.

Though the actual painting of them was not his own work, Leonardo must have created the whole, dazzlingly 'natural' scene. It recalls Alberti's comment on the 'beautiful effect some of the more lively architects used . . . to make columns, especially in the porticos of their gardens, with knots in the shafts in imitation of trees which had their branches cut off.' The inclusion of roots was an innovation, reflecting Leonardo's appreciation of the forces of nature. While tree and vegetable designs were fairly common in interior designs for north Italian palaces, Leonardo transformed a routine heraldic motif into a unified vision of 'natural architecture'.

The intertwining branches marked the union of Ludovico, Duke of Milan, and Beatrice d'Este. Perhaps the roots were depicted to stress the hope that the alliance stood firm. The gold cord was a fashionable Sforza-d'Este motif, the *fantasia dei vinci*. It featured also on Beatrice's clothing as a filigree decoration of gold 'knots'. Four tablets suspended over the main axes of the room recorded the political events of the 1490s, such as the arrangement of Bianca Maria Sforza's marriage to the Emperor Maximilian, the Sforza's claim to the dukedom of Milan and the Battle of Fornovo between the French and the Italians in 1495.

THE LAST SUPPER

When the invasion of Italy by Charles VIII of France disrupted Leonardo's work on the horse monument of the Duke, Francesco Sforza, Leonardo became depressed, and in need of his patron's support. Fortunately, in 1495, the Monastery of Santa Maria delle Grazie in Milan commissioned a fresco of the Last Supper for their refectory. Though the result was to be the first High Renaissance painting,

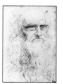

Leonardo was hardly able to continue with it for lack of funds, and was forced to plead with Ludovico il Moro (Francesco's son, who dined regularly in the refectory), 'For thirty-six months I have had six mouths to feed, and in all I have received only fifty ducats', for numerous sketches. (The 'six mouths' included his pupils, Salaino, Botraffio and d'Oggiono, and a servant girl, Caterina.)

For the composition of the painting Leonardo traced the disciples, one by one, naked initially so as to obtain precisely their positions and movements. He even noted what weights they should be. Then he drew them in groups with flowing robes to provide the rhythm of the composition. Their 'body-language' (a phrase which Leonardo would have liked) had to indicate their state of mind, the *moti mentali* behind the *moto actionale*. On the left of the picture, Peter's angular motion expresses shock in contrast to young John's sleepy curves; a tense Judas recoils. Bartholomew, leaping to his feet at the end of the table, is shown as a hard-featured man, without saintliness but with an alert intelligence that the others lacked. All were active, making significant gestures, as Leonardo himself noted down. 'One was drinking and left his cup in its place as he turned toward the speaker. Another twists the fingers of his hand and turns with stern brow to his colleagues. Another with outspread hands displaying their palms, shrugs his shoulders as high as his ears, and gapes in astonishment . . . Another, holding a knife in his hand, turns and upsets a glass.'

The fresco had to cover the whole evening's events. Thus Judas' left hand, hovering over a dish, refers to Christ's words, 'He that dippeth his hand with me into the dish, he shall betray me'. Leonardo expressed the shock waves emanating from those words in the form of physical waves passing over the various groupings of heads towards the peripheries, like waves of water. Christ points to the bread and wine to signify the institution of the Eucharist. Peter holds a knife, foretelling his severing of the soldier's ear at the time of Christ's arrest. The 16th-century writer Giraldi noticed that:

> As soon as he was prepared to paint any figure, Leonardo considered first its quality and nature, whether it should be noble or common, lighthearted or severe, troubled or happy, good or evil; and when he had grasped its nature he set out for places where he knew that people of that sort gathered together and carefully examined their faces, their manners, their habits, their movements; and, as soon as he found anything that seemed suited to his purpose, he noted it in pencil in the little book which he carried at all time at his girdle.

Judas gave Leonardo considerable trouble as he never found a model for him with sufficient expression. When the Prior at Santa Maria complained of his slowness, Leonardo replied, 'Every day I devote two hours to this work'. 'How can that be if you never go there?', queried the Duke. 'For one whole year I have gone every day, morning and evening, to the Borghetto, where the scum of humanity live, to find a

THE LAST SUPPER

It is a tragedy that a man with Leonardo's brilliant mind and deep scientific interests should have been so careless about the science of painting. However, the traditional fresco technique placed considerable limitations on the artist, making it difficult to build up rich tones and colours, so it is perhaps not surprising that Leonardo's constant desire to experiment led him to abandon the old methods and invent what he believed to be better ones. He began the painting in 1495 and it was reported as being near completion two years later, but was already decaying in 1556. What we see today is the work of generations of restorers, yet the power, vitality and originality of the work remain.

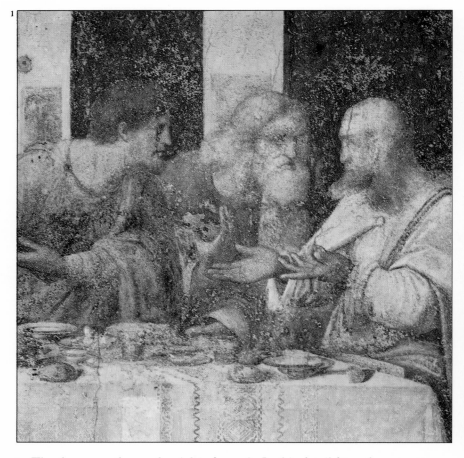

1 The three apostles on the right of the painting are Matthew, Simon and Thaddaeus.

2 The fresco, measuring 80 × 14 feet (24.38 × 4.27 metres) recounts the evening's events. It is set high on the wall above the monks' refectory, but is designed to be seen as though the viewer were on the same level.

3 In this detail from the extreme left, Bartholomew leaps to his feet. The apostles beside him are James the Less and Andrew.

4 This section of the painting features Judas, whose hand hovers over a dish ("He that dippeth his hand with me into the dish, he shall betray me"). A shocked Peter holds a knife, foretelling his severing of the soldier's ear.

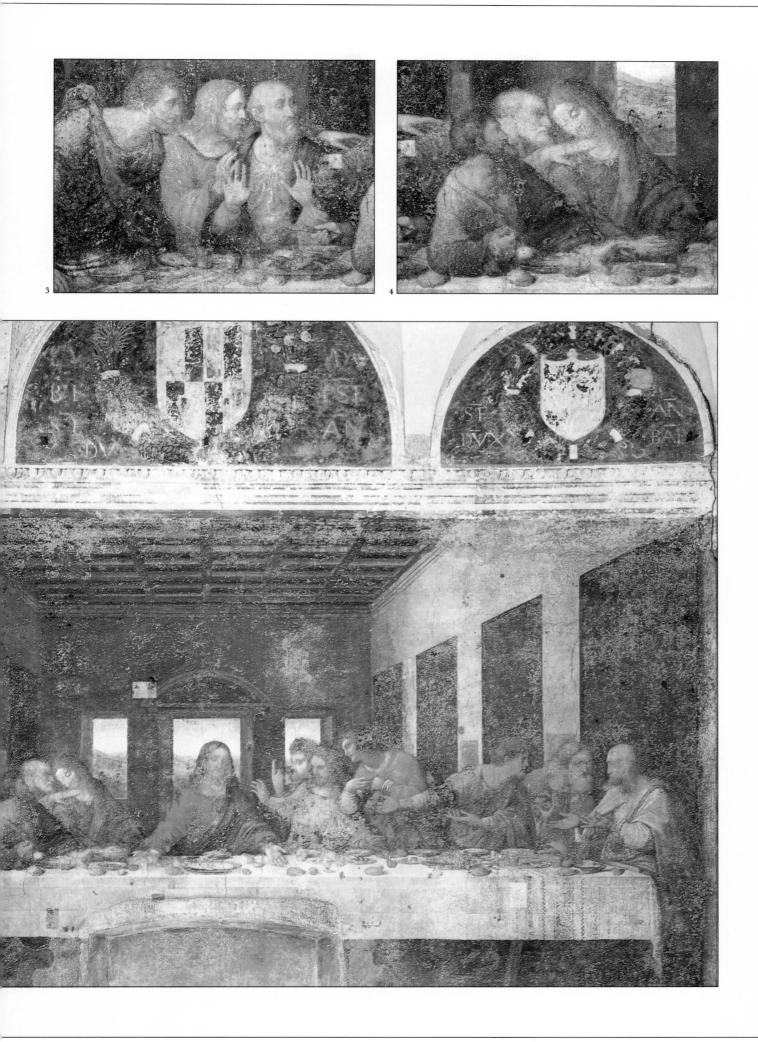

face that will express the villainy of Judas, and I have not yet found it. Perhaps I could take as a model the prior who has been complaining about me to your Excellency; but I should not like to make him a laughing-stock in his own convent.' Though Vasari implies Leonardo did so, he does not actually say so. In fact the Prior was a good-natured, intelligent man. Some critics think his Judas resembled Savonarola, the dictatorial monk executed in 1498. Finally his success in identifying Judas 'physiologically', so that he stood out from the others, enabled Leonardo to dispense with the usual practice of putting him on the opposite side of the table to the other disciples.

In 1497 the seventeen-year-old Matteo Bandello saw and commented on Leonardo at work.

> Many a time I have seen Leonardo go to work early in the morning and climb up the scaffolding, because the *Last Supper* is somewhat above ground level; and he would work there from sunrise until the dusk of evening, never laying down the brush, but continuing to paint without remembering to eat or drink. Then there would be two, three or four days without his touching the work, yet each day he would spend one or two hours just looking, considering and examining it, criticizing the figures to himself. I have also seen him (as the fancy took him) leave in the middle of the day when the sun was in Leo from the Corte Vecchia, where he was working on his stupendous clay Horse and he would come straight to Delle Grazie; and he would climb the scaffolding, seize a brush, apply a brush stroke or two to one of the figures, and suddenly leave and go elsewhere.

One of the problems that Leonardo had to resolve for the painting was the choosing of a central viewpoint for a fresco so high on the wall. A subsequent, recent computer graphics' scan has confirmed that he chose Christ's right eye, as if the viewer is raised up from floor level. To have used the refectory floor as the viewpoint would have meant that the table obscured the disciples from the viewers. To avoid any sloping back effect of the table, Leonardo set it right in the forefront. The computer graphics' scan showed his concern to make the painting look as if the 'upper room' was an 'extension' of the refectory where the monks dined. He achieved this by ensuring that the refectory's western windows lit the painting, but only from the Christ-centred viewpoint, for it was geometrically impossible from any other angle. This forced him to provide a table too narrow for the disciples to eat at, with Peter and Thomas having no seats from which to rise up.

Leonardo's desire for richness, tone and colour led to his abandoning traditional fresco methods, which required a speedy application of pigment before each day's area of freshly applied plaster dried. He tried an experimental method, probably using an egg-based medium on top of dry plaster, suitably primed with a kind of mastic or size. He used some oil when mixing his colours, in place of, or in addition to, fig latex. But the painting was already decaying in 1517. By 1556, it was 'so badly

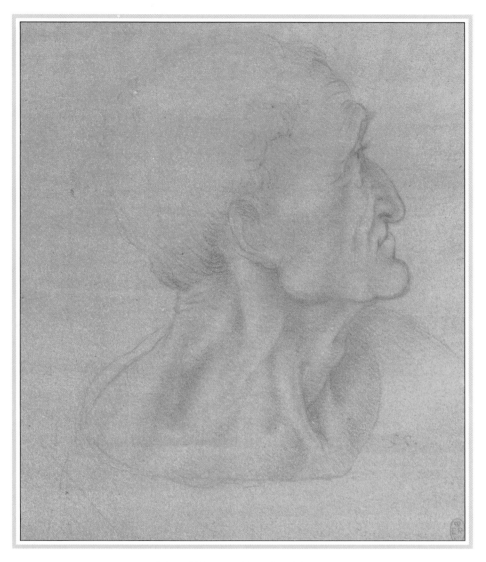

STUDY FOR THE LAST SUPPER
c 1495-7

Leonardo drew Judas three times – dark-featured, hook-nosed and
ugly. In the final painting he appeared even more obviously
villainous than this sketch suggests.

affected that nothing is visible except a mass of blurs'; by 1568, it was
'totally ruined'. There was hardly a scrap of Leonardo's painting left on
the wall. However, his success in painting it had won him back the
Duke's patronage, and the acquisition of a 'vineyard and a piece of
property of 16 rods' near San Vittore.

Over the centuries the painting has been restored between eight and
twelve times. In 1788 Goethe described the Guiseppe Mazza restoration
as being only distantly related to Leonardo's original. The Romantic
period's restorations, recorded in Raffaello Morghen's engraving of
1800, were the least faithful – Leonardo was no Romantic. The 1947

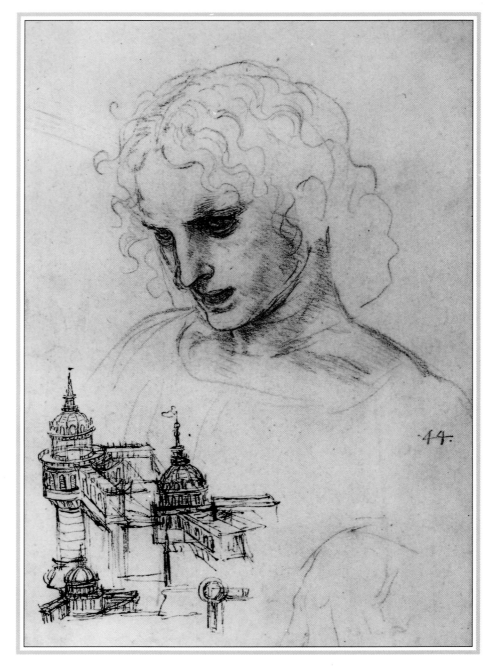

STUDY FOR THE LAST SUPPER
c 1495-7

The most vivacious of the studies, this was for the head of St James
the Greater. The castle was probably a design for a Sforza one.

restoration took place when it was almost invisible under green mould. To appreciate what the original was like, it helps to compare the restored painting with the engraving in the *Sforza Book of Hours*, done within two or three years of the painting. In the engraving, the room is a smaller, hexagonal one, with Christ a larger, more majestic figure, with the right hand giving the sign of the Trinity, while pointing at Judas, as the rest of the disciples freeze in astonishment. Below Christ, in Latin, is written, 'Amen, I say unto you, One of you shall betray me'. Numerous details are different from the Morghen engraving, yet the *Sforza* engraver was known to be an expert and was likely to have copied the original painting accurately. If so, Leonardo had painted a forceful 'betrayal' scene, not the friendly supper-party of the restored work.

THE BATTLE OF ANGHIARI

On 29 June, 1440, at Anghiari the savage mercenary commander of Milan, Niccolo Piccinino, attacked the Patriarch leader of the papal troops and the Florentines; he lost. Wishing to stress its inviolability, the Florentine Republic decided to commemorate this event, and the Battle of Cascina, in its magnificent new council chamber in the Palazzo Vecchio, in 1504. Both battles had a relevance to their present struggles – Cascina over Pisa and Anghiari against the dreaded Milanese. Leonardo's *Battle of Anghiari* and Michelangelo's *Battle of Cascina* were to flank the throne of the Gonfaloniere, the chief executive, along the eastern wall of the hall at the palace. Though other pictures were to mark the Republic's development, none were to be finished.

Leonardo's initial contract was revised on 4th May, 1504, with strict penalty clauses. As a preliminary, he studied Latin records of battles, noting down salient points in the Italian translations made for him. While Machiavelli thought Anghiari had been a mere four-hour skirmish, with the only death being that of a man falling from his horse, Leonardo's notes recorded in detail the accounts of the contemporary historian, Leonardo Dati, who maintained it was a hard-fought day-long fight with heavy casualties.

The terms of Leonardo's contract were all-demanding, for, starting on the left, Niccolo was to harangue his men; the Milanese to approach in clouds of dust; St Peter to appear to the Patriarch; central to the painting was the fight for the River Tiber bridge; the Patriarch's forces were to save the faltering Florentines; the enemy to be routed; the dead to be buried; the trophy to be erected.

Leonardo was forced to simplify and omit. The two soldiers to the left of the picture are Milanese; possibly the man with the upraised sword is Piccinino, as he fits Leonardo's physiognomic theories on bestial men. To the right the Florentines charge, in the absence of St Peter. A distant town, tents against the skyline, and a meandering river provided the setting for furiously fighting soldiers. Three continuous scenes – the beginning, middle and end of the battle – were to be spread over 54ft by 21ft (16.7 by 6m), so giving the viewer the illusion of being on the battlefield.

Some of his preliminary drawings, maelstroms of swirling lines, remain. *A Rearing Horse, c*1505, shows Leonardo's desire to represent the dynamics of the rearing motion correctly. His *Studies of Horses, a Lion and a Man, c*1503-4, concentrate on the animals moving at ferocious speed, or in fighting positions showing terror and aggression. The section of the painting which he did complete shows horses attacking each other with bared teeth. He had promised to finish the painting by February 1505 or return all payments. However, payments still continued after time ran out. The experimental panel was the central fight for the enemy's standard (*gonfalone*), with the horsemen using their horses like battering rams.

THE BATTLE OF ANGHIARI

This was to be a mural for the huge new council chamber of the Palazzo Vecchio in Florence, the companion piece for Michelangelo's *Battle of Cascina*, commissioned at the same time. Both were to commemorate the victory of the Florentine Republic over its enemies, Pisa and Milan, but neither painting was ever finished. Michelangelo began work on a full-scale cartoon in 1504, but was then summoned to Rome by Pope Julius II, and Leonardo completed only the central section. It was described by observers as 'a marvellous thing', but due to his experimental technique it had vanished fourteen years later. It is known to us only through copies, of which the one by Rubens is the most famous. This and the superb drawings give us at least a flavour of this ambitious work.

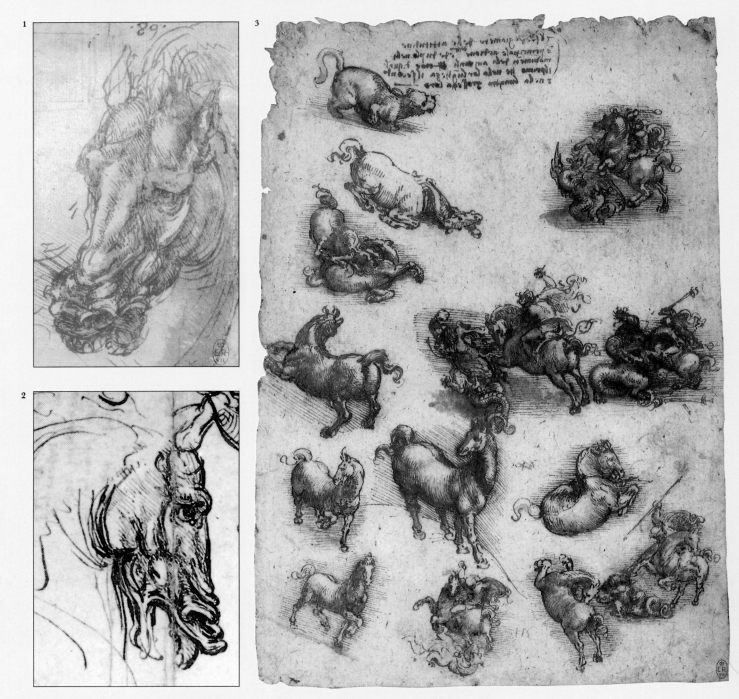

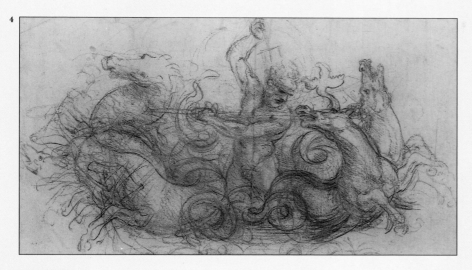

1,2 The ferocity of infuriated horses is vividly captured in these studies.

3 At the top of this sheet of studies (*c* 1517) Leonardo wrote 'serpentine postures comprise the principle action in the movements of animals . . .'

4 The drawing of 'Neptune with Four Seahorses' was made at the same time as the studies for the *Battle of Anghiari.*

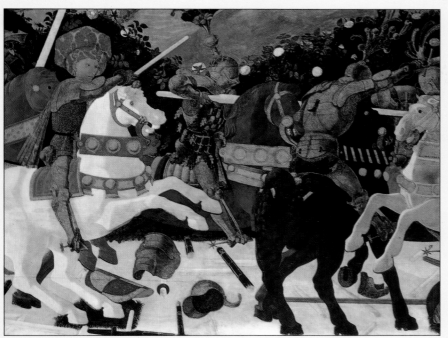

5 Detail from *The Rout of San Romano* by Paolo Uccello (1396/7-1475). This makes an interesting comparison with Leonardo's work. Perspective and colour dominate his paintings, with horses and figures appearing quite static.

6 This is a study for the central section, which showed the fight for the standard.

7 Rubens' copy of Leonardo's *Battle of Anghiari,* painted *c* 1603, was based on an engraving by Lorenzo Zacchia in 1558, and thus is inaccurate in a number of details.

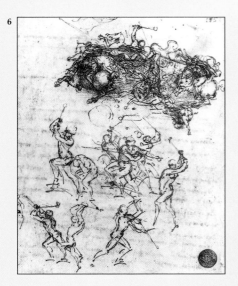

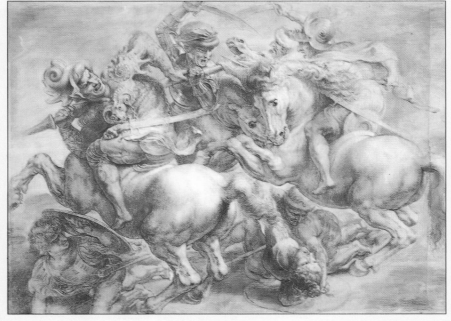

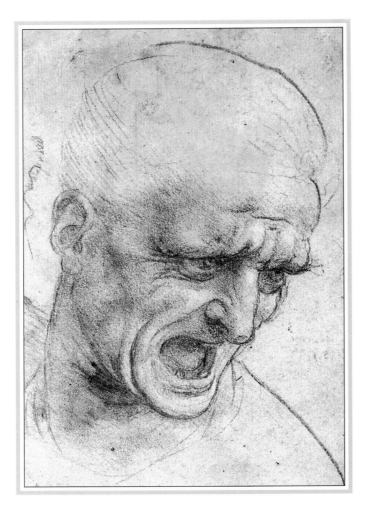

STUDIES FOR THE BATTLE OF ANGHIARI
1503
———

This warrior was to be involved in the fight for the standard.

Leonardo experienced a number of practical problems.

> On 6th June, 1505, a Friday, at the stroke of the 13th hour [9 am] I
> began to paint in the palace. At the moment of putting the brush to
> the wall the weather changed for the worse, and the bell started to
> toll, calling the men to the trial. The cartoon came loose, the water
> poured down, and the vessel carrying it broke. And suddenly the
> weather worsened still more and a very great rain came down till
> nightfall. And it was as dark as night.

A sudden increase in humidity had liquefied the paste attaching the
cartoon to the wall, so that it slid to the floor as he raised his paintbrush.
His technique was apparently too experimental. From the materials
that were delivered, it seems he used a layer of granular plaster (as Pliny
had recommended), primed to a hard flat finish, with a layer of resin-
ous pitch applied with sponges, which should have been a suitable base
for oil-based colours. He evidently tried to dry the pigments by lighting

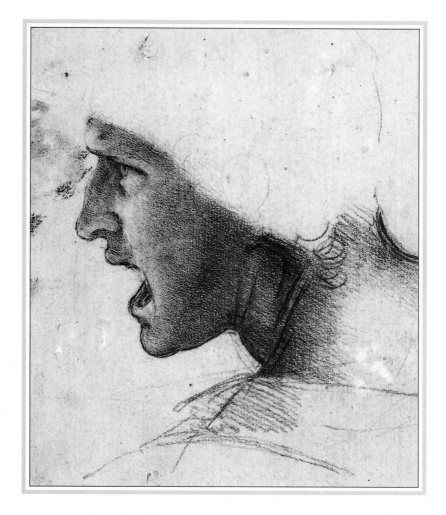

STUDY FOR THE BATTLE OF ANGHIARI
1503

A powerful but sensitive drawing of a young soldier.

a fire beneath the painting but the dampness probably stemmed from faulty linseed oil which failed to respond.

Later on he used an ingenious form of scaffolding to raise himself to the height needed and finished the central scene of the fight for the standard. However, Vasari said he had to give up when the paint ran. Another contemporary pointed to defective plaster which persistently rejected the colours that were ground in walnut oil. A fragment was still on the wall in 1510, which a 1549 guidebook described as a 'marvellous thing'. Certainly the unfinished painting and the cartoon made an enormous impact on young contemporary painters, including Raphael. But it had vanished fourteen years later, when Vasari painted his chaotic battle scene over it. Ultrasonic tests in 1976 failed to find any trace of Leonardo's painting beneath. The fact that Leonardo was faced with this disaster helped to feed the legend that he never finished anything although he certainly did complete the central section.

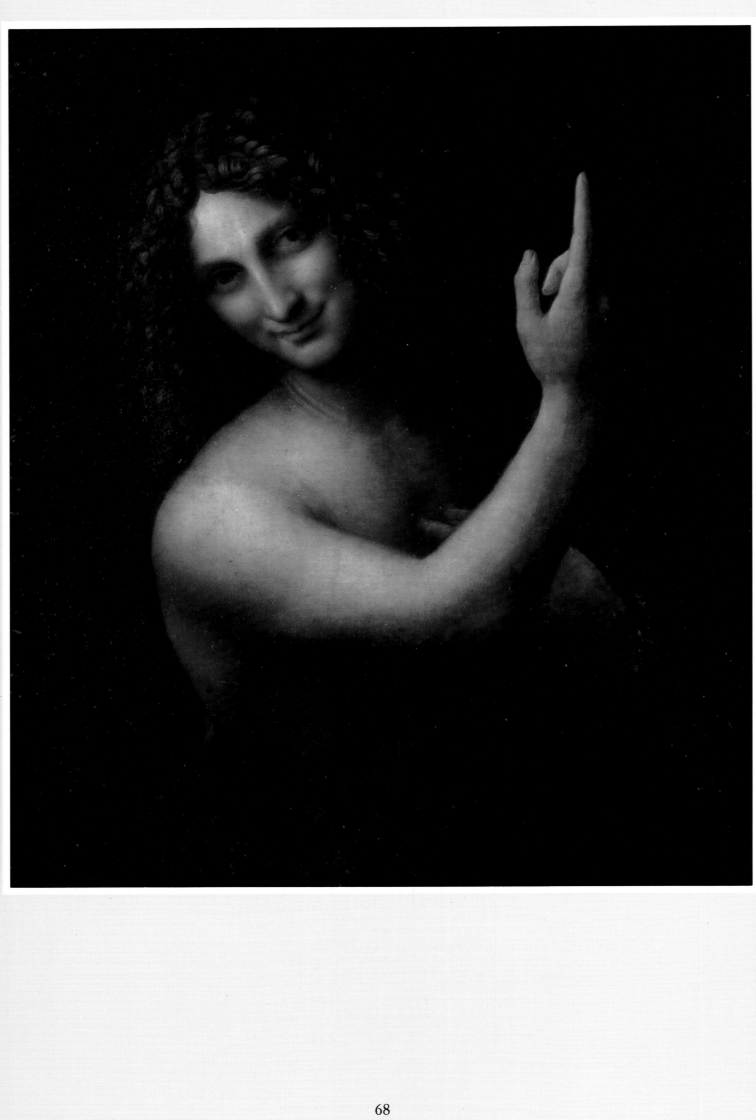

LATER PAINTINGS AND SCULPTURES

ST JOHN THE BAPTIST

c 1509

The sweep of broad shoulder and curving arm is reminiscent of a bird in flight. Monochromatic sodium light has revealed a cross in the saint's hand and a leopard-skin garment, both added by later hands.

LATER PAINTINGS AND SCULPTURES

One of Leonardo's last, and least admired, paintings presents something of a mystery. In 1642, Cassiano del Pozzo, 17th-century editor of Leonardo's *Tratto della Pittura*, wrongly called it *St John*, for the green landscape is unsuitable for a wilderness saint. He commented, 'a most delicate work, but it does not please because it does not arouse feelings of devotion, and the background is unlikely'. In 1695 the official catalogue called it *Bacchus*, and the vine leaves and a spotted leopard-skin loincloth were added to its naked figure. Robert Payne dubs it a visionary figure in a visionary landscape. The latter is typical of Leonardo's religious features of rocks and flowing water, while the figure could be an angel pointing the way to death, or on an errand of mercy.

In contrast his *St John the Baptist*, *c*1509-10, has two striking characteristics – the saint's delicate, almost feminine features, so reminiscent of his *St Anne*, yet with disturbing eyes, and the beautiful hand with its index finger pointing heavenward. The encircling darkness enhances the mysterious quality of the apparition-like figure.

In this painting Leonardo carried his *chiaroscuro* technique to the limit. The only light striking the figure emphasizes his finger gesture. A different tonal background would have completely transformed the effect, as 'from a distance nothing will appear other than the illuminated parts'.

Hands were always one of Leonardo's specialities. He had devoted a series of studies to them for the *Mona Lisa*, as well as for the angel in the *Virgin of the Rocks*. They have a delicately beautiful quality about them. The absence of any landscape serves to heighten the figure of St John in this painting.

The figure is positioned in the same way as the angel in his *Angel of the Annunciation*, known today only from a pupil's drawing. While the angel in the latter pointed upwards to emphasize the heavenly paternity of Mary's future child, in this painting St John points to the heavenly origin of his anticipated successor. Perhaps he is the inviting angel who, in the darkness of night, or of the soul, appears to indicate the way to heaven.

Although Leonardo sought to establish laws in nature, he did not rule out periodic divine intervention. Indeed, the very perfection of nature proclaimed a Creator as the 'cause of causes'. Leonardo was content to leave matters of the soul to 'the minds of friars, the fathers of the people, who by inspiration possess the secrets', while himself concentrating on what lay within the scope of human intelligence.

Judging by his smile, St John was one 'who by inspiration possesses the secrets'. The painting was in the possession of Cosimo de Medici when Vasari saw it. Later it passed into the collection of Louis XIII, who gave it to Charles I, but in 1649 the French banker, Jabach, secured it for Mazarin. It now hangs in the Louvre.

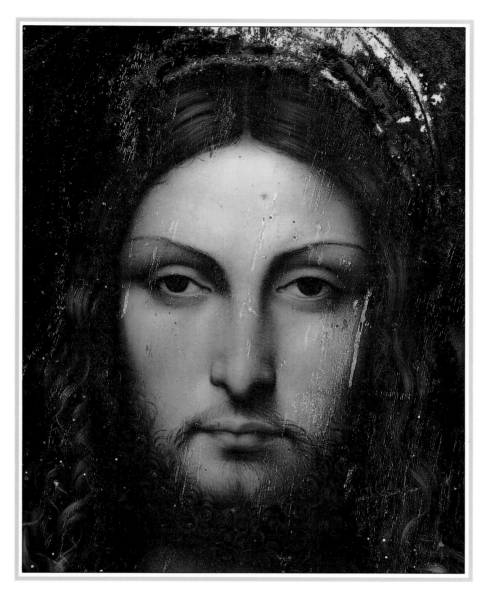

DETAIL OF THE SALVATOR MUNDI
1513

In spite of the sterner expression befitting the subject, the painting
style has much in common with that of *The Mona Lisa*.

THE SALVATOR MUNDI

'Suppose' wrote André Malraux, 'that one of the world's masterpieces
were to disappear, leaving no trace behind it, not even a reproduction;
even the completest knowledge of its maker's other works would not
enable the next generation to visualize it. All the rest of Leonardo's
oeuvre would not enable us to visualize the *Mona Lisa*.' As it is believed
that seventy-five per cent of all Leonardo's works are still lost, any new
discovery is likely to alter our perspective of his art.

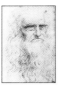

WATER STUDIES and DESIGN FOR THE LEONARDO ACADEMY
c 1510

Leonardo was fascinated by intertwined patterns, as shown by his water studies (above left), his design for a Leonardo academy (above right) and the stole in the *Salvator Mundi*. Vasari complained he 'wasted his time drawing knots of cords'.

One such case is the *Salvator Mundi*. This painting was known through an etching made by Wencelaus Hollar in 1650 and from seven 16th-century copies. All seem to reflect Leonardo's original at various stages of its painting. Louis XII of France commissioned the work, of Christ blessing his people, regarding it as a suitable model for his own approach to kingship, especially after he believed Christ had saved him from a fatal illness. Christ blessing the world was a recurring subject in French and Flemish art and, in Leonardo's day, it was customary to paint half-length portraits on small wooden panels for private devotional purposes. This painting was Leonardo's attempt to make the invisible visible, to give visual form to abstract religious ideas.

Louis XII opened negotiations with Leonardo in 1506. The painting was finished, as much as it ever was, by 1513. As it was delivered after the Queen's death, Louis donated it to a religious order connected with her in

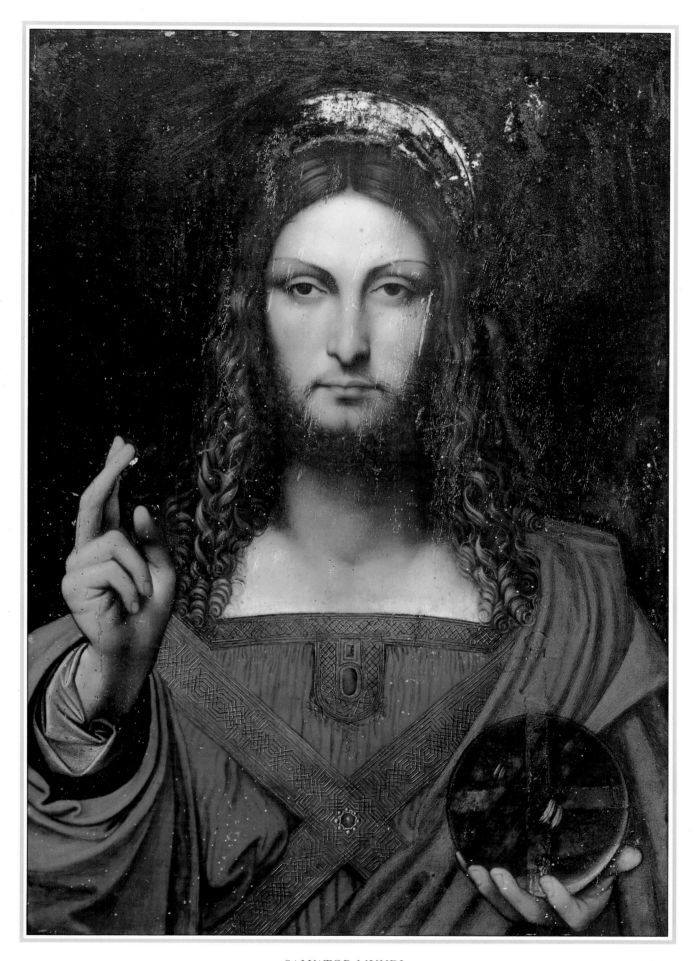

SALVATOR MUNDI
1513
—

The odd vestment tuck on the right side near the stole signifies the
lance piercing Christ's side.

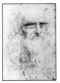

Nantes. More than a century later, when Queen Henrietta Maria of England saw the painting in 1650, while on a pilgrimage following her husband's, Charles I's execution the previous year, she asked Hollar to make an etching of it to add to others of famous paintings he was doing for her. In the 19th century the convent that possessed the *Salvator Mundi* was dissolved and the painting was sold to Baron de Lareinty of Paris. In 1902 the Comtesse de Béhague bought it, and it has subsequently passed to her nephew and then to his son, Jean Louis de Ganay.

Tests have persuaded art historians of its authenticity. Monochromatic sodium lighting and ultra-violet tests have shown alterations made since Leonardo's day to the pearls around the jewel on the stole, and have indicated the removal of the cross on the orb. A thick coat of varnish had been added. An infra-red test revealed the basic sketching behind the painting, which Leonardo had altered little while painting, and X-rays showed the paint had been applied in thin layers on a wooden base – characteristic of Leonardo's last five years' work, and virtually identical to his simultaneous *St John*. He had used nut wood for both, while his use of face shadows, and the light angle, is similar too. His use of colour recalls the *Last Supper*. The painting's triangular composition is a typical Leonardo geometric arrangement and the hair is reminiscent of his 'water swirl' hair in other paintings. The eight-pointed central star signifies resurrection and corresponds to the eight lines of the threads on the stole. While the ruby represents passion and martyrdom. The translucent globe (an orb when surmounted by a cross) recalls the words, 'I am the Light of the world' and the stole symbolizes the Voice of Immortality, recalling the fact that Catholic priests don stoles as a sign of accepting the New Covenant.

Although he had only reports of the painting, and had not actually seen it, Vasari wrote of it:

> In this head, whoever wished to see how closely art could imitate nature, was able to comprehend it with ease, for in it were counterfeited all the minutenesses that with subtelty are able to be painted, seeing that the eyes had that lustre and watery sheen which are always seen in life, and around them were all those rosy and pearly tints, as well as the lashes, which cannot be represented without the greatest subtelty. The eyebrows, through his having shown the manner in which the hairs spring from the flesh, here more close and there more scanty, and curve according to the pores of the skin, could not be more natural. The nose, with its beautiful nostrils, rosy and tender, appeared to be alive. The mouth, with its opening, and with its ends united by the red of the lips to the flesh-tints of the face, seemed in truth, to be not colours but flesh. In the pit of the throat, if one gazed upon it intently, could be seen the beating of the pulse. And, indeed, it may be said that it was painted in such a manner as to make every valiant craftsman, be he who he may, tremble and lose heart.

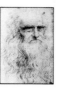

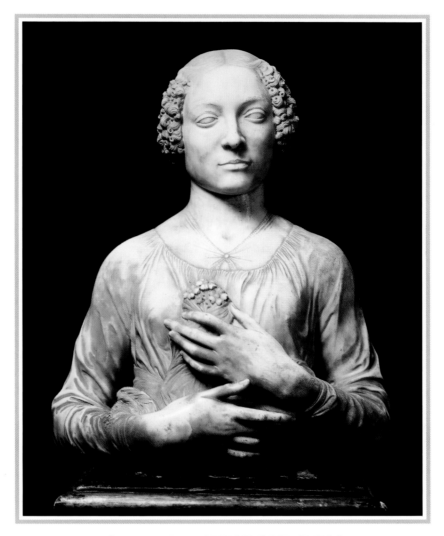

LADY WITH A BUNCH OF FLOWERS

This marble bust has for long been attributed to Verrocchio, but
there is a possibility that it is Leonardo's work.

SCULPTURE VERSUS PAINTING

During the Renaissance, the priority of the different arts was fiercely
argued over, as each was seen to reflect the universal truth. Which of the
arts, given their different spatial and temporal qualities, most perfectly
transmitted nature's design to human understanding? Leonardo took
part in one such debate at the Sforza Castle on 9th February, 1498. His
notebooks *(Treatise on Painting)* show he clearly put painting above
sculpture.

Although it was customary to exaggerate in such debates, his speech
was controversial enough to be discussed fifty years later. He dismissed
sculpture as fit only for intellectual pygmies, mere stone hewers, for the

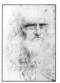

sculptor could not show cloudscapes, coloured pebbles in clear water, and, though he depicted warriors in battle, no dust could rise from his horses' hoofs. His materials limited him in a way the painter's do not.

> The painter has ten considerations . . . namely light, shade, colour, body, shape, position, distance, nearness, motion and rest; the sculptor has only to consider body, shape, position, motion and rest. First, sculpture demands . . . a light from above, and painting carries everywhere with it its own light and shade. Sculpture owes its importance to light and shade. The sculptor is aided in this by the relief inherent in sculpture, and the painter places his light and shade, by the very conditions of his art, in the places where nature would naturally produce it. Nor can the sculptor vary his work with a variety of colours; painting is fulfilled with colour.
>
> The perspectives of the sculptor do not seem to be true at all; while the perspectives of the painter encompass aerial distance even to a hundred miles beyond the picture. The sculptor lacks aerial perspective; he can neither represent transparent bodies nor reflections, nor bodies as lustrous as mirrors, and other translucent objects, neither mists nor cloudy skies . . . Sculpture has the advantage that it is provided with a better resistance against the ravages of time, but a painting made on thick copper, covered with white enamel, then painted with enamel colours, put into the fire and baked, is more durable than sculpture. A sculptor may say that when he makes a mistake, it is not easy to correct it . . . there is thus no comparison between the intelligence, skill and analysis required in painting and that required in sculpture. In sculpture there is no difficulty with perspective, because of the limitations of the material, not because of the limitations of the artist . . . Painting is a marvellous artifice, based upon the most subtle observations, of which sculpture is wholly lacking, since it demands only casual analysis.
>
> To the sculptor who says his science is more permanent than painting, I reply that the permanence belongs to the material . . . not to the sculptor. [Sculpture] is mechanical and less fatiguing to the brain. Compared with painting, it requires little thought, because the sculptor is always removing material while the painter is always adding to it. Also, the sculptor is always removing a single material, while the painter is constantly adding colours made of different materials . . . Shadow, light and perspective are subjects the painter must learn by the force of his intelligence, identifying himself with nature, while the sculptor finds these matters already determined for him. Sculpture is not a science but a mechanical art, for it causes the brow of the artist to sweat and wearies his body . . .

In addition to painting's superior descriptive power, according to Leonardo it also possessed a unique command of beauty by relating visual harmony and time. 'Painting represents its essence to you in one

TERRACOTTA ANGELS

Although attributed to Verrocchio, there are those who see
Leonardo's hand in this bas-relief. The angels have a feeling of
power and majesty unusual at this period.

moment through the power of sight.' Hearing is momentary in com-
parison. Painting can transport the spectator into winter or summer
scenes, on hillsides or in valleys, and instantaneously move him to love
or hate, joy or terror. Michelangelo, who had only read extracts from
the speech, commented in 1547, when Leonardo's horse sculpture had
been forgotten, 'No painter ought to think less of sculpture than of
painting', or vice versa, as they both 'proceed from one and the same
faculty of understanding', adding that 'my maidservant could have
expressed [it] better'.

His spirited defence of painting as the primary art did not prevent
Leonardo from being determined to succeed as a sculptor too. His
origins as a sculptor are obscure. In an early task list he wrote 'designs
for furnaces', perhaps indicating an interest in bronze casting. When
writing to Ludovico, Duke of Milan, he claimed mastery in marble
sculpture. Certainly his whole vision of form in space was fundamen-
tally conditioned by his time with Verrocchio, who had pioneered
spatial freedom in sculpture, breaking with medieval rigidity, a fact
Leonardo fully grasped, as his first drawings for sculptural projects
show. Vasari records he did casts of 'children's heads, executed like a
master'. Using a system of 'architectural' surveying from three view-
points, he could master three-dimensional form.

None of his sculptures survive, although there are two which might
be his. One is the marble *Lady with a Bunch of Flowers*, long attributed to
Verrocchio, and the other is a terracotta bas-relief of angels, now in the
Louvre. Apart from the hands of the *Lady*, reminiscent of the *Mona
Lisa*'s, the work is in Verrocchio's style. Perhaps the youthful Leonardo
had copied Verrocchio, adding his own touch with the hands.

EQUESTRIAN MONUMENTS

Leonardo longed to equal, if not surpass, Donatello and Verrocchio as a sculptor of equestrian monuments. Ludovico gave him the opportunity for a 22ft (6.7m) high equestrian statue of his father, Francesco Sforza. Leonardo began with a vigorous study of horses (their anatomy, movements, moods, peculiarities, fears, whims) and various methods of casting bronze.

Such a large equestrian statue presented a major problem of balance. Raising both forelegs would make it difficult to provide sufficient support for the statue on the hind legs alone. Standing on all four legs, or with one raised, the statue would appear too static. Extensive experimental drawings led Leonardo to raise one of the horse's forelegs sharply and one hind leg slightly. In 1490 he had seen the Roman equestrian monument at Pavia, and noted that vitality could be achieved in a horse sculpture without it rearing. Finally he decided on a high-stepping walk. In order to emulate antiquity which delighted in large and lifelike statues, the heart of Renaissance ambition, he aimed at two things, a uniquely intense study of horse anatomy and sheer scale — his was three times life-size and weighed over 60 tons (6000kg). He began by visiting the Duke of Milan's stables to take meticulously measurements of the most beautiful horses.

As with his study of humans, Leonardo wanted to see how motion affected the skin in its relation to its muscles and tendons. The way in which he drew muscles bunching and skin wrinkling followed his own rules for painting: 'Remember, painter, that in the movements you depict as being made by your figures, you disclose only those muscles which are relevant to the motion and the action of your figure, and in each case make the muscle which is most relevant most apparent and that which is less relevant is less shown . . . the flesh which clothes the joints of the bones and other adjacent parts increases and decreases in thickness according to bending or stretching . . . That is to say increasing on the inside part of the angle produced by the bending of the limbs and becoming thinner and extended on the part on the outside of the exterior angle.' He had in mind a treatise on animal motion, or a book on the horse.

Between 1491 and 1493 he spent a lot of time considering the casting problems involved. The statue's size meant that the traditional 'lost wax' method was inadequate. Not only would that process leave ugly solder lines when the sections were joined, but the unevenness of the lost wax mould would result in an equally uneven thickness of bronze when that metal was poured in. This would make the exact calculation of the amount of molten bronze needed an impossible task. Leonardo needed to have enough bronze, and yet keep it as thin as possible to ensure the statue's weight was kept low.

His revolutionary method of sectional moulding began with the construction of a full-size earthen model. Over it he made impressions

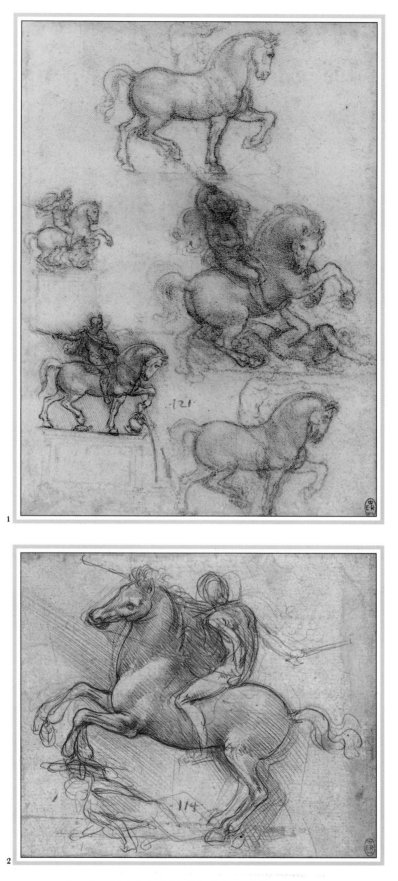

STUDIES FOR EQUESTRIAN SCULPTURE

To take the weight of the bronze, a metal rod had to pass through
the arm of the fallen figure and along the horse's leg (top). In
making his studies Leonardo explored the way motion affected the
skin as well as the muscles and tendons (above).

which were to become the female sections of the mould (see his drawing of the head and neck section). Then he intended putting an homogeneous layer (the 'thickness') of a malleable substance, such as wax or potter's clay, inside these moulds. Male moulds would then be made of fire-clay and the gap between the male and female moulds filled with molten bronze. His greatest achievement in statue construction was that this process enabled a hollow plaster impression to be obtained in which it was possible to cast wax to obtain a wax counter-model of the original. This could be checked for any deficiencies, which could then be corrected before the casting was done.

The moulding process was thus no longer simply a matter of high-level manual labour, but a creative work involving the artist. The casting hood needed to complete the task had to be completely dry and fitted over the male mould in the casting pit, which itself was surrounded by the ovens containing the molten bronze. Hence Leonardo must be accorded an extremely important position in the history of the technique for casting, according to Maria Brugnoli of Rome University in 1981. Leonardo's procedure was subsequently used in cannon production and for a statue of Louis XIV in 1699. He had designed 'the most gigantic, the most startling, the most glorious masterpiece ever to come from the hands of a man.'

In 1493, he displayed a full-size model of the statue in the Duke's palace courtyard on the occasion of the marriage of Bianca Sforza to the Emperor Maximilian. This 'earthen horse' was admired by all for its colossal size and vivacity, so convincing Leonardo that it was his supreme achievement. Fra Luca Pacioli, Leonardo's mathematician friend, wrote that 'Leonardo . . . justified his name in sculpture . . . and painting against all rivals, as in the marvellous equestrian statue which is 12 ells [13.7 metres/45ft] high . . . and the entire weight of it amounts to 200,000 pounds.' Unfortunately a French invasion forced Ludovico to use the bronze intended for the statue for munitions. The invaders even used the clay model for target practice.

A further opportunity arose in 1508 with Marshal Trivulzio, the viceroy of Milan's request for an equestrian statue in Milan. Trivulzio wanted a marble monument with two bronze figures of himself, one on horseback and the other recumbent, together with eight figures round the base. Leonardo costed the monument at 3046 ducats, although Trivulzio had, in fact allowed for 4000. One sketch showed a rearing horse, reflecting Leonardo's view of the horse as a supernatural animal: he had read in the classics that mythologically speaking the horse was the mount of the gods. Thus a man on horseback became divine, a superman. Perhaps that is why Leonardo rode so much in Milan and Rome. Among the fifteen sketches for the horse, one shows a fallen soldier reaching up to grasp an upraised hoof, so that half the weight of the statue was supported by a man's arm and the horse's leg. Again Leonardo was unfortunate, as Trivulzio and his French troops had to flee when the Milanese rebelled. With his patron gone; it was pointless for Leonardo to continue the sculpture.

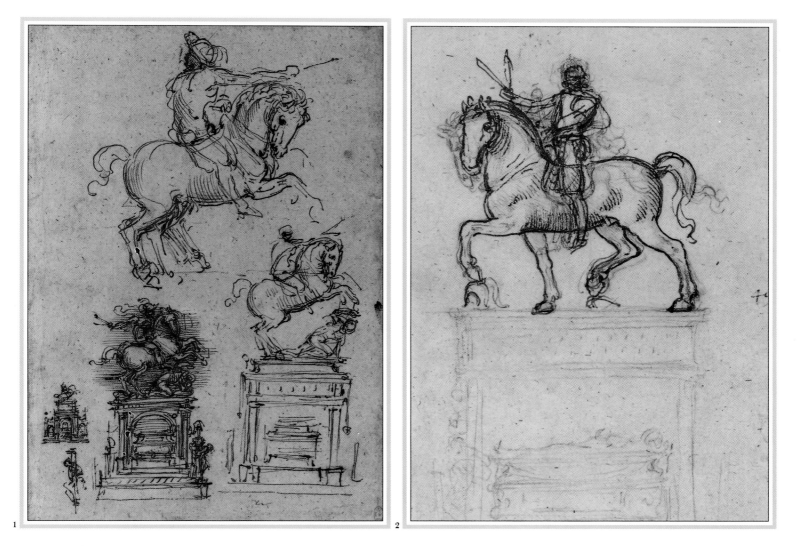

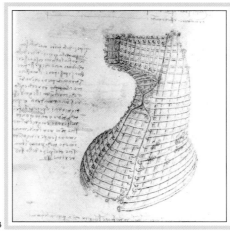

THE TRIVULZIO MONUMENT: STUDIES AND DESIGN FOR
A CASTING DEVICE
c 1509-10

Both drawings (top) were done *c* 1509-10. The heads of the rider and
his mount were turned to face the viewer, thus breaking the profile
of the design. The monument was planned so that the fallen soldier
would take much of the weight of the horse. Leonardo also gave
careful consideration to the relationship between horseman and
base. In the elaborate device for casting the monument (above), the
outer mould for the head and neck was held in place by a corset of
iron hooks and stays.

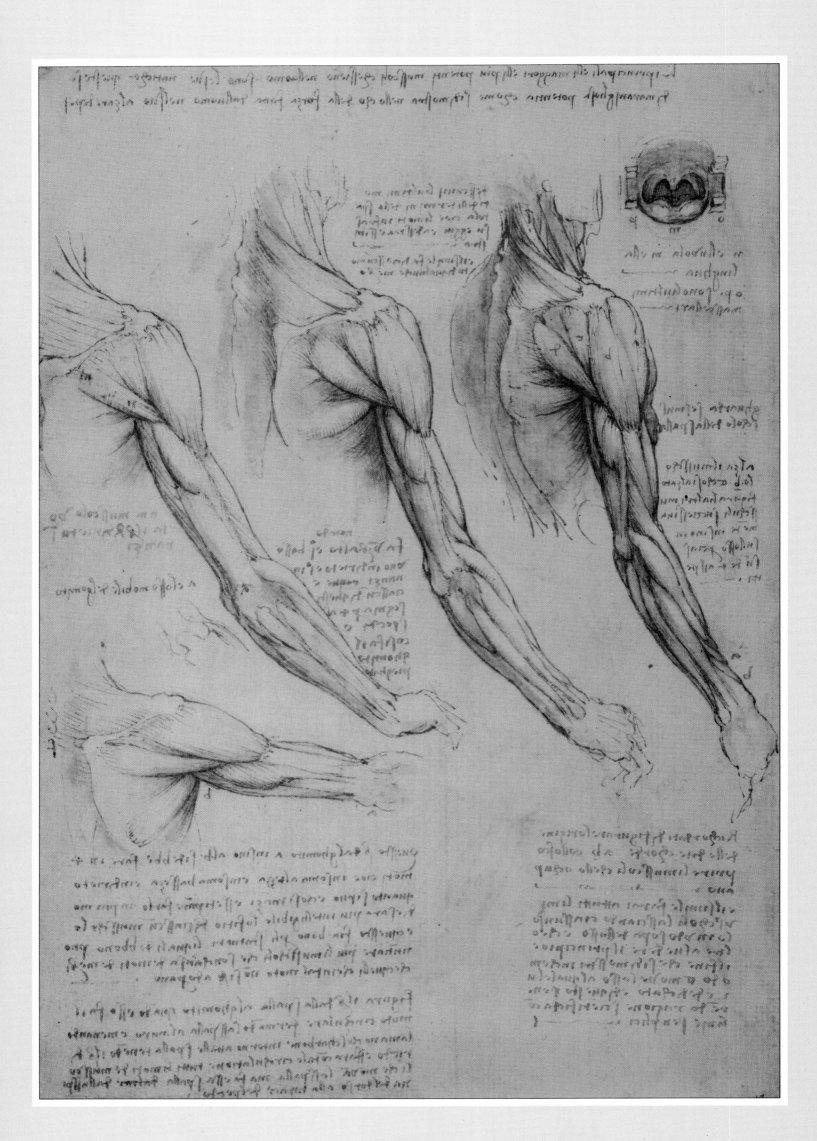

THE ANATOMIST

MUSCLES OF THE ARM AND SHOULDER
c 1510

This forms part of Leonardo's comprehensive survey of the human
body. 'I turned the arm into eight aspects, three from the outside,
three from the inside, and one from behind and one from the front.'

THE ANATOMIST

L eonardo chose to study the physiological movements of the body and mind in order to analyse movements of human *microcosm* and explain how his 'four powers' brought these about. So his physiology sought to demonstrate how these invisible powers produced transformations of shapes, and how the body, in exercizing its infinite movements, 'does not increase either in weight or size'. His earliest drawings were an attempt to analyse the physiology of visual experience as related to perspective. As we have seen, for him perspective was the key to an objective reality.

Had his *Treatise on Anatomy*, begun in 1489, been published, it would have contributed to the advance of medical science, not only in the field of dissection and analysis, but also in relating man to the time and space of the universe in which he lived. It embodied growth, emotion, perception and action, the complete picture of man, the living organism in an ever-moving universe, and was not just an anatomical textbook.

> The work must begin with the conception of man, and must describe the nature of the womb, and how the baby lives in it, and in what degree it resides there, and the way it is enlivened and nourished, and its growth and what interval there will be between one degree of growth and the next, and what it is which pushes it out of the mother and for what reason it sometimes comes out of its mother's womb before the time due. Then I will describe which members grow more than the others when the baby is born, and set out the measurements of a one-year-old baby. Then describe the growth man and woman, and their measurements and the nature of their complexion, colour and physiognomy. Then describe how they are composed of veins, nerves, muscles and bones. This I will do at the end of the book. Then I will show in four expositions the four universal states of man; that is: mirth, with the various acts of laughing and describe the cause of laughter; weeping in various manners with its causes; contention with various acts of killing, flight, fear, ferocity, boldness, murder and all the things pertaining to similar instances; then show work, with pulling, pushing, carrying, stopping, supporting and similar things. Then describe attitudes and movement; then perspective through the function of the eye, and hearing – I will speak of music – and describe the other senses.

It was an ambitious project, for Leonardo saw man in motion as a sentient, responsive and expressive being. Hence his rows of 'time-and-motion' sketches of man in action to demonstrate the dynamic forces at work – the synchronized motions of the human frame, with its levers, pulleys and joints. His studies of heartbeats and the working of muscles are still valid today. The technique he developed for illustrating the 'tree of the vessels' and the 'tree of the nerves' was entirely novel and highly sophisticated. He used a variety of illustrative forms – full relief, transparency and sectionalization. His aim was to build up a complete pic-

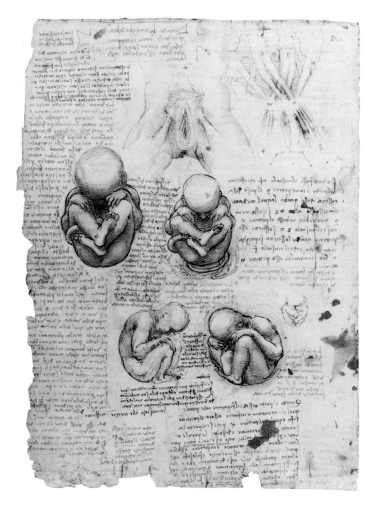

THE FOETUS
c 1510-12

Aware of the medical value of his drawings, Leonardo drew the baby
in different positions, with slight variations of the position of the feet.

ture of each system, and so arrive at a synthesis of form to prove they
fitted natural law.

Leonardo used dissection for this purpose, and was the first to draw
the dissected body accurately and systematically in three dimensions.
He drew the shoulder from eight angles, for example. He wanted his
anatomical drawings printed by copper engraving, believing them to be
his supreme contribution to knowledge. Dissection conditions in mor-
tuaries at night by candlelight, however, he found hard to face.

> As one single body did not suffice for so long a time, it was necess-
> ary to proceed by stages with as many bodies as would render my
> knowledge complete; and this I repeated twice in order to learn the
> differences. And if you should have a love for such things, you
> might be deterred by loathing, or if this did not sufficiently deter
> you, you might be restrained by fear of the living through the night
> hours in the company of these corpses, quartered and flayed and
> horrible to behold.

To draw caked in blood, with a piece of cloth over the mouth and nose,
was a far cry from the elegant working conditions of portrait painting.

THE AGES OF MAN

The 'ages of man' was an accepted medieval and Renaissance theme. The ages varied from three to seven; Leonardo preferred six. Alert to the transitory nature of life, he fully appreciated the corrosive effects of time, and keenly studied the human figure in all its stages of life. He wanted to know how the soul entered the foetus, as well as the relationship of the foetal soul and those of its parents. Referring to the mother's soul, he wanted to know 'Why one soul governs two bodies', adding an accompanying drawing showing a direct conduit for the passage of the life of the father's soul during intercourse from the spinal chord to his penis. This was a traditional notion. Later he wrote, 'the act of coitus, and the parts employed in it are so repulsive that if it were not for the beauty of the faces and adornments of the participants and their frenetic disposition, nature would lose the human species.'

From 1490 Leonardo's fascination with the process of procreation resulted in a remarkable series of drawings, demonstrating his mastery of the pen and ink technique. In his notes he discussed the exact length and position of the umbilical cord, mistakenly recording that 'the length of the umbilical cord is equal to the length of the foetus at every stage of its growth'. A further conclusion was that the baby did not respire in its mother's body 'because it lies in water and he who breathes in water is immediately drowned . . . and where there is no respiration there is no voice'.

Two themes recur in Leonardo's drawing of males, symbolizing the diversity of human life: the androgenous youth and the 'nutcracker' man. The latter varies from mature virility to toothless decrepitude, introducing a sense of caricature. 'In narrative paintings there ought to be people of varied temperaments, ages, flesh colours, attitudes, fatness, leaness – heavy and thin, great, small, corpulent, lean, fierce, meek, old, young, strongly muscled, weak and with small muscles'. His *Study of the Apostle Philip, c*1495-7, demonstrates his observation that 'in the young the parts will be lightly muscled and veined, with delicate and rounded contours and of agreeable colour.' His *Male Nude Seen from Behind* epitomizes his vision of the male body in its prime. Like Michelangelo he exploited the expressive potential of heavily muscled figures so typical of High Renaissance art and sculpture.

> Every part of the whole should be in proportion to the whole. Thus if a man has a thick and short figure he will be the same in all his limbs, that is to say, with short and thick arms, wide and thick hands, and short fingers with joints in the prescribed manner, and so on with the rest of the parts. I intend to say the same about plants and animals universally.

Though he was interested in the classical theory of the four temperaments, Leonardo rejected its rather rigid classification of facial types into four categories:

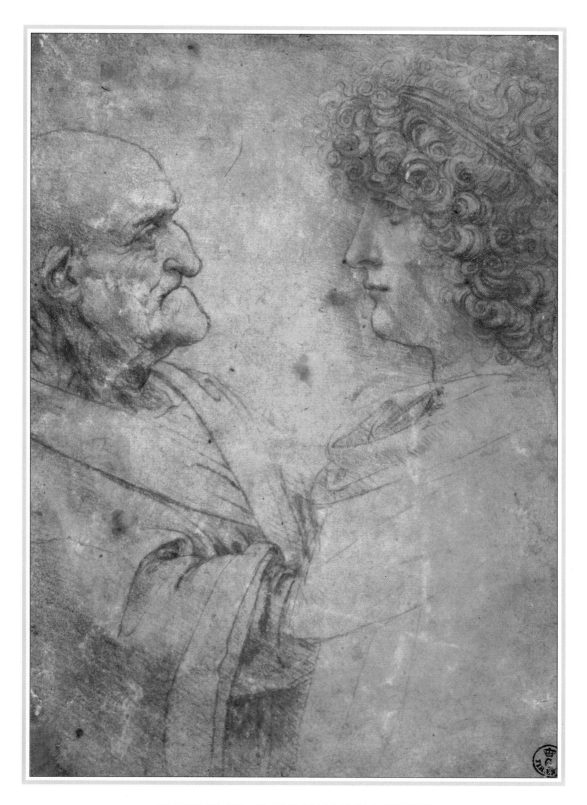

PROFILES OF AN OLD MAN AND A YOUTH
c 1495

Face to face, two idealized ages of man emphasize the transient
nature of human beauty.

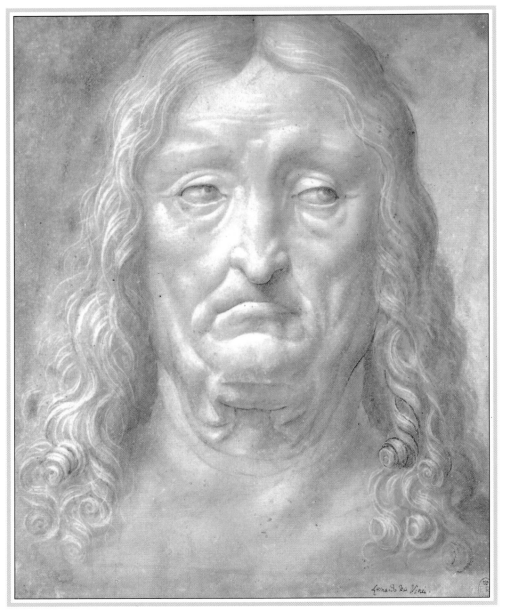

HEAD OF AN OLD MAN

Leonardo made many studies of age, and in this finely modelled red
chalk drawing the furrowed, sagging flesh is detailed with
uncomfortable precision.

The signs of the face show us in part the nature of men, their vices
and temperaments . . . and those who have facial features of great
relief and depth are bestial and wrathful men, with little reason,
and those who have strongly pronounced lines located between the
eyebrows are wrathful . . . An angry person has raised hair, lowered
and tensed eyebrows, and clenched teeth, and the two edges of the
sides of the mouth are arched downwards.

Commenting on his *Five Characters in a Comic Scene*, he wrote: 'Make
the motions of your figures appropriate to the mental conditions of
these figures.'

The way that the ageing process leads to death was the subject of his
only fully documented dissection of a corpse, that of the centenarian in
1507-8, whose portrait he drew at the top of his dissecting page. It was
Leonardo's first dissection to find the cause of death, rather than to
determine the internal details of the human body. 'This old man, a few

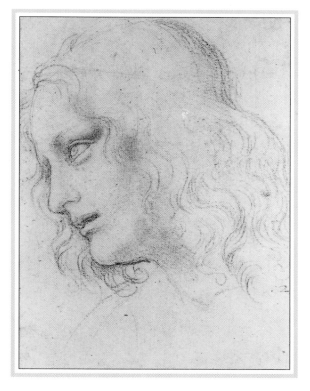

STUDY FOR THE LAST SUPPER
c 1495-7

This study for the apostle Philip demonstrates Leonardo's
observation that 'in the young the parts will be lightly muscled and
veined, with delicate and rounded contours and of agreeable colour'.

hours before his death, told me that he had exceeded one hundred
years, and that he was conscious of no deficiency in his person other
than feebleness. And thus sitting on a bed in the hospital of Sta Maria
Nuova in Florence, without any movement or sign of distress, he passed
from this life. And I made an anatomy to see the cause of a death so
sweet.' He contrasted his dissection of a 'child of two years', in which I
found everything to be opposite to that of the old man'. Examining the
old man's vascular system, he found his aged vessels had not provided
an adequate blood flow. He concluded that death:

> proceeded from weakness through lack of blood in artery which
> feeds the heart and lower members, which I found to be very dry,
> thin and withered . . . In addition to the thickening of their walls,
> these vessels grow in length and twist themselves in the manner of a
> snake . . . The liver loses the humour of the blood . . . and becomes
> dessicated like congealed bran in colour and substance . . . and
> those who are very old have skin the colour of wood or dried
> chestnut, because the skin is almost completely deprived of
> nourishment; and the covering of the vessels behaves in man as in
> oranges, in which as the peel becomes thicker so the pulp dimin-
> ishes, the older they become.

He analysed the cause of the old man's death as the furring up of his
arteries and blood vessels, and did so in terms of the analogy of man's
relations to the universe when he wrote of the man's internal channels
becoming silted up like a river. According to the hydrodynamic laws he
had formulated in the 1490s, all the body's different systems, like rivers,
ferried the vital supplies of life throughout the body. His work on the
Arno canal confirmed the theory according to which the velocity of a
constant volume of fluid transmitted through a channel was indirectly
proportional to the channel's cross-sectional area.

ANATOMICAL DRAWINGS

Leonardo's relatively crude drawing, *Anatomical Figure showing the Heart, Liver and Main Blood Vessels, c* 1488-90, showed the main systems of human beings as the 'tree of the vessels' by which the 'humours' are transmitted through the body. He intended to 'cut straight through' the heart, liver, lung and kidneys so as to show the 'tree' in its entirety. These 'spiritual parts' were responsible, he argued, for the generation and flow of the 'natural spirits', which, in turn, arose from the liver, while the 'vital spirits' originated from the heart. These physiological and morphological conceptions were the traditionally held ones of his day. His *Principal Organs and Vascular and Urino-Genital Systems of a Woman, c*1507, the most striking of Leonardo's human body drawings, showed just how far his knowledge had developed over the years. With added explanations, he labelled every part of his *Lungs and Upper Abdominal Organs, c*1508-9, drawing. Though the organs are thought to be a pig's, it is still one of his most synthesized drawings.

He returned to his anatomical studies in 1510 and 1515, concentrating on the heart and embryology. Simultaneously he completed his studies of the muscles and the skeleton of the shoulder, arms and legs. He replaced his tidy simplifications of early days with a greater awareness of the complexity of natural design, and was no longer satisfied with simply demonstrating the human form and functions. Everything had to be explained as well. 'Nature begins with the cause, and ends with the experience; we must follow the opposite course, that is beginning . . . with experience and from this investigate the reason.' This contrasts with his comment when dissecting the centenarian, 'Understand the cause and you will not need experiment'. His explanations of anatomical detail were initially explained by words such as 'this was ordained by nature so that . . . ', so assuming that, as the Creator, nature or necessity made a shape, it must have a function. Thus the heart valve revealed 'how the Creator does not make anything superfluous or defective'. He was aiming for a triumphal conclusion to his studies.

His notes on bodily functions were essentially done to show their mechanical principles. Thus he argued that the muscles running diagonally from the upper spine to the ribs maintained the bones in a supportive system, as 'such a convergence of the muscles of the spine hold it erect just as the ropes of a ship support its mast'. In both cases the structures are under tension so that each part supports the others, while allowing for motion within their structure. The human body is a composite of compact, economic mechanical designs capable of achieving a range of movements and, as such, witnesses to the perfection of natural design.

For Leonardo anatomical engineering involved a system of levers that were capable of transmitting a linear force into a circular motion. He argued that all muscular actions followed the *macrocosm*'s 'four

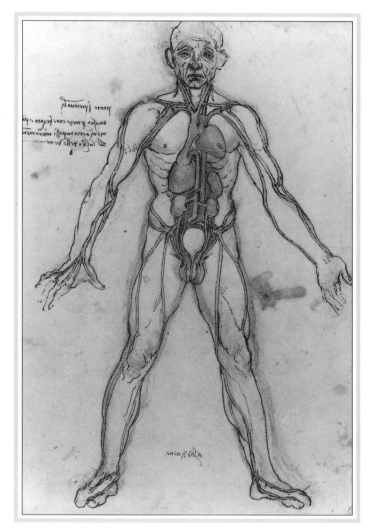

ANATOMICAL FIGURE
c 1488-90

A crude drawing showing the heart, liver and blood vessels, which
Leonardo saw as the 'tree of the vessels'.

powers' law, so resulting in changes in the geometry of the positions of
the muscles and limbs, geometric transformations. In such muscular
and visceral transformations, what was diminished in one dimension
was added to in another, so that no visceral or muscular part increased
in weight or size during the activity. Thus the space left by the dia-
phragm was equal to the space occupied by the corresponding forward
movement of the abdominal wall. This 'principle of transformation', in
which space acquired equalled space lost, was a necessary law of move-
ment in his opinion. Any muscle contracted in one direction needed to
expand in another. If an arm is flexed at the elbow, it shortens the
flexed side and extends on the the exterior side. Thus movements of the
body bring about geometric changes, whilst the surface areas, volume
and weight, remain constant. The new space occupied exactly compen-

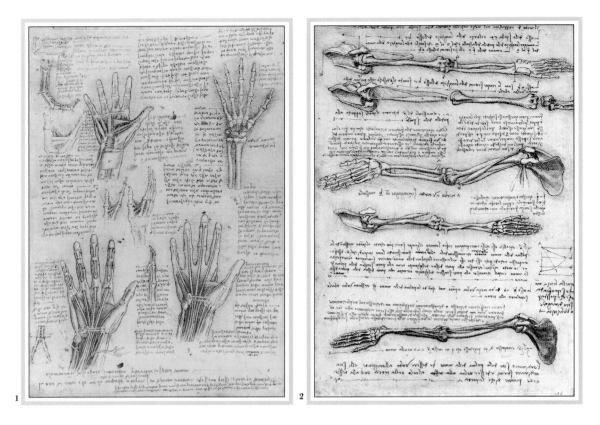

THE HAND AND ARM

(1) A pen and ink drawing with black chalk (*c* 1510) showing
everything involved in the hand's structure and operation,
emphasizing the flexor tendons. The purpose of this drawing (2), of
the same date, was to study the movement of the biceps and their
vital role in operating the bones of the arm and hand.

sates for the space vacated. Muscle contraction, he believed, was essentially a power produced by a change of shape.

Leverage is examined in his *Superficial Anatomy of the Foot and Lower Leg c*1510. Its complexity was such that he had to increase his usual depiction of three or four stages of dissection to six. The arm, shoulder and upper thorax muscles needed eight views in all. He abandoned his 'magic transparency' technique (see pages 84-5) for a more direct view of what the dissecting surgeon would find as he worked. 'Show the bones separated and somewhat out of position so that it may be possible to distinguish better the shape of each bone by itself. And afterwards join them together in such a way that they do not diverge from the first demonstration except in the part which is concealed by their contact.' This brilliantly innovatory portrayal is now a standard for modern technical illustrations. Noticeably he added lengthier explanations to his later drawings. Influenced by the assertion of the 2nd century AD anatomist Galen that 'nature does nothing in vain . . . the artifice of nature is worked out in every part', he constantly aimed to explain how every detail operated within natural law.

The superb design of the heart, representing the climax of his attempt to understand internal functions, is shown in his *Studies of the Vortex Motion of the Blood within the Heart, c*1513. The heart had to be understood in the light of dynamic law and mathematical necessity. Unfortunately for accuracy he used a bovine heart, and supported the

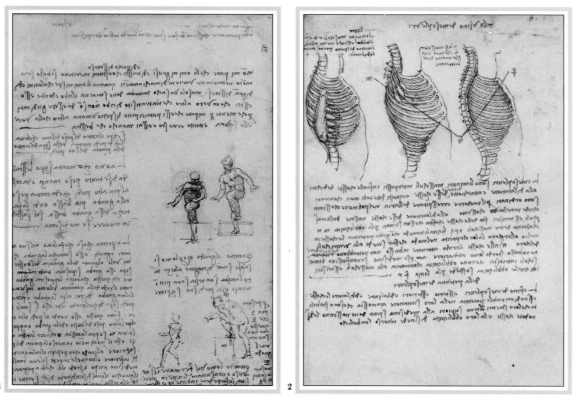

1 HOW A MAN MOUNTS A STEP: HOW A RUNNING MAN
STOPS

Drawings examining a complex series of movements.

2 MUSCLES OF THE CHEST DURING BREATHING

One of Leonardo's studies of the respiratory system; in this case
examining its visible effects on the ribcage and muscles.

Galen view that blood passed through invisible pores in the septum
which separates the ventricles. 'The heat of the heart is generated by the
swift and continuous motions made by the blood which make friction
within itself by its revolvings.' Overheating is only avoided by the 'help
of the bellows called the lungs'. Thus the heart operates in tune with
the hydrodynamic laws governing the motion of the blood. To further
explain the laws governing its operation, he drew on his study of the
thickness of tree trunks and branches.

He refused to abandon his conviction that there were regular causes
behind natural effects. Thus he insisted that everything must have a
mathematical explanation, increasing the complexity of his drawings to
support this. 'There is no certainty in the sciences where one of the
mathematical sciences cannot be applied or which are not associated
with mathematics.' 'He who debases the supreme certainty of math-
ematics feeds on confusion and can never silence the contradictions of
the sophistical sciences.' Such views would have found favour with
medieval scientists such as Alhazen, Roger Bacon or Pecham.
Leonardo had succeeded in uniting their mathematics with his com-
plex vision of organic structure – his elusive goal being the marriage of
mathematical certainty, through mechanical law, with organic com-
plexity. Yet he remained convinced that this was the way the human
body had to be studied, in spite of being forced to conclude that the
relationship between mathematical theory and practice was far from

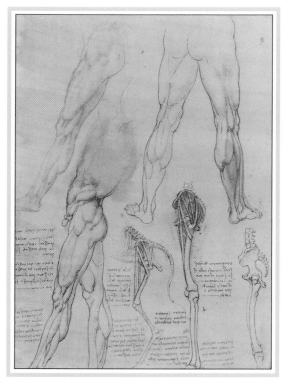

COMPARISON BETWEEN THE LEGS OF MAN AND HORSE
c 1506-7

'To compare the structure of the bones of the horse to that of man,
you shall represent the man on tiptoe in figuring the legs.'

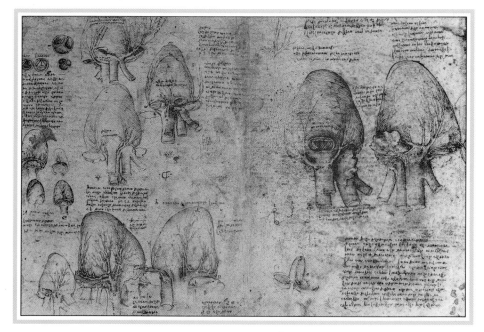

STUDIES OF THE HEART (OF AN OX?)
1513-14

This superb pen and ink drawing is one of a series of heart studies

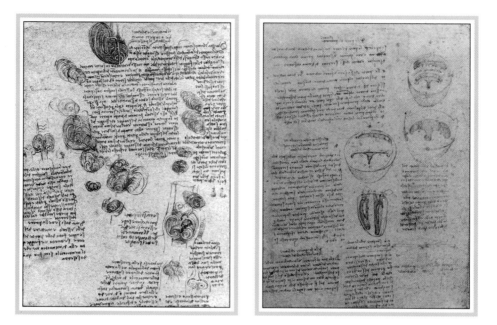

STUDIES OF THE HEART
1513-14

Leonardo's heart drawings are not anatomically accurate; they are
thought to be based mainly on an ox heart. He believed that
geometric rules governed the design of the valves. The vortex
motion (above right) was in tune with Leonardo's water studies. As
he saw it, dynamic law and mathematical necessity ruled the heart.

straightforward. Even 'the science of weights is led into error by its prac-
tice', he conceded.

The heart's cusped valve enabled him to work out a mathematical
science of anatomy. For him, this neat piece of natural engineering,
allowing for the correct flow of blood, could be mathematically proved
to work on a three-valve system by comparing it to geometrical figures
of triangles within circles. Geometric principles, he argued, governed
the design of the valve as both were concerned with the relationship of
areas to areas, and different configurations. Thus geometric rules pro-
vide the cause for the heart's valve design. The accuracy of his calcula-
tions were confirmed by B. J. Bellhouse in 1970.

Leonardo used his water studies to explain the workings of the heart
and the circulatory system. He concluded that the blood, pumped
round the body, is forced into something of a spiral motion so creating
vortices within the valves' cusps, which in turn control their opening
and shutting. He even considered constructing a glass model of the
aortic valve to test his theories and, drawing on his conclusions, specu-
lated on the possibilities of achieving perpetual motion in a similar
manner. But by 1500 he was convinced that any mechanical process
would involve the loss of power at each stage and so abandoned this
area of study. Despite some false and inconclusive results his anatom-
ical studies were an amazing achievement, given the knowledge of the
time and the conditions under which he had had to work.

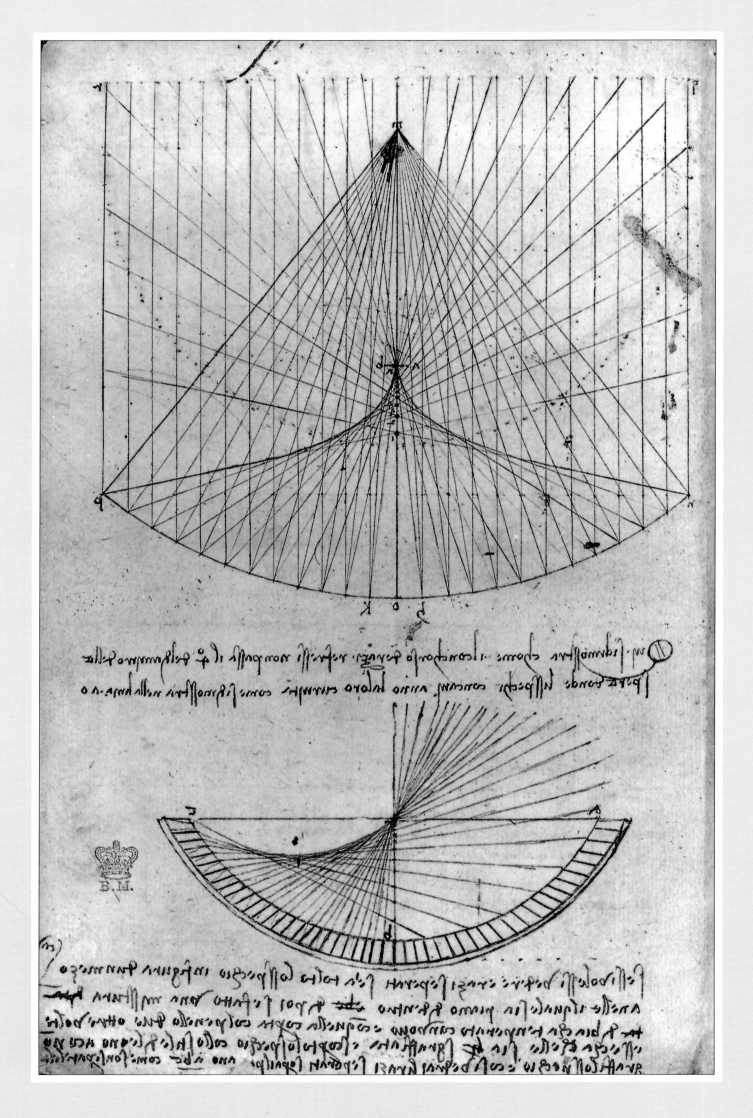

THE
SCIENTIST

CONSTANT AND PARABOLIC CURVATURES
c 1492

These diagrams relate to Leonardo's investigations into the possible
uses of curved mirrors. Shallow concave mirror rays (top) focus on
an axis rather than a single point, but the parabolic half-mirror
focuses them on only one point, and thus could be used for burning.

L eonardo's isolation in the history of science arises from the fact that his work falls outside the main current of the flow of recognized progress. For 300 years since his death his efforts to create a scientifically organized body of knowledge have been either ignored or misunderstood. It is difficult to relate his work to science today, as he built his science up from the 'four elements' (earth, water, air and fire) and the 'four powers' (movement, weight, force and percussion, or impact), which are no longer the basis of modern science. Furthermore, all his methods and concepts were visual, and he did not make the distinction between 'experience' and 'experiment' made today.

His scientific background was that of Aristotle and Plato, as modified by later Muslim and Christian philosophers. Aristotle held the 'common sense' view that the world and the universe were what our senses told us about them. Revolving around the 'four elements' were first the planets and then the stars. For Plato, the stars and planets were spiritual entities which influenced earthly events. From the 9th century, the imposition of Christianity on Platonism produced the argument that all nature was God's manifestation, his creation. This made theology the queen of the sciences.

In Leonardo's day the debate was between the later Platonists' arguments that only ideas were real, and those of the Aristotelians, who said the senses provided the realities. The medieval idea was that the universe was composed of a fusion of natural, moral and spiritual events constituting ultimate reality. Leonardo was to combine his scientific work in a way not done by later researchers. He fused the *macrocosm* of the world with the *microcosm* of man. He framed this comparison entirely in mechanical terms, rejecting any astrological influence, though still retaining a soul, or spirit. The 'four powers' made the *macrocosm* and *microcosm* work. 'This earth is the world machine.' Water is 'the vital humour of the terrestrial machine'. 'Nature cannot give the power of movement to animals without mechanical instruments . . . for this reason I have drawn up the rules of the four powers of nature.'

Leonardo drew a distinction between alchemy and chemistry, so often confused in his day, but ruled out any biochemistry in the body in favour of the physical nature of the 'four elements'. The elements all had atoms (his 'natural points'), which 'can never be divided into any parts'. For him, a fifth, spiritual essence was necessary to exert power to shape the growth and movements of the elements in the world, just as the soul was necessary for the body, as 'powers' and 'bodies' were all transient in nature.

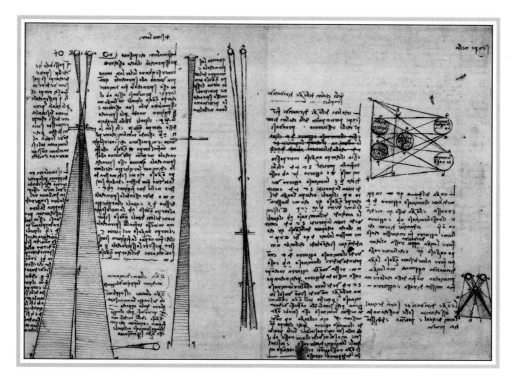

IMAGES PASSING THROUGH APERTURES AND OTHER
STUDIES
c 1508

The drawing demonstrates how the eye, a complex refractory
apparatus, doubly inverts incoming images.

THE SENSES: LIGHT AND SHADOW

His researches led him to inquire into the relationship between the
senses and the intellect. 'There are four powers, memory and intellect,
lust and desire; the first two are mental and the others sensual. The
three senses, sight, hearing and smell, can be but little inhibited, touch
and taste not at all.' His search proved startlingly original as it passed
through the path of light and perspective into the field of anatomy. By
1489 he was inquiring into 'how the five senses are the ministers of the
soul', asking whether they are on the surface of the body or within the
brain and eventually concluding the latter. Convinced that sight pro-
vided the clue, he traced the optic nerve to the brain, and concluded
that 'experience' depends most on the sense he found anatomically
dominant, namely sight. 'Do you not see that the eye embraces the
beauty of all the world? The eye is the commander of astronomy; it
makes cosmography; it guides and rectifies all the human arts; it con-
ducts man to the various regions of the world; it is the prince of math-
ematics; its sciences are most certain; it has the measure and height of
the stars; it has generated architecture, perspective and divine painting.'

As both artist and scientist, by 1490 Leonardo saw that the road to science was via the sense of sight, for the eye was the 'window of the soul'. He used the recently developed perspective technique, already described, to reproduce objects on glass panes. Accepting Alberti's teaching, he argued that 'perspective' meant the rational demonstration of how objects transmit images to the eye by a pyramid of lines. 'The pyramid is the name applied to lines which, starting from the edges of the surface . . . converge from a distance to meet as a single point.' By using this new technique, he found he could deduce a number of perspectives from the drawing of an object: from the outline a proportional linear perspective, from its colour proportional colour perspective, and from its loss of definition at the edges aerial perspective (or 'perspective distinguishing detail').

These three kinds of perspective diminished with distance in 'pyramidal proportion', so producing an overall rule of linear perspective. He also concluded that 'proportion is not only found in numbers and measurements, but also in sounds, weights, times, spaces and in whatsoever power there may be'.

This led him to ask what was the nature of light itself, and hence vision. 'Light drives away darkness. Shadow is the deprivation of light.' 'Shadows [are] of supreme importance in perspective because without them opaque and solid bodies will be ill-defined.' Naturally he had to investigate how light cast shadows of varying densities on objects, and the patterns formed as it strikes and rebounds. What geometric laws affected the rebounding of light on different types of surfaces? He sought to formulate comprehensive rules for the behaviour of light and shade under all kinds of conditions.

His scientific investigations into light were to make a major contribution to his paintings, in which light and dark (*chiaroscuro*) and misty qualities (*sfumato*) formed outstanding features. 'Bathing objects in light is merging them with the infinite', he wrote. The painter must leave nothing to guesswork. He noted that from a purely subjective point of view, contrast makes light objects seem brighter when set against dark backgrounds, and vice versa.

In his *Studies of the Gradations of Shadows on and behind Spheres, c*1492, he graded the effects of light coming through a window. With such calculations, he was able to go on to grade light and shadow according to the quantity of illumination and angle of exposure, so convincing himself of the universal laws governing nature.

He found that light spread in circular waves, similar to those created by a stone dropped in water. He concluded that the construction of the physical universe was from the wave motion through all the 'elements'. For him, movement spreads out in circles from any source of energy (an impact, for example), producing wider and weaker circles. Thus two pyramids, one of movement and one of power, arise from an impact. Whereas the powers of sun, light and heat travel in straight lines, those in 'fluid' elements (water, wind, fire) go in curvilinear pyramids or cones, which he called 'fulcates'.

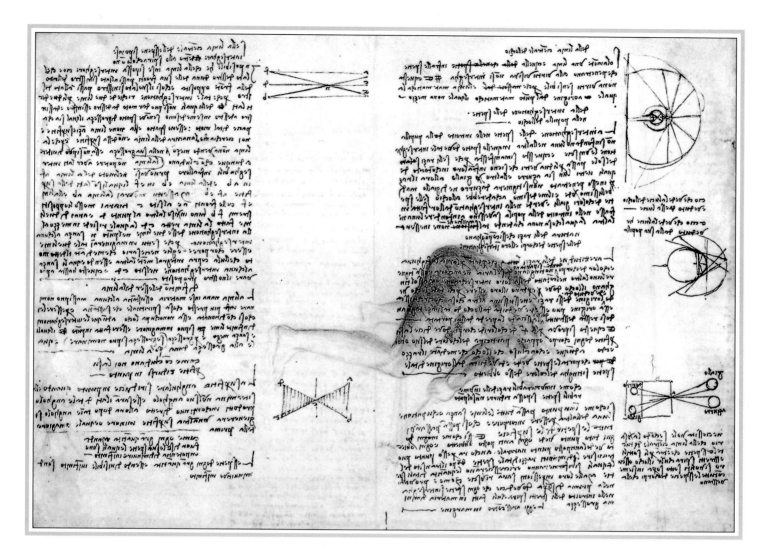

REFRACTION OF LIGHT THROUGH THE CORNEA

Note how the prominence of the curvature of the cornea enables the
visual field to extend backwards more than 180 degrees.

THE EYE

His studies took him beyond the 'objective' eye of the perspectograph
(Leonardo's aid for artists to draw in true perspective), to the 'subjec-
tive' effect it had on the brain. This first involved him in studying the
eye itself, and then in working out how its messages were received and
processed by the brain. He saw the eye as a geometrical instrument
composed of spherical and segmental components. Of these spheres,
the lens was the key component, lying at the centre of the system and
containing the vital element of 'visual power'. This classical teaching
was at odds with the actual structure but, as eye dissection was very dif-
ficult, Leonardo accepted the most popular optical book of the day
John Pecham's *Perspectiva communis*. Medieval opticians saw optics as a
true science in which nature and geometry were evidently allied.

Leonardo's notebooks continually praise the value of the eye – the
optical instrument designed with geometric precision for it 'reconciles
the soul to stay in its bodily prison'. Through its vision the soul is
delighted at the sight of nature's wonders and capable of delineating
their mathematical rationale. Since 'experience' is the key to
Leonardo's approach to the study of all things, the eye provides the key

to that pursuit. A rational analysis of the sum of all things depended upon the eye examining everything by the light of reason. His mathematical and geometrical approach to study likewise depended upon the eye. For him, the visual experience was more certain than any other form of sensory perception.

By 1490 his knowledge of the eye, and the working of sight, had greatly improved. Previously he had suggested that the eye's lens magnified images 'like a glass ball full of water'. This notion of visual rays (a kind of perceptual spotlight) coming from the eye dated back to Plato. Only the Muslim philosopher Alhazen held the opposing view that visual images enter the eye from the object. Leonardo considered both views, added his recently acquired knowledge on the eye's structure, and concluded that vision was not just a passive process, but was activated by a 'power' that flows along the optic nerves. Thus he accepted the principle, born out now by the way television operates, that the formation of an image which enters the consciousness *is* processed. This processing involves energy, or power, and is not merely an imprint of an impression. Furthermore, this power lies within the eye as it is projected outside as visual potential. As evidence that an image enters the eye, he referred to the sun's image remaining in the eye after you look at the sun and then shut your eyes. This convinced him that vision did not result from rays going from the eye to the object.

So what reaction took place when an image entered the eye? He examined the dilation and contraction of the pupil, concluding that, as in ordinary light, the pupil is regulated to produce conditions necessary for vision, so vision is brought about by a particular pattern of movement induced by the impact. As vision creates 'impressions' by waves which are relayed to the brain, so oscillation, or wave motion, underlies the sensation of vision. He realized that light entering the eye changed its path – it was refracted – so that 'the eye sees the object bigger than is given by the painter's rules of perspective'. Of course, Leonardo only dealt with monocular vision.

THE BRAIN

In 1487, using the work of earlier anatomists, he had likened the head and the brain to the layers of an onion. The main point of his drawing of *Vertical and Horizontal Sections of the Human Head* was to link the eye with the three cavities or ventricles in the brain. Present-day experts disagree as to just what Leonardo's conclusions were owing to the confusion of his papers and his changing ideas. According to Kenneth Keele, at this opening stage in his investigations, Leonardo believed that the first of the ventricles was where the two main senses, sight and hearing, met and entered the consciousness. This drawing shows he was as ignorant as his contemporaries where 'experience', rather than 'experiment' was concerned. They filled the gap in their knowledge

with imagination, though Leonardo's led him to think perspectively, unlike that of others. Later in 1487, he drew the optic nerve linked to the first ventricle and marked it '*intelletto*' (intellect) and '*imprensiva*' (impressions' receptor), the middle one '*volonta*' (will) and '*senso comune*', (the Aristotelian term for common sense, the meeting point of all the senses, providing unified perceptions of the outside world), and the third, '*memoria*' (memory). The fact that he put intellect in the first, where the eye nerves run, shows the importance he attached to vision. '*Imprensiva*' is the place where the sensory impressions are processed, so that the intellect can draw understanding from them.

Later, he added 'judgement' to *senso comune* and *volonta*, as he concluded that decisions to make voluntary movements were made in this cavity. Together with sensation and emotion, these were the location of the soul. Thus the ventricles not only received and analysed information, they transmitted commands of motion and emotion.

Subsequently he increased the number of ventricles to four, putting *senso comune* in the third, or 'middle' ventricle, and memory in the 'fourth'. He concluded that 'the soul resides in the seat of judgement, and judgement in the place where all the senses meet, the *senso comune* . . . The *senso comune* is the seat of the soul, memory is its monitor, and the *imprensiva* is its standard of reference'. Thus the five senses are the ministers of the soul, and not vice versa.

In contrast, Martin Kemp argues that medievalists had put the *senso comune* with the *imaginato* or *fantasia* (imagination) in the first ventricle, *intelletto* in the second, and *memoria* in the third. He then says that, because of his concept of artistic imagination, Leonardo moved the *fantasia* to the middle ventricle to join the *intelletto* so that it could act in concert with the rational faculties. Kemp says that he followed classical and medieval views of 'neurological plumbing' for the transmission of motor impulses, 'animal spirits', down the spine and through the nerve tubes. This does not fit the nervous system as we know it today.

Leonardo's earlier dissection drawings, especially of horses, were actually illustrations of his conceptions of the underlying 'causes' of their anatomies. He was devising inner forms to fit their supposed functions in the context of *microcosmic* law, just as other scientific researchers would have done in his day. It was assumed in those days that if a scientist could grasp the secret of natural function well enough to draw it, he could claim to have understood it. Later, Leonardo realized that his earlier drawings contained too much wishful thinking.

THE PERSPECTIVAL PYRAMIDAL LAW

For Leonardo all the inner and outer senses had been designed for the sake of the sensory perception of the mind, because the greatest function of man's soul was to understand the operation of the natural world. He rejected contemporary views, like those of the Florentine, Pico della

Mirandola, that sensory knowledge was merely 'imperfect knowledge, not only because it requires a brute and corporeal organ, but also because it only attains to the surface of things . . . it is vague, uncertain and shifting'. To the Platonists searching for truth *within* man's soul, he said the knowledge they claimed to arrive at could never be verified against objective truth as it could only 'begin and end in the mind'.

For Leonardo, 'Wisdom is the daughter of experience . . . All our knowledge has its foundations in our sensations . . . All science will be vain and full of errors which is not born of experience, mother of all certainty.' Thus he followed Aristotle and Roger Bacon. Sensory experience was not an end in itself, for the brain worked rationally on the experience, under the soul's direction.

The entire process of seeing was the subject of his perspectival pyramidal law. The whole scheme of the eye as the 'window of the soul' is geometrical in nature. That is to say there was a rational mathematical relationship between the 'real object' and the image seen, a relationship he sought for the sake of his painting. He had constructed this physiology of vision from the physics of his 'four powers' of nature, which in turn controlled all the movements of the 'four elements' in the *macrocosm* and the *microcosm.*

He then applied his 'spiritual power' ingredient to the physical world of the *macrocosm* and the physiological world of the *microcosm* of man. For him, force, or energy, had its origin in spiritual motion, and this motion flowed through the limbs of man and moved their muscles. Today the nucleus of the atom, as a centre of force, has been demonstrated in atomic bombs.

His reading of the medieval opticians led him to realize that his rather simple view of the eye's functioning, learned from Alberti, the Florentine artist and writer, needed revision. All kinds of external distortions had to be taken into account. Even the eye itself created distortions, such as 'the twinkling of a star'. He then realized that the eye had deceptive propensities, with the serious implication that *seeing* could not be straightforwardly identified with *knowing,* as he had previously assumed. This new discovery struck at the very heart of his theories on the pyramidal mechanism of perspective perception, as it deprived the painter of the physical existence of his pyramid of perspective. So he realized that 'perspective made by art' on a flat surface was subject to the distortions of 'perspective made by nature'.

Though the 'painter's perspective' worked reasonably well in many circumstances, there were many reasons for its failure to correspond with the artist's perception of the outside world. For example, the light's rays on the eye cause a wider visual angle than used by the 'perspectivist who believes that the visual rays come straight into the eye'. Effectively the eye enlarges what is shown in the painter's perspective. Such findings must have shaken him, as he had postulated for so long that a painting accurately portrayed the visible world. He appears to have reconciled himself to minimizing the eye's limitations as best he could. He no longer went in for his extended expositions of linear perspective.

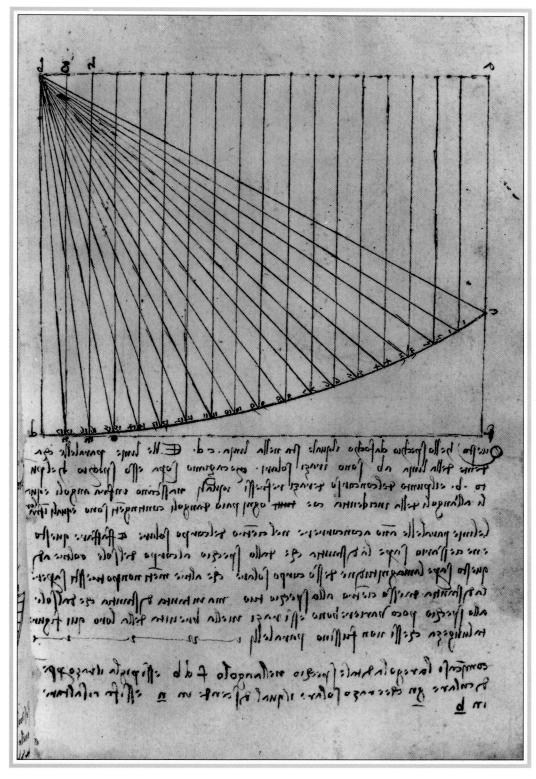

STUDY OF CONCAVE MIRRORS
c 1492

Leonardo was fascinated by both the patterns of intersecting light
rays and the possible uses of mirrors.

His conclusions are shown in his *Studies of Images passing through Apertures, Coloured Lights, the Human Figure in Motion, and Light and Shade,* and his *On the Eye* treatise, both *c*1508. The eye is seen as a complex refractory apparatus, in which the incoming image was doubly inverted, producing deceptions and illusions. 'No image . . . penetrates into the eye without being turned upside down, and in penetrating the lens it will be turned the right way up again.' Lacking accurate knowledge of the eye's internal structures, he now argued that every part of the pupil possesses visual power, but was not prepared to accept that the eye could operate with an inverted image. Where he differed from medievalists was in his speculation that the rays were inverted (and reversed again) in the pupil.

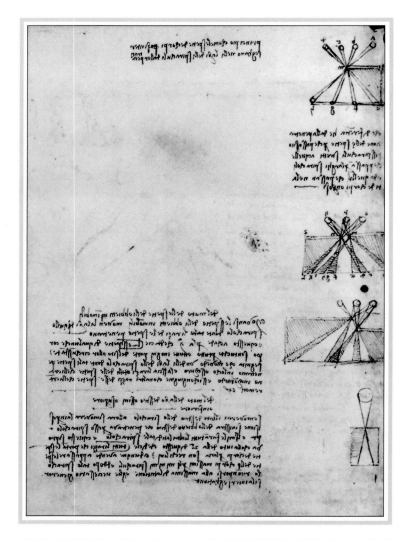

THE PROJECTION OF IMAGES THROUGH ONE OR MORE
HOLES IN A CAMERA OBSCURA

Leonardo sought to demonstrate that linear rays can cross without
mingling as they have 'no physical breadth'.

OPTICS

Like Alhazen and Bacon before him, Leonardo had used the *camera obscura* effect of projecting light through a pinhole aperture to show that linear rays can cross without mingling ('all the lines can pass through one point without interfering with each other because they have no physical breadth'). This effect of multiple light sources casting images through two apertures into a dark room, proved that 'the images of bodies are all infused throughout the air'. His experiments involved the use of glass balls full of water, lenses and mirrors.

When demonstrating the five grades of shadow by making a series of drawings of a man using a sledgehammer, he came close to a cinematic approach of 'motion through space' in art work. Bearing in mind his descriptions of a battlefield and the 'Deluge', together with his theatrical experience, he might easily have made his mark as a *Cinemascope* director in this century.

He also studied reflection and compared the reflections of light to the bouncing of balls. Just as a ball makes its hardest impact when thrown at an angle perpendicular to a surface, rather than glancingly, so light will have its brightest effect when it strikes directly from in front. The varying degrees of light on a face can be analysed precisely according to the angle they strike at.

After reading the works of medieval opticians, Witelo and Pecham, he examined reflection from curved mirrors. He also solved the problem of deciding where an object at a given location is seen in a curved mirror by using a hinged-rod instrument. In 1513-14 he used what he had learned about reflection to create his 'sagoma', an enormous parabolic mirror which he designed to provide solar energy to heat dye-works' cauldrons for the Medici textile industry development in Rome, only to be frustrated in his endeavours by his workmen's failings. He also designed a telescopic mirror-grinding machine with a focal length of 19ft (5.8m) and another for making concave mirrors.

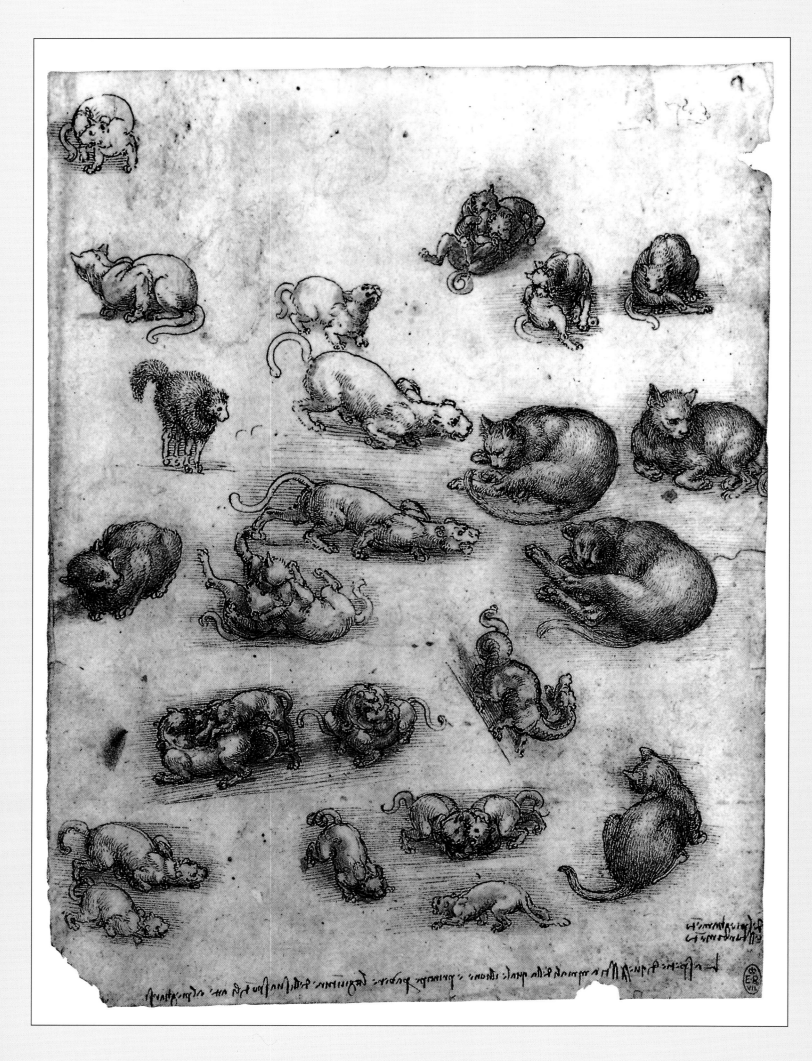

LEONARDO AND THE NATURAL WORLD

CATS, LIONS(?) AND A DRAGON
c 1513-14

The studies, showing a complex range of movements from wrestling to repose, are among the latest of Leonardo's observations of animal motion.

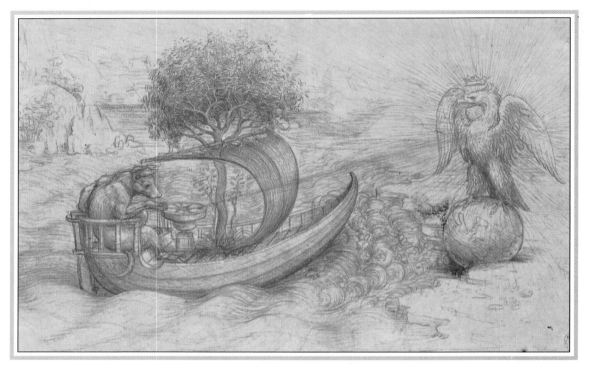

ALLEGORY WITH A WOLF AND EAGLE
c 1515-16

The billowing sail indicates fortune's whims, the olive tree-mast her
peacefulness. The Pope (wolf) steers the Church (ship) through the
rough seas towards the Holy Roman Emperor (eagle), whose French
crown shows the far-reaching ambitions of King Francis I.

L eonardo's tender concern for living creatures was reflected in
his art, and at the beginning and end of his career he drew cats,
first for his *Virgin, Child and Cat* painting, and later to study
their motions. As a youth he painted the *Medusa* with her hair of snakes
and lizards. Later he reproduced every sort of animal in his work – lap
dogs and crabs, oxen and asses, falcons and eagles, bats and lambs,
ducks and wolves, and even the small ermine in the *Lady with Ermine,* as
it 'does not eat other than once a day, and it will rather be taken by
hunters than wish to escape into a dirty lair'.

He experimented with flies to study the variations in their buzzing.
He trimmed their wings, which were buzzing loudly, then put a touch
of honey on them to obtain a different sound. He concluded that 'the
quality of the sound will go from a sharp note to a deep one in direct
proportion to the extent that the free use of their wings has been cur-
tailed.' Intrigued by animal behaviour, he once said, 'I have seen dogs
trying to bite painted dogs, and a monkey did an infinite number of
stupid things in front of a painted monkey.'

In a different vein, he would sometimes use animals to give meaning
to political cartoons. His *Allegory with a Wolf and Eagle* refers either to
the ambition of Francis I of France to become the Holy Roman

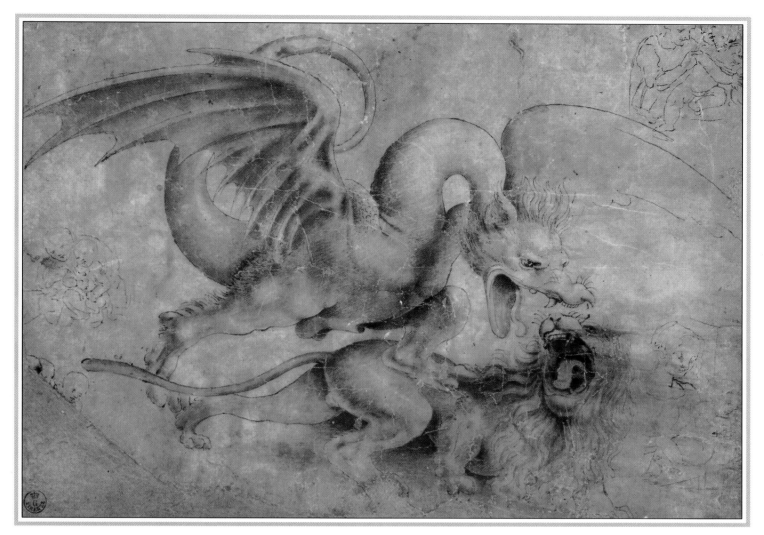

DRAGON STRIKING DOWN A LION

This red-chalk drawing was inspired by Leonardo's interest in the
fantastic.

Emperor, or his patronage of canalizing the Adda in Lombardy, 1516.
Leonardo was not alone in finding meaning in nature, seeing both real
and fabulous animals and plants as symbolic of God's creation. Their
characteristics then reflected something of the moral constitution of
creation. Thus nature embodied significance as well as science. He
used fables about animals as a means to stressing man's ignorance of
natural laws. He wrote of a lovesick monkey smothering a little bird
with its overaffectionate kisses, a predatory crab being crushed by the
rock it hid under, and a pear tree disdaining the laurel and myrtle
because its wood is a favourite for woodcarvers, while theirs was fit only
for wreaths.

TREES

Tracing the geometry of plant growth, Leonardo explained how species
were characterized by the angles at which their branches were related to
each other and to their main stem. This searching for symmetry in
plants foreshadowed the 19th-century development of theoretical
botany known as phyllotaxis. His three-part classification of tree

growth is today known as monopodial (for example, elder), sympodial (elm) and spiral phyllotaxis (walnut). He spotted the advantage of spiral phyllotaxis in that the leaves do not overshadow each other. Admittedly with some inaccuracy, he explained a tree's growth by checking how the constant sap flow sent qualities into its branches in proportion to its cross-section. This showed an advanced appreciation of the form and function of trees.

His later writings showed that he realized that any illuminated object 'is never seen entirely in its true colour', especially in the natural world. He noted 'reddish' lights with 'greenish' shadows, while there were 'bluish' shadows on white objects. So trees became a particularly worthwhile study from the point of view of 'apparent' colour. He concluded that each leaf was affected by the combination of four tonal factors: shadow, lightness, 'luminous highlight' and transparency. Thus a concave leaf's surface 'seen in reverse from underneath sometimes is seen half shaded and half transparent'. Each leaf draws its colour from the 'blueness' of the atmosphere and the adjacent leaves. Naturally he considered the overall effect as well, telling painters to 'Remember that the varieties of light and shade in the same species of tree will be relative to the rarity and density of the branching', while, at a distance, 'accidents' of light and shade become mingled into a single, predominant effect.

Inevitably Leonardo looked for rules to make sense of the diversity he found among trees with their variable branch structures. For the fir and cherry trees, 'the top of the outermost shoots form a pyramid from the middle upwards; and the walnut and the oak from the middle will make a hemisphere'. He found general laws amidst apparent randomness, such as the following: 'Nature has placed the leaves of the latest shoots of many plants so that the sixth is always above the first and follows successively in this manner.'

1 A COPSE OF TREES

c 1500

Subtle variations of touch with the red chalk emphasize the diversity of the foliage, the depth and thickness of the copse and the direction of the light.

2 CROSS-SECTION OF BRANCHES

Leonardo believed that, owing to the constant flow of sap, the quantity of sap in each branch was in proportion to its cross-section.

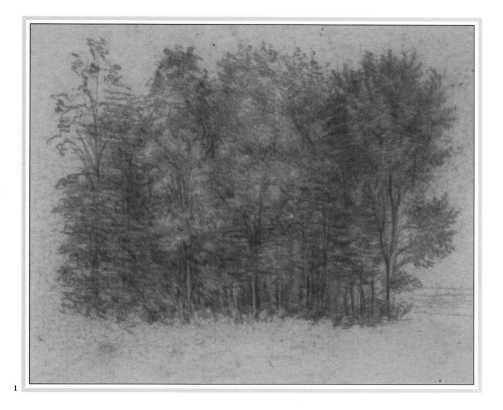

1

2

PLANTS

Medieval Gothic painters tended to use herbalists' copy books when painting flowers, but Leonardo painted his direct from nature. While his contemporaries included plants purely for decorative purposes, he took care to put them in their correct botanical setting. He painted them in their natural groupings, demonstrating his knowledge of their spacial layout and their due season. Furthermore, he chose the plants for their suitable symbolic value, for instance the lily and the enclosed garden symbolized the Virgin's purity. The *Benois Madonna* holds a flower of the *Cruciferae* family, which the Christ-child solemnly reaches for, thus foreshadowing the Cross. Accurately portrayed irises, with their leaves twisted to give a spiralling movement, can be seen on the bottom left of the Louvre version of the *Virgin of the Rocks*. By the Virgin's face are *Aquilegia,* or columbine (dove plants), symbolizing the Holy Spirit. The stains on the St John's wort suggest a martyr's blood, while the creeper *Cymbalaria* symbolizes constancy and virtue. His emphasis on irregular contours and detailed attention to light and shade is reminiscent of Dutch art, though the wiry outlines in his plant drawings for *Leda and the Swan* recall Verrocchio's metalwork.

He was fascinated by the shapes of plants and parallels in shapes (as can be seen from his studies of the plant commonly known as the Star of Bethlehem), also in swirls of water and the way plants and trees form vaulting patterns. Topiary art also interested him. While plant science was in its infancy, with no attempt at classification, Leonardo approached the subject in a much more descriptive way in his attempt to find the laws governing the whole of nature, although it frustrated him not to find a unifying principle behind all biological and physical phenomena.

In or around 1482 he made a list of his early works, which began with 'many flowers copied from nature'. As his observations on plant life are scattered throughout his notebooks, it was difficult to appreciate the major step forward he made in plant classification and life-cycles until recent analysis of his notebooks. Most of his research was done in the last dozen years of his life, indicating his continuing delight in nature, while contemporary gardeners relied for their plant knowledge on Dioscorides' 1st-century gardening book (indicating just how little the subject had advanced before Leonardo's time). His work was notable for its fresh approach, as he was quite prepared to cross subject boundaries between plant and animal life and water movements. Until 1490,

THE INFANT CHRIST WITH PLANTS AND FLOWERS
Detail from the *Virgin of the Rocks* (Louvre version)
c 1483

The flowers are *Cyclamen purpurascens* or *Cyclamen rependum*, whose heart-shaped leaves symbolize love and devotion.

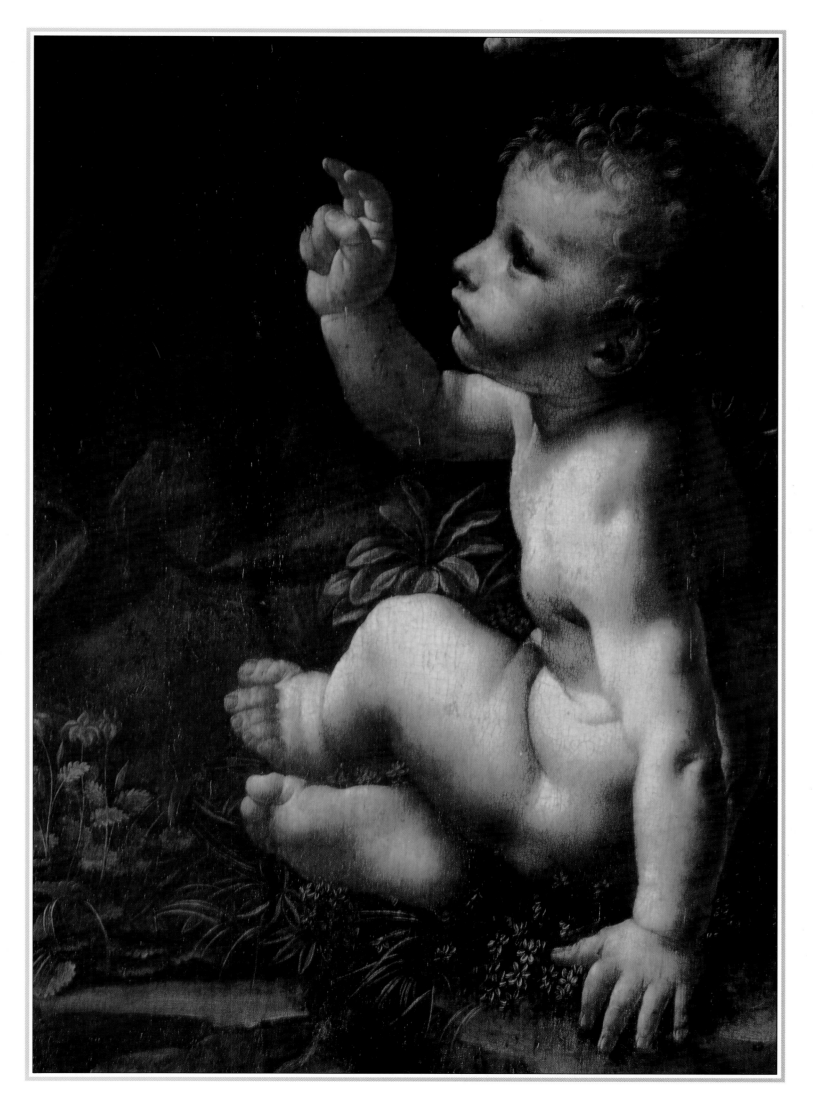

LEONARDO THE BOTANIST

Leonardo drew plants and flowers throughout his career, sometimes as studies for paintings and sometimes in connection with his scientific studies and his perpetual quest to grasp the systems that governed all living things. In his drawing of the rush and sedge shown below both plants are comprehensively described, the inscriptions giving exact details of structure, colour, size and habitat. But in spite of his desire to classify, he clearly also loved nature for its own sake, and was fascinated by the shapes of plants and the patterns they made. This interest in the natural world was by no means new, nor was it peculiar to him – there was a strong vein of naturalism in Florence and elsewhere in Italy. Ghiberti's Baptistery doors are adorned with a wealth of landscape detail, and Gozzoli's frescoes for the Medici Chapel feature carefully observed plants, flowers and animals. From medieval times nature had been seen as part of God's scheme of creation.

1 This drawing of a rush and sedge (*c* 1510) may have been intended for Leonardo's planned 'Discourse on Herbs'.

2 A detailed and sensitive drawing of a long-stemmed plant, *Coix lachryma-jobi*, done *c* 1515.

3 A red chalk drawing for the lost *Leda and the Swan*, dating from *c* 1508 and showing a small oak branch and spray of Dyer's greenweed.

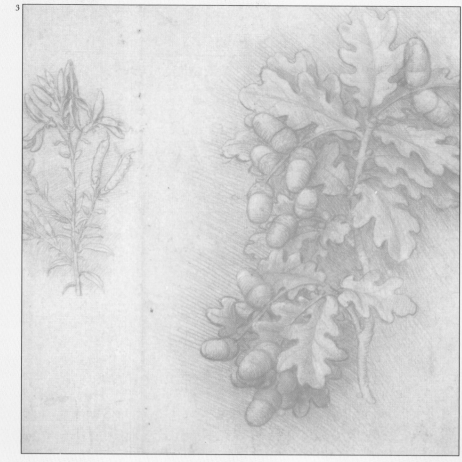

4 The flowers seen in this detail from *The Annunciation* (*c* 1473) are stilted in comparison with the later drawings.

his observations concentrated on the outward forms of plants, but from 1510 onwards he searched for law and order in nature. His later plant drawings noticeably exhibit the most energy, showing an increasing interest in the botanical science of plant life. He commented, 'Observation to theory, theory to practice . . . those sciences are vain and full of errors that are not born of experience.'

He was preoccupied with plant growth, researching into why plants grew the way they did, including their sexuality and regenerative process. He experimented with the effects of water and light on plant growth. His deductions showed how growth depends on the release of chemicals as well as water and sunlight. Some of his work was not validated until further research work was done in the 17th and 18th centuries, while his analysis of what happens during grafting was not confirmed to be correct until 1927. As a lone researcher, he made truly remarkable progress.

He was also fascinated by the power of roots to split rocks. His *Fables* express his appreciation of a seed's generative value. 'After a short time the nut began to prize open and put roots between the cracks of the stone, and to enlarge them, and to thrust out branches from its hiding place'. While working on optical research, he noted 'a great oak that has a modest start in a little acorn'.

LANDSCAPE

The earliest of Leonardo's drawings of rock formations was probably *A River running through a Rocky Ravine with Birds in the Foreground, c*1483, probably linked to the *Virgin of the Rocks* commissioned that same year. The vertical clusters of rock pinnacles are typical of his rock drawings, though they differ from those of his later career. Rock pinnacles for Leonardo represented the natural line of defence in the life of the world, in contrast to water, 'the vital humour of this arid earth', which cut ravines and split rocks asunder to reveal the inner anatomy of the world by its remorseless power. He considered 'the ruin of mountains falling down, their bases consumed by the continuous currents of rivers which gnaw at their feet with very swift waters [and] the subterranean passage of waters, like those which exist between the earth and the air . . . which continually consume and deepen the beds of their passage.' His researches produced geological evidence of remorseless erosion in land and water over the centuries as the elements sought their natural levels.

From 1506 to 1509 his studies of the 'body of the earth' were complementary to those of the human body.

> This earth has a spirit of growth, and its flesh is the soil; its bones are the successive strata of the rocks which form the mountains; its cartilage is the volcanic rock; its blood the springs of the waters. The lake of blood that lies within the heart is its ocean. Its

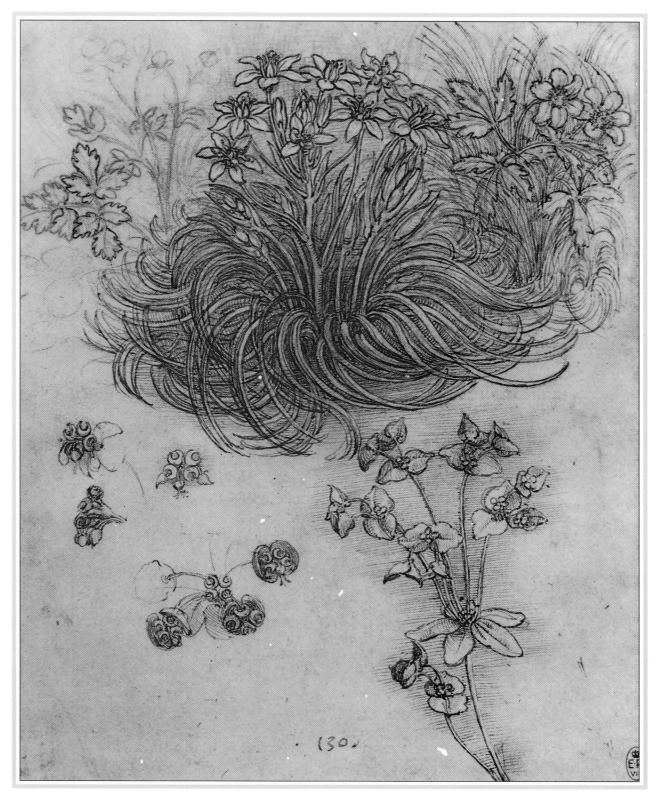

THE STAR OF BETHLEHEM AND OTHER PLANTS

c 1508

This red chalk, pen and ink drawing was one of a series of plant
studies for the lost *Leda and the Swan* (see pages 28-9).

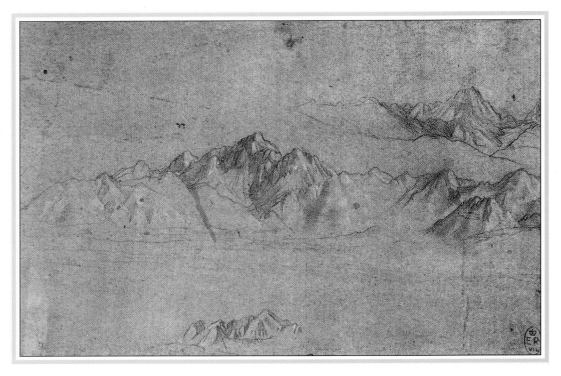

MOUNTAIN LANDSCAPE
c 1508

A study for *St Anne, Virgin, Child and Lamb*. Mountains fascinated
Leonardo, whether as artist, geologist or engineer.

> breathing is by the increase of the blood in its pulses and even so in
> the earth is the ebb and flow of the sea. The ramification of the
> veins of water in the earth are all joined together as are those of the
> blood in animals.

Thus the earth's veins are not just superficial features, but penetrate
deeply into its permeable body. His *Horizontal Outcrop of Rock, c*1510-13, in
black chalk is one in a series of geological drawings, aimed at showing the
rhythmic configuration of the strata which occurs with land erosion and
water power. For him, the 'bony' framework of strata was eventually
clothed in the thin 'skin' of the soil on which vegetation could gain a grip.
Just as Leonardo was concerned to determine the effects of the power of
water on earth, so too was he determined to understand the dynamics of
the cyclical movements of fluids above the earth – rain, snow and so on, as
his *Storm over a Valley in the Foothills of the Alps, c*1506, shows. As well as
spotting the optical effects of rain, he could not resist taking the oppor-
tunity to point out that the painter could bring life to his painting by his
control of the sky, which in turn brought both distance and colour to the
composition in a way that sculpture could never emulate.

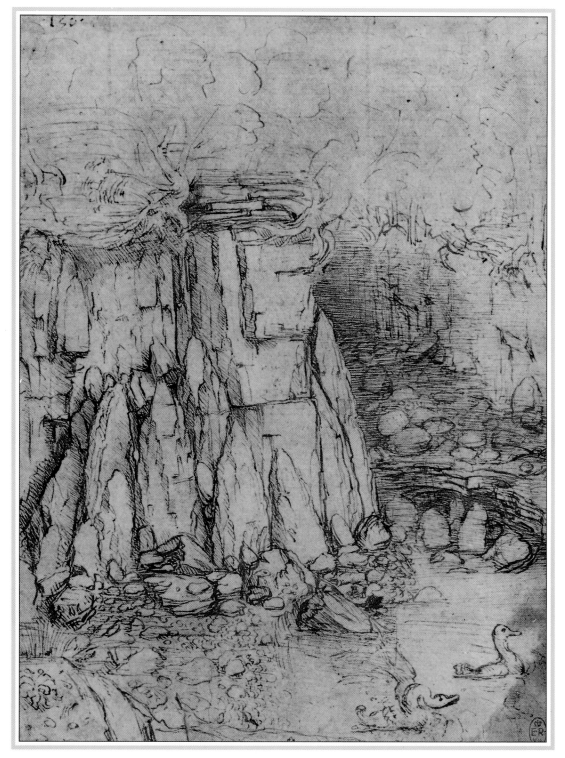

RIVER RUNNING THROUGH A ROCKY RAVINE
c 1483

The ravine reveals the 'inner anatomy' of the world, while the
precariously perched trees and lively water-birds point to life's
transience and motion.

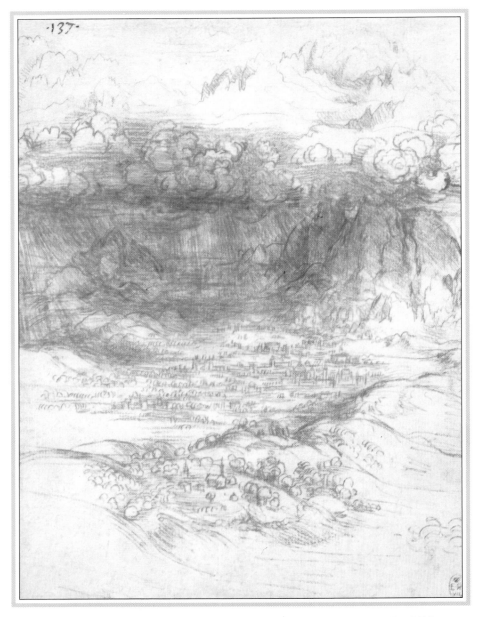

STORM OVER A VALLEY IN THE FOOTHILLS OF THE ALPS
c 1506

Leonardo's notes read: 'The rain as it falls from the clouds is the
same colour as those clouds, that is to say on its shaded side, unless
indeed the sun's rays should break through them.'

STUDIES OF MOTION

'Motion is the cause of every life', wrote Leonardo. The action of force lay behind everything, creating all movement and change, and hence life itself. 'Force is an immaterial power, an invisible potency which is created and infused by animated bodies in inanimate ones through acquired violence, giving those bodies the appearance of life.' He followed classical mechanics in arguing that all motion comes from one of two sources. 1) From a 'natural' source: everything has an innate desire to move to its natural level as determined by its relative weight to its composition (gravity). 2) From a 'violent' force, acting against the natural state of rest ('percussion', impact).

The medieval idea was that force began motion, and *impetus,* the motive power impressed into the object, continued it. Leonardo wrote, 'All bodies continue to move as long as the impression of the force of their movers remains in them', thus 'impetus transports every movable thing beyond its natural position.'

In 1497 he listed the problems. 'What is the cause of movement; what is movement in itself . . . what is impetus?' He compared the distance travelled by a bouncing ball and a thrown ball. His early law of conservation of impetus in bouncing was later refuted. Gradually he became more alert to the frictional factors affecting impetus. He referred to three types of friction: 'simple', resulting from the dragging of one material against another; 'compound', caused by contact between two different surfaces; 'irregular', caused by the edges or irregularities of the moving object.

He also studied the motion of waves because they were more continuous than bouncing balls. Water combined mobility and heaviness; it was a very dynamic element, rising in vapour, falling in rain. 'Moving water strives to maintain the course pursuant to the power which occasions it.' His attempt to formulate a vocabulary of water movements ended with sixty-four separate terms, at which stage he became too involved with 'cascades'.

He also studied the properties of air and water, stressing that they acted differently as 'air is condensible to infinity and water is not'. According to Leonardo, the velocity of air rushing into the space behind an object was greater than that of the compressible air in front of it, and this aided the object's forward motion. On the other hand, incompressible water had to move at the same speed in front and behind an object, so providing less aid to impetus.

This conclusion, albeit an erroneous one, tempted him to design boats, and led to mistaken calculations.

> Three ships of uniform breadth, length and depth, when propelled by equal powers, will have different speeds of movement; for the ship which presents its widest part in front is swifter, and it resembles the shape of birds and fishes such as the mullet. And this

ship opens with its sides and in front of it a great quantity of water which afterwards with its revolution presses against the last two-thirds of the ship.

Thus, he argued, the ship with the narrowest bows and widest stern does the opposite, while the third, with an even width of bow and stern comes mid-way.

Each force produced effects which obeyed absolute rules in relation to distance travelled, time taken and effective resistance. Though acknowledging the proportional rules of dynamics which Aristotle referred to, Leonardo was prepared to challenge them just as medieval philosophers had done. But a decade later, in 1508, he re-adopted them, probably because he failed to understand the medievalists' proportional formula. As his appreciation of the numerous natural resistances to force grew, so he modified Artistotle's ratios of power, time, distance and weight, direct ratios, which he had earlier accepted. However, like many medievalists, he had overlooked the qualifications that Aristotle himself had made to his ratios, so that, overall he returned to the authentic Aristotelian teachings.

His answer to the question 'Whether the movement of the air is as swift as its mover', was 'no', because 'the movement of the dust . . . which follows a horse [shows], for after having moved a short distance it turns back with an eddying motion and thereby consumes its impetus.' Finally he concluded that the impetus involved never had a velocity equal to that of the primary movement, nor does the wave of air, created by the impetus, make the object move. Philosophically he added, 'It is impossible that anything of its own can be the cause of its own creation; and those things which are of themselves are eternal.' With gravity, he failed to grasp the uniform acceleration theory which determines the distance which a body falls in a given time. His mathematical insight was insufficient, for he wrongly assumed the length of a fall was directly proportional to time.

THE VORTEX

Water fascinated Leonardo. He would spend hours at the river bank checking the transmission of sound in water. But it was the powerful vortex, or whirlpool effect of water, that attracted him most. He noticed how a water twists and turns, eating first into one bank, then into its opposite, and how:

> At times it turns towards the centre of the earth consuming the base which supports it; at times it leaps up swirling and bubbling to the sky; at times revolving in a circle it confounds its course . . . Thus . . . it is ever removing and consuming whatever borders upon it. Going thus with fury it is turbulent and destructive.

Thus the natural dynamics of water wove an infinite variety of elusive geometric patterns. He began by classifying four types of natural spirals – 'convex, planar, concave and columnar'. Each had its own dynamic properties, making it act in different ways. The vortex's whirlpool effect epitomizes Leonardo's approach to geometry, which in turn reflects his concern for motion. As its spiral, rotary motion is swifter nearer the centre of its revolution, 'it makes the concavity in the form of a pyramid, and makes it so much the more swiftly as the pyramid is more pointed.' This concave spiral, acting with geometric regularity like a natural power-drill, gouged remorselessly away and sucked everything into it. For him the vortex was the ubiquitous sign of the life that was beneath the surface of the natural world.

While his drawings of the potential of motion in the natural world reflect his intuitive response to motion, his rigorous mathematical analysis showed his intellectual desire to demonstrate the dynamics of nature. His work was rooted in classical theories and in late medieval natural philosophy. The four elements of earth, with water, air and fire around it in concentric circles, all seek to find their own level in the natural order. It would need an 'accidental' force to move one of them from its allotted position. While an object below its natural level, such as a submerged bubble, would seek to ascend by the shortest route possible, an object above its natural level would fall by the law of gravity (not yet formulated, but evidently understood). Lateral movement would be determined by the weight of the object and the force used to propel it. Leonardo used the late medieval term 'impetus' when describing the quality of the force applied. 'Impetus transports a mobile body beyond its natural location. Every movement has terminated length, according to the power that moves it, and upon this one forms the rule.'

He considered floating grass seeds on flowing water, and deliberated on dyeing two colliding streams to find out exactly what motions would occur. He discovered an infinite number of geometric permutations in moving water, a conclusion he could have arrived at with fewer than the 730 experiments he conducted. However, his drawings of swirling water demonstrate its turbulent effects dramatically. He concluded that three factors were involved: the primary motion of a falling column of water; the secondary motion of the accidently submerged air; the reflex motion of the main mass of water in the pool below. The air bubbles added complexity to the vortex pattern. He analysed the air bubble's fragile architecture, so fascinated was he with its behaviour and form. The air 'penetrating the water in sinuous motions changes its substance into a great number of shapes'. When it 'raises its head through the surface of the water with as great a weight of water joined to it as the said tenacity can support . . . it stops there in a perfect circle'.

According to Leonardo, if an object met an opposing force it would try to continue its impetus. Thus water and air would use the eddy procedure to maintain their impetus, while light rays would rebound in such a way as to make their angles of reflection equal their angles of

incidence. In his drawing of *Studies of Water passing Obstacles and Falling into a Pool*, *c*1508-9, water is faced with a complexity of collisions with the obstacles it meets when falling into the pool, and, by twisting and circular movements, eddies on its way. The bubbles come to the surface as the water rebounds against the obstacles it meets. Beside this demonstration of his theory of impetus and revolving motion, he noted, 'The motions of water which have fallen into a pool are of three kinds, and to these a fourth is added, which is that of the air being submerged in the water.' The air is first submerged, and then, compressed, it moves beneath the water before returning to the surface. 'Such water then emerges in the shape of large bubbles, acquiring weight in the air and on this account falls back through the surface of the water, penetrating as far as the bottom, and it percusses and consumes the bottom.' Meanwhile, an eddying motion is made on the surface or 'skin' of the pool by the water which returns directly to where it had fallen. There was also a swelling motion made by the reflected water when it brings the submerged air to the surface.

THE GEOGRAPHY OF WATER

Leonardo devoted a major part of his studies to the geography of water, a bone of contention in both classical and medieval times. Among others, he read Aristotle, Pliny and Ptolemy, and the Arabian authors as well as medievalists, such as Albert of Saxony, on the subject. Then he studied the configuration of the four elements: fire enclosing air, enclosing water, enclosing earth. To some extent he followed Plato's argument that the elements corresponded to geometric shapes. Yet he acknowledged that the earth's shape was irregular and contained within it cavities for water and air. Geologically he argued that the earth had become raised up more than it once was:

> . . . as by degrees it became lightened by the flow of water away
> from it through the Straits of Gibraltar; and it was raised so much
> more because the weight of the water which flowed away from it
> was added to that of the earth which was turned to the other hemi-
> sphere.

Consequently he forecast that eventually the Mediterranean would 'reveal its bed to the air and the only water-course remaining will be a very great river'. In this he followed Jean Buridan's 14th-century *Questions on Aristotle's 'On the Heavens and Earth'* via Albert of Saxony. Leonardo concluded that, 'The highest mountain there is on the earth is as far above the surface of the sphere of the water as the greatest depth of the sea is below the surface of the sea.' He deduced that the earth was an unstable mass liable to natural elevation and depression. This explained for him the presence of fossilized sea creatures on high land.

WATER PASSING OBSTACLES AND FALLING INTO A POOL
c 1508-9

The most complex of Leonardo's water drawings. The obstructions
created floral patterns or hair-like flows.

He rejected the popular biblical 'Deluge' or 'Flood' theory, as that would have left fossils only on mountain tops and in high lakes, not in lower layers. Its short duration would not have allowed time for the slow cockle, for example, to move so far.

He was fascinated with the motion of the tides and queried whether they were moved by the sun and moon, or by 'the breathing of a terrestrial machine'. As the former offered him no solution, he sought the explanation in the earth as a breathing body. He noted the earth was sectionalized by rivers and seas, like veins, which could be ruptured. He knew Pliny's view that water penetrates the earth along connecting veins and breaks out as springs. He used this theory to oppose medievalists who argued that the oceans' surfaces rise at their centres higher than necessary to activate mountain springs. He also used the analogy of plants oozing sap.

Between 1508 and 1510 he began to doubt whether mountain springs were caused by a blood-like circulatory process. In contrast to the way men's veins narrow with age, the earth's widen. Also the origin of the seas is contrary to that of blood, as the seas receive their water from rivers, 'which are only caused by the water vapours raised into the air'; whereas the 'sea of blood' is the cause of veins. So he had to abandon his earlier theory, his analogy being deprived of its life-blood. Yet he maintained that all the various bodies of nature, in all their infinite variety, were perfectly created to perform all their varied functions in a shared context of universal law. According to Leonardo, it was in that shared context that the unity of earth, the *macrocosm,* and man, the *microcosm,* were to be found. Only where analogous functions occurred would analogous effects be found, so that every case had to be checked individually. That done, man would be able to harness natural causes and effects for his own ends.

THE DELUGE

Leonardo was fascinated by the possibility of the earth's forces running amok. His unfinished work, *The Deluge and its demonstration in painting,* started in 1513, employs sixteen pastels to cover the intensity of his visionary emotion. Noticeably he began this work composed of letters and drawings in the year that twelve Franciscans passed by on a preaching tour to argue the unsuitability of Leo X as Pope. Convinced that an apocalyptic scenario was in the offing, he expressed his feelings in letters addressed to a mysterious Diodario of Syria, lieutenant of the Sultan of Babylon, and more vividly with his drawings. The letters tell of the adventures of a prophet who witnessed the Deluge in Armenia.

In this 'end of the world' situation, tempestuous winds, rockfalls and earthquakes swept cities away, as animals were tossed aside, trees bent double, and praying men were engulfed in a fireball – only the prophet survived. In a four-stage annihilation. Leonardo saw himself as the

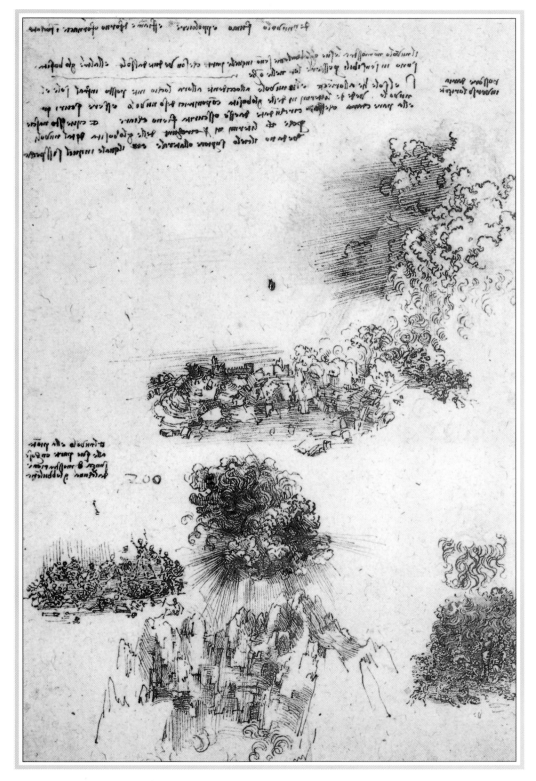

APOCALYPTIC SCENES OF DESTRUCTION
c 1517

———

The open pit (bottom) was probably inspired by Dante's *Inferno*. The
skeletons on the left may refer to Ezekiel's valley of bones.

prophet, while Diodario may have been Giuliano de Medici, and the Sultan, Leo X. It was to contain adventure, strange encounters and intrigues, with the final triumph of the prophet over his enemies.

Amidst the terror was an army on the march, with giant misshapen animals tumbling from the sky – a huge headless horse, a horse with three curling elephant trunks sprouting from its neck, horses shaped like dead tree roots. Nature was disintegrating before Leonardo's visionary eye. Thus one drawing shows the world destroyed by an apocalyptic army, and another by an apocalyptic storm.

He had jotted down his twelve subject headings in an apparently confused order: the preaching and persuasion of the faith; the sudden deluge; the city's destruction; the people's death and despair; the search for the liberating prophet; the cause of the mountain's destruction; the havoc it created; destruction by snow; finding the prophet; his prophecy; the deluge in eastern Armenia solved by cutting through the Taurus Mountains; how the prophet showed that the destruction fulfilled his prophecies. The end was a vision of peace and plenty, when the Deluge had been drained away by the hydraulic engineer with the gift of prophecy. This prophet proved to be both a figure of faith and an hydraulic engineer, as he solved the problem by tunnelling through the Taurus Mountains.

Leonardo's description of one Milan-centred storm was preceded by a meteorological analysis of wind formation, in which he asserted that 'it is necessary for a great quantity of air to rush together in order to create a cloud, and, since it cannot leave a vacuum, the air rushes in to fill up with itself the space left by the air first condensed and then transformed into a cloud'. Of the Deluge itself he wrote:

> Let some mountains collapse headlong into the depths of a valley and dam up the swollen waters of its river . . . Let the biggest [rivers] strike and demolish the cities and country residencies of that valley. And let the disintegration of these high buildings of the said cities raise much dust which will rise up like smoke or wreathed clouds through the descending rain. Let the swollen waters gyrate within the lake which contains them, and with eddying vortices percussively strike against various objects and rebound into the air as muddied foam, which, as it falls, splashes the water that it strikes back up into the air.

Water's combination of mobility and weight made it the most feared of the elements, in Leonardo's opinion. Man is powerless against its fury. 'Impetus' and 'percussion' are typical of his water-research terminology. Just as the mathematics of impetus control the heart, so too are they the force behind his extraordinary series of drawings known as the *Deluge Studies*. They were linked to his intended *Treatise on Painting*, being given subject headings such as 'darkness, wind, tempest at sea, deluge of water, forests on fire'.

His *Cloudburst of Material Possessions, c*1510, is only too relevant to Western capitalism today. 'Oh human misery – how many things you

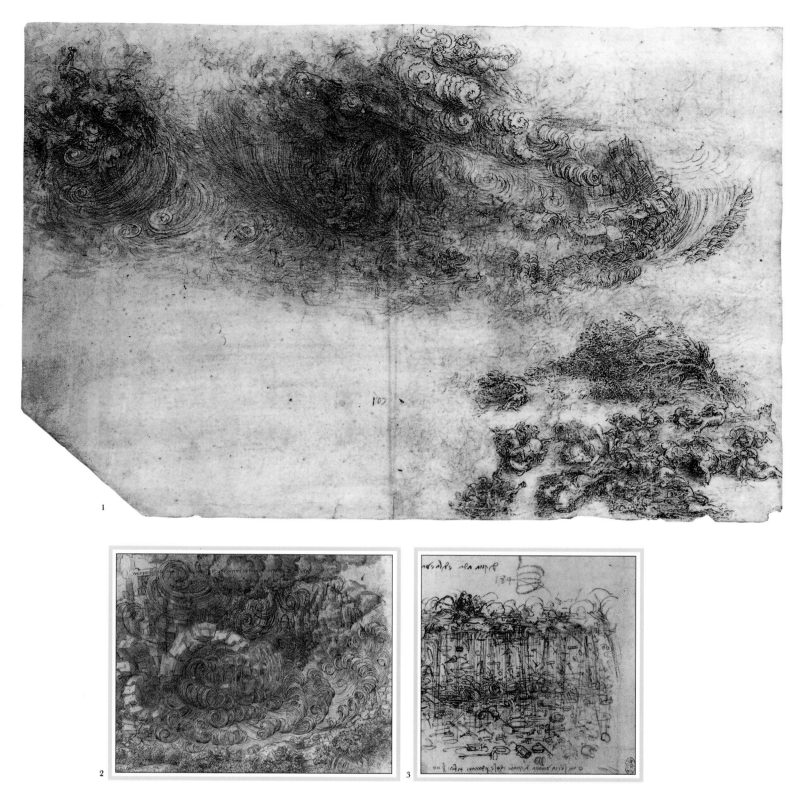

THE FORCES OF DESTRUCTION

In 'Hurricane over Horsemen and Trees', *c* 1418 (1) the destructive forces of cloud and water gyrate around their victims – the 'pitiless slaughter of the human race by the wrath of God'. (2) One of Leonardo's series of 'Deluge Studies', *c* 1515. Writing about rain he noted: 'show the degrees of rain falling at various distances and of varied darkness; and the darker part will be closer to the middle of its thickness'. 'Cloudburst of Material Possessions', *c* 1510 (3) is clearly an allegory, but it is not easy to decipher it. The note below reads 'Oh human misery – how many things you must serve for money', while the one at the top reads 'on this side Adam, on that Eve', perhaps suggesting their fall was to blame.

must serve for money', bewailed Leonardo as he drew tools, bagpipes, clocks, spectacles, ladders and pincers raining down on the earth. He may perhaps have been hinting at the horrendous outcomes of the world's motion running down. Certainly he was much preoccupied with destruction: his detailed description of capsized boats, the hopeless gestures of the drowning, despairing suicides and fermenting corpses of animals could provide scenarios for modern 'disaster' films.

Though he questioned the Bible's accuracy, in particular with regard to the Flood and fossil placements, he did not reject its narrative out of hand. It is impossible to know whether his Deluge material refers to the Bible or not − probably not, as he refers to Neptune and Aeolus being seen in the confusion. In one of his earliest Deluge drawings, Ovidian wind gods are visible. Noticeably he used the definite article, 'the', when referring to the Deluge, but only the indefinite when dealing with tempests, gales and downpours. Though his observation of sedimentation and resulting leaf fossils, was beginning to point the way, he was hampered by the absence of the concepts of epochs and evolution.

Doubtless he used his actual experience of a colossal storm at Vinci that he witnessed when he was four years old.

> For ten hours we experienced such havoc as I would not have thought possible. First we were assailed and attacked by the violence and fury of the winds, and to this was added the fall of great mountains of snow that filled up the entire valley, thus destroying a great part of our city. Not content with this the storm brought a sudden flood of water that submerged all the city's lower part, and then there came a sudden rain, or rather a destructive flood or torrent of water, sand, mud, and stones, tangled with roots, and branches and fragments of many trees; and every manner of thing flying through the air fell on us; and finally a great fire broke out, not carried by the wind, but as it were carried by ten thousand devils, and it completely burned up this neighbourhood and has not yet ceased. Those few who remained unharmed are in such dejection and terror that they scarcely have courage to speak to one another; it is as though they were stunned . . . And all these evils are nothing compared with those that are promised to us shortly.

Leonardo seemed convinced that imaginary things could really happen. 'The time will come when our luxuriant and fruitful earth will grow dry and sterile. By reason of the pent-up waters in the earth's womb and by reason of nature's laws, the earth will follow its inevitable course, and passing through the circle of ice-cold, rarefied air, it will complete the cycle through the element of fire. And the surface of the earth having become at last a burnt cinder, all earthly nature shall cease.' Leonardo came close here to predicting the late 20th-century concerns with the destruction of our planet.

GEOMETRY

Leonardo wrote, 'There is no certainty in science where mathematics cannot be applied'. After meeting Fra Luca Pacioli, a professor of mathematics at Pavia, he eagerly pursued the subject, keen to grasp both arithmetic and geometry as they 'embrace all things in the universe'. Beginning in 1501, he concentrated on geometry; between 1504 and 1506, on hydrology, and in 1505, on solid geometry. Pacioli once said of Leonardo's pyramidal drawings, 'these figures . . . truly no man can surpass'. Each man had an inquiring mind devoted to mathematical order, yet was detached enough to see to the heart of the universe. Leonardo did sixty geometric structures and a geometrically designed alphabet for Pacioli's *De Divina Proportione;* he made use of diagrams from Pacioli's book, *Summa de arithmetica, geometrica,* and mastered some complex procedures to make calculations on time-and-motion studies, though he was liable to make errors in his arithmetic.

Leonardo intended to call his geometric treatise *On Transformation.* He was fascinated by the creation of equalities of area between curved and rectangular forms and delighted in 'slicing' and 'moulding' geometric bodies into new configurations. All his work on solid geometry reflected his ability to visualize such forms in concrete terms, as well as his grasp of shape and volume. He corrected Archimedes' mistaken version of the centre of gravity of a trapezium. He then went on to work the centre out for a tetrahedron, comparing it with its 'magnitude' centre.

He often stressed that geometry was concerned with 'continuous quantity', while mathematics dealt with 'discontinuous quantities', applying this former principle to motion and representing forms in space. Thus his *Muscles of the Arm and Shoulder in Rotated Views, c*1510, are not just some of his finest anatomical studies of muscles, but also offer a geometrical study of the human body. Taking up John Pecham's medieval observation that every part of the air is filled with radiant pyramids of light arising from a lit object, Leonardo drew a variety of viewpoints to show the apex of each as a visual pyramid. Anatomically he aimed at nothing less than a fully comprehensive visual survey of the human body from all angles in numerous poses.

His obsession with the infinity of geometric transformation is clear in his study of the equivalences of area in straight-sided and curvilinear figures. He showed a Renaissance interest in the mathematical proportions of the body, using the 1st-century BC architect, Vitruvius', positioning of the body, as Dürer was to do later on. Typical of his findings is the following, 'When a man kneels down he will diminish by a quarter of his height. When a man kneels with his hands to his breast, the navel will be the midpoint of his height and similarly the points of his elbows.'

His attempts in 1492 and 1503 at the age-old problem of squaring the circle (a formula for constructing a square of the same area as a given circle) were inconclusive but his *Geometrical Investigations of Areas and*

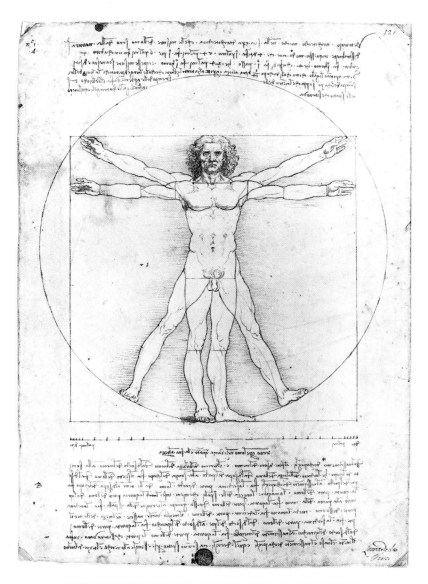

THE PROPORTIONS OF THE HUMAN FIGURE
c 1487

A formalized concept of logical division, after Vitruvius. The ideal
proportions could be applied to any branch of art.

Calculations proved that his knowledge in this area went well beyond
that of contemporary artists. He started with Archimedes' attempt by
transforming a circle into a polygon, before trying various triangles. He
tried 'cutting' a circle into 'slices' which he 'unrolled' into a collection of
triangles.

Then he progressed to reducing a 'sliced' circle to rectilinear figures,
which he then squared. He wrongly believed he had succeeded, though
he did conclude that geometry was the basis for the functional design of
all organic forms – as his work on the vortex showed, for example. For
him, the properties of organic nature and abstract geometry were
totally integrated – the eye providing the key to observing this vision of
the world. The geometry behind his paintings has already been con-
sidered.

His belief that pure geometry lay behind all natural design led to his
illustration of dodecahedrons for Pacioli's book. He developed a
method of drawing them in both solid and skeletal form, a practice
which has been followed ever since. But he rejected Pacioli's argument
that the world could be physically built from Platonic solids.

His endless rows of diagrams point to his fascination with intricate
relationships of area between circles, triangles, squares, polygons, sectors

and segments. Perhaps they provided him with light relief for his *De ludo geometrico* (*ludo* being a 'diverting pursuit' or 'game'). In his old age, he was greatly concerned with mathematical abstractions. The more he studied the great mathematicians of the past, the more he valued their science, for its expression of truths that were intellectually incontrovertible. 'Here no one argues that twice three makes more or less than six, nor that a triangle has angles smaller than two right angles.' As Kemp has written, 'Nowhere was Leonardo more a classicist in the Renaissance sense than in his late geometry.'

ACOUSTICS AND ASTRONOMY

Vitruvius had drawn attention to the circular effect of acoustics in theatrical design – the voice moving round in an endless number of circles, like waves made by a pebble thrown into water. Leonardo regarded this as a series of successive 'tremors', pointing out that those caused by two stones will intersect yet will still retain their geometrical integrity. This circular transmission suited the kind of ordered progression in space he believed in whenever force occurred in the natural world. All powers of transmission in such a world are subject to comparably pyramidal laws. The same diagram was usable for the fading of sound, the action of gravity and the perception of size. So the painter and musician must base the sciences of their arts on the laws of mathematical progression and harmony.

In his search for meaning in the universe, Leonardo concluded that any 'prime mover' must be beyond the eight or more encircling spheres of planets and stars. He knew Ptolemy's teaching on planetary movements, as well as the astronomic textbooks, including Aristotle's and the medieval commentators on his work. Leonardo did little more than make visual observations of the heavens, regarding the eye as a reliable witness. He attempted to calculate the sun's distance from the earth, as well as the size of the moon. He was more concerned with planetary shapes than their movements, perhaps thinking Ptolemy had done the other work already.

He was interested in the transmission of light from one planet to another, and in the moon's optical properties. 'The moon is not luminous of itself as it does not shine without the sun', so it had to act like a spherical mirror, he concluded. He accepted Aristotle's view that the moon was made of materials such as alabaster and crystal. He believed that while the sun made 'innumerable images' when it was reflected by the rough surface of the moon, these images fused together on their journey earthwards. It followed logically that the earth must look the same to anyone standing on the moon, as it had essentially the same nature. 'The earth is a star much like the moon.' This was not a new idea, and Leonardo saw the earth as the astronomical centre of the universe just as others did.

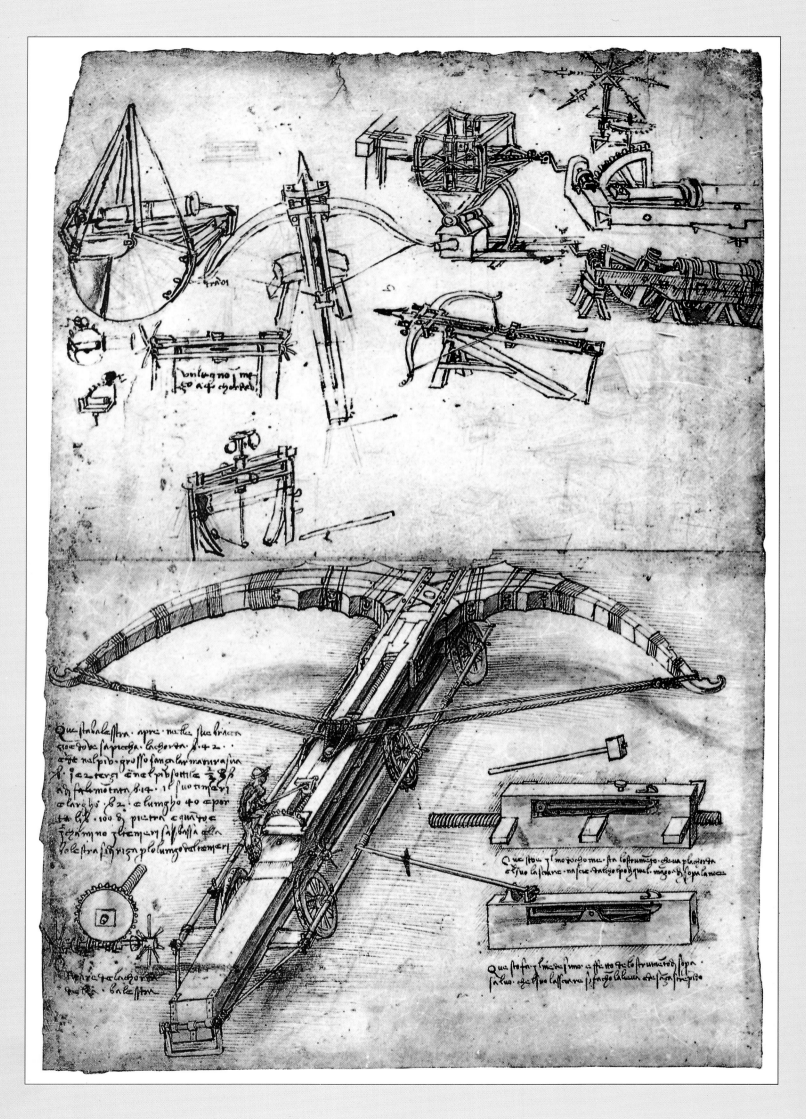

THE MILITARY ENGINEER

LARGE CROSSBOW OR BALLISTA

The weapon was to be 86 feet (26.2 metres) long, with alternative
firing mechanisms, one with a spring released by a hammer blow,
the other tripped by a lever action.

THE MILITARY ENGINEER

Leonardo has been described as the supreme master of the effects of violence, and a keen inventor of the forces of destruction. On three occasions he accepted posts specifically for that purpose. Such a positive and persistent pursuit of military engineering and weaponry development seems to contradict his respect for life and nature. However, he was alert to the dangers of science and the exploitation of the natural resources leading to the earth's destruction, and his many warnings now have a prophetic ring to them. Essentially his life's work was to make sense of Creation at every scale, from the grand to the microscopic. The more he researched into this wide-ranging subject, the more he came to respect what he discovered.

A partial answer to the apparent contradiction in his actions is his need to find employment offering opportunities for travel, and the chance for further scientific observation. The incessant warfare between Italian city states, with their rapidly changing alliances, put a high premium on the development of technical weapons, fortifications and military engineering, so providing Leonardo with his opportunity.

Florence in Leonardo's day was a focus of many wars. The first half of the 14th century had witnessed the construction of numerous fortresses, so that by the end of the century the professional status of the military engineer was held in esteem. The outcome was a realization that those with the necessary practical engineering experience were painters, sculptors and architects. Francesco di Giorgio Martini (1439-1501) of Siena led the field with over a hundred fortresses to his credit. Leonardo, thirteen years his younger, was well qualified to follow in his footsteps, especially as Martini gave him a copy of his *Treatise on Architecture, Engineering, and Military Art* (published in the 1480s).

To equip himself for the task, Leonardo examined classical studies on the art of warfare. In his opinion, being a practical military engineer involved a personal grasp of what warfare was really like. His lesson to an artist about to paint a battlefield scene shows just how well he understood the realities of combat.

> You should first paint the smoke from the artillery as it mingles in the air with the dust stirred up by the movement of horses and the combatants. Realize the mingling thus: dust, being composed of the earth, has weight, and although on account of its fineness it will rise easily to mingle with the air it nonetheless is eager to resettle. The finest particles attain the highest reaches and consequently there it will be least visible and will seem to have almost the colour of the air . . . Show the foreground figures covered in dust – in their hair, on their brows and on other level surfaces suitable for dust to settle . . . And if you show one who has fallen, indicate the spot where he has slithered in the dust turned into bloodstained mire. All around in the semi-liquid earth show the imprints of men and horses who have trampled over it. Paint a horse dragging along its dead master, leaving behind it the tracks where the corpse has been hauled through the dust and mud.

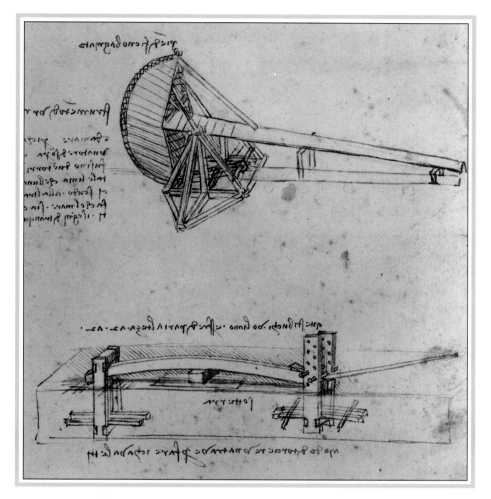

DESIGN FOR MARITIME ASSAULT MECHANISM AND
BENDING BEAMS
c 1488

From a ship's bows, the scaling-tower swung upright against the
enemy shore defences when its counterweight, filled with wet hay,
was released.

Realizing the possibilities inherent in a military advisory role, Leonardo wrote to Ludovico il Moro, Duke of Milan, listing thirty-six ways in which he could serve him, with nine categories of military engineering, ranging from bridging, trench draining and covered ways, to bombarding machines and new weaponry.

Among the items listed were designs for 'very light and strong bridges which can be easily carried, with which to pursue, and sometimes flee from, the enemy; and others safe and indestructible by fire or assault, easy and convenient to transport and place in position. When a place is besieged I know how to cut off water from the trenches and how to construct an infinite variety of bridges, mantlets, and scaling ladders, and other instruments pertaining to sieges. I also have types of mortars that are very convenient and easy to transport', with which he guaran-

teed 'to hurl small stones like a storm, with the smoke of these causing great terror to the enemy, and great loss and confusion' – the forerunner of shrapnel. When 'a place cannot be reduced by the method of bombardment, because of either its height or its location, I have methods for destroying any fortress or other stronghold, even if it be founded upon rock'. For naval warfare, 'I have many engines of kinds most efficient for offence and defence, and ships that can resist cannon and powder'. He knew how to pass under ditches and rivers through 'caves and secret winding passages, made without noise'.

Portable bridge designs had greatly advanced in the 15th century, and there was nothing novel in Leonardo's offer, except that his were to be 'fire- and battle-proof'. Although he wrote in absolute terms, demanding his claims be taken at face value, he offered no proof of their viability. 'Machines of marvellous efficacy' does not sound particularly convincing, for example.

FORTIFICATIONS

The more assault weapons, especially firearms, improved, the greater the need to improve defences. Just how practical Leonardo's fortifications were can be seen from the precise calculations he made on the amount of earth to be moved, and what a workman could do in either sandy or rocky ground in a day. On such observations he could make reliable decisions on how his labour force should be organized to achieve the best results. His anatomical work aided him in this for, unlike other artists, he had done a 'time-and-motion' study of farm workers in the fields by sketching all they did in detail. Not only was he centuries ahead of his time in so doing, but he aimed to design semi-automatic machines to replace many tasks which men could barely physically cope with.

Over a period of experimentation, he developed a fortress design the like of which was not to be seen for centuries again. Previously soldiers on towers had dumped hot tar on scaling-ladder assaults by their adversaries. Leonardo was one of the first military architects to plan for cannons on towers, showing that he fully appreciated the revolutionary new art of organizing effective firepower. Early on he designed the first 'modern bastions', outposts on the four corners to provide flanking fire. Later he rejected the traditional square castle, and proposed a radical circular fortress with concentric fortified rings to provide firing positions, while between the rings were trench-like areas for emergency flooding if the enemy breached the outer wall. Instead of a high-standing prominent fortification, he opted for a sleek low-profile frontage to the enemy – the forerunner of the 1939 Maginot Line. All these changes stemmed from his appreciation of improved cannons producing an increasing velocity for their shot, with the resulting 'percussion' (impact) made on walls. 'Percussion is less strong, the more

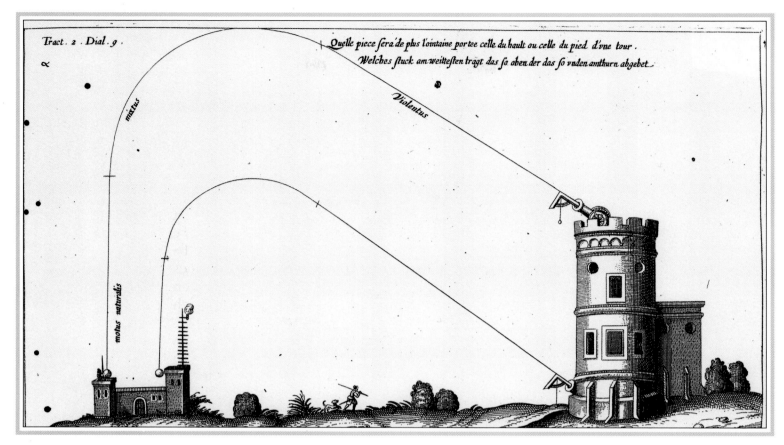

Quelle piece sera de plus lointaine portee celle du hault ou celle du pied d'vne tour .

Welches stuck am weittesten tragt das so oben der das so vnden amthurn abgebet .

A CANNONBALL'S TRAJECTORY
1613
—
The accepted view was an initial impetus, a downwards gravity
curve, and air-resistance causing slowing (a straight descent line).

oblique it is', noted Leonardo, duly introducing low curved walls to
reduce the effect of the impact.

His notes on tower construction show just how careful his analysis of
defence needs was.

> If a square tower is provided with pyramids at the corner, with
> varied shelters, like stairs, double bridges, devious entrances and
> ditches, it will have, by itself, great resistance . . . At the strongest
> corners, towers should be placed, with lateral defences, which
> defend the walls which contain the massive corners . . . The second-
> ary towers must be low and wide, covered by a vaulted and beveled
> roof, at a very obtuse angle, in order to deflect the transversal shots.

His work on the defences of the strategically placed port of
Piombino, fifty-four miles south of Pisa, was not known until the 1965
discovery of his notebooks in Madrid. Cesare Borgia had asked him for
a plan in 1502, so when he subsequently worked for Cesare's enemy,
Jacopo Appiani, in 1504, he was able to produce his ideas immediately.
He planned a 1260ft (385m) long trench through rocky ground from the
citadel to Richotta Castle; straightening a moat and digging a 590ft
(180m) tunnel, from the citadel to the town gate, for both communi-
cation purposes and as a reserve escape route; and enlarging the citadel
with a 39ft (12m) tall, 49ft (15m) diameter tower. The tunnel's entrance
could be blocked by a drawbridge if there was internal rebellion.

> The castle commander must be able to go through the entire for-
> tress, including the upper, the middle and the lower parts, using

tunnels and underground passages, which shall be arranged in such a way that none of them could be used to reach the commander's quarters, without his consent. And through these ways, using portcullis and sluice gates, he must be able to imprison in their own rooms all those of his retinue, who may plot against him, and may close or open the door of the main entrance and the relief route. And this danger is even greater than the enemy itself because those on the inside have greater opportunity to do harm than the enemy who is shut out.

To detect the use of underground passages, he suggested placing some dice on a drum above the passage. If the passage was used, the vibrations would move the dice.

WEAPONRY

Ludovico's senior armourer persuaded Leonardo to provide illustrations of battle scenarios for his textbook on defensive fighting between horsemen and foot soldiers. Today, nothing remains except a few pages of ugly spear heads and hand-to-hand combat scenes based on the mock battles he watched. He had read Roberto Valturio's *De Re Militari* (1483), which covered all Roman military devices and included a hundred woodcuts of 'engines of war'. As a result he improved scythed chariot designs. Depicting one of these, with men lying around with legs cut off below their knees, he admitted that in the thick of battle they were just as likely to injure one's own men as the enemy.

He was sure his wooden 'armoured car', operated by eight men (or possibly horses), would break open enemy ranks, enabling the infantry to proceed. These were the 'covered vehicles, safe and unassailable, which will penetrate the enemy and their artillery' that he had promised Ludovico il Moro, to 'take the place of elephants' of old. Leonardo was not alone among Renaissance inventors who habitually promised new weaponry for their patrons. His weapons fall into three categories – – *ballistas,* or catapults; cannon; handguns. For mechanical information about *ballistas* he relied on military technological literature by Archimedes, Pliny and Vitruvius, and, for recent developments, on Francesco di Giorgio Martini and Roberto Valturio's *De Re Militari.*

Leonardo's huge *ballista* included advanced design features. The great bow of laminated sections provided maximum flexibility, as the worm and gear mechanism drew the bowstring. The canted wheels provided a wider, more stable base and reduced road shock. His semi-automated crossbow was a kind of treadwheel 'machine gun', enabling the suspended archer to fire the four bows rapidly as his comrades turned the wheel. Other versions show his use of the energy stored in twisted and bent wooden arms, in the torque of ropes and in metal springs by means of racks and pinions or worms and gears.

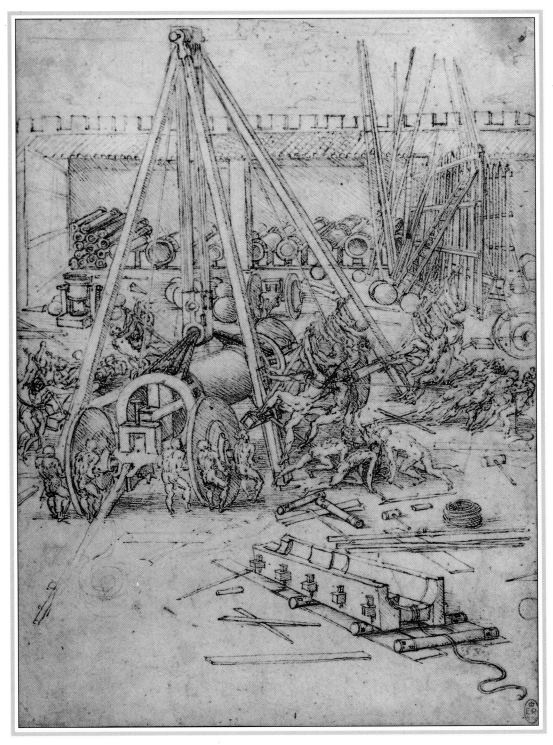

ARTILLERY PARK
c 1487

Teams of men struggle with axles and winch-levers to haul a huge
cannon onto its carriage.

THE WEAPONS OF WAR

Leonardo's experimental weaponry sought to solve some of the challenges presented by the military revolution of his time. The man-powered armoured car, a fundamentally impractical device, was an attempt to provide a substitute for the heavily armoured knight. Similar thoughts produced the scythed chariot, an ancient prototype to which Leonardo added some mechanical refinements – the scissors mechanism. The repeating large crossbows and the ballistic tests Leonardo made with smaller models were seeking to preserve a cheaper alternative technology to the increasingly efficient firearm. That these were dead ends was recognized by Leonardo himself, who also developed some multi-barrelled light cannon.

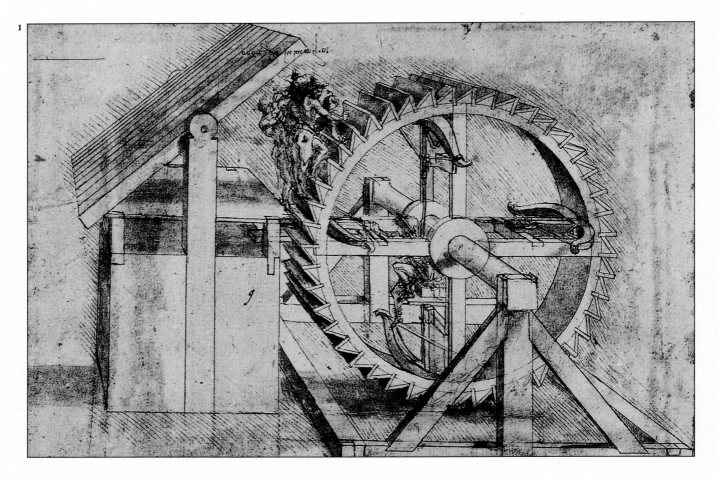

1 Treadwheel 'machine-gun' crossbow. Treading on the outside of this wheel instead of the inside provided greater leverage.

2 Leonardo carried out ballistic tests as he sketched his crossbows. Here he sought to show the pyramidal law of force of a bow, believing there was a relationship between the angle of a taut bowstring and the force required to withdraw it.

3 Two scythed chariots with bodies on the ground, c 1487. 'When this [chariot] travels through your men, you will wish to raise the shafts of the scythes, so that you will not injure anyone on your side.'

4,5 Designs for an eight-man wooden armoured car, c 1487.

6 Model made after Leonardo's drawings. The vehicle was operated by turning the cranks.

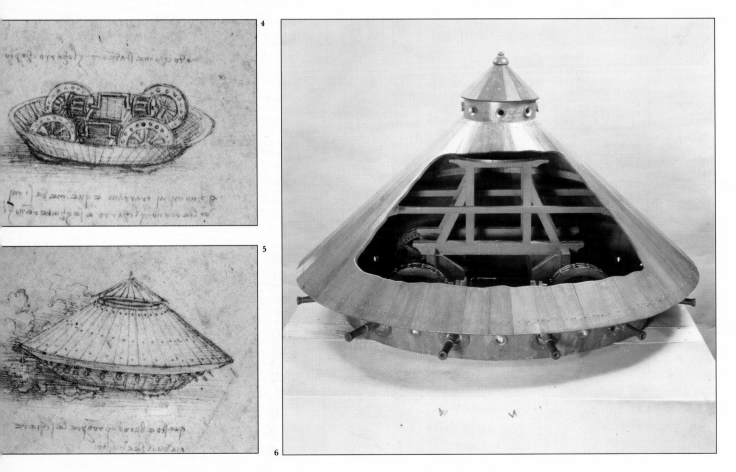

TRAJECTORY EXPERIMENTS

Leonardo tested stressed crossbows, observing the behaviour of discharged bolts to work out the relation of bow tension to the range of the bolt. He allowed for air resistance, appreciating that air was thinner higher up. A series of tests measured input force, gravity and vertical trajectory. 'Test it first and state the rule afterward.' Thus 'the length of the arrow's descent was proportional to the weights used in the spanning of the crossbow'. So the depth of penetration was in direct proportion to the arrow's vertical rise and bowstring's tension. He confirmed the notion that an arrow shot vertically will fall vertically downwards. Leonardo was the first to draw the trajectory as a continuous curve – a fact clearly unknown to the Italian mathematician Niccolo Tartaglia, when he endorsed Albert of Saxony's three-stage view in a book published in 1537.

Though he did not develop mathematical ballistics (that fell to Newton in 1687), Leonardo's unerring eye, backed up by tests, saw that a parabolic curve, deformed by air resistance, was the true trajectory. A century later Galileo ignored air resistance when examining trajectories, knowing nothing of Leonardo's note that, 'The air becomes denser before bodies that penetrate it swiftly, acquiring more or less density as the speed is of greater or lesser fury'. Leonardo was centuries ahead of his time in lessening resistance by streamlining missiles and adding directional fins.

He tested the trajectory of a cannon ball by vertically firing two balls from the same cannon, separated by equal gunpowder charges between the breech, the lower and the upper balls. The top ball cleared the muzzle for the lower one, but rose higher than the latter as its propulsion was aided by the lower ball's charge in addition to its own. Leonardo calculated the effects of the wind on sound, flash and impact, finding that foggy weather led to a louder bang. He considered incendiary shells studded with spikes, and poison shells so that 'all those, who, as they breathe, inhale the said powder with their breath will become asphyxiated'. He considered how anti-aircraft gunnery might have to face future flying machines.

> To fire a rocket to a great altitude, proceed this way: Set your cannon upright; load the cannon with a ball connected to a rocket by a chain, leaving the rocket on the outside . . . Then secure a small board, with gunpowder, level with the touchhole of the cannon. Having done this, fire the rocket, and the rocket's fire, falling on the board and the touchhole, will fire the cannon. The cannonball will drive the rocket more than three miles high and a flame half a mile long will be seen trailing the rocket.

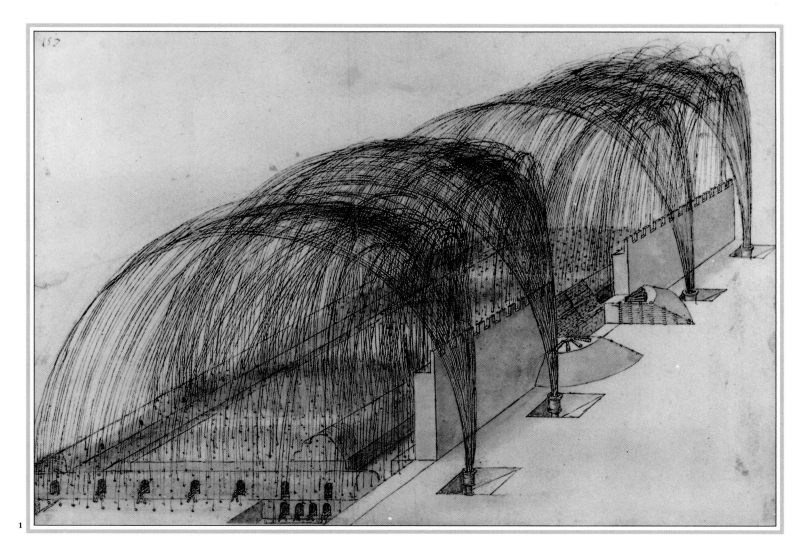

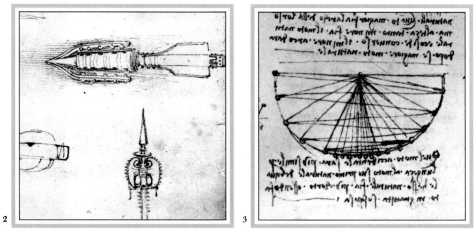

BALLISTICS

Leonardo's drawing of mortars firing stones into the courtyard of a
fort (1) shows a graceful, awesome bombardment covering 400 feet
(122 metres) beyond a 32-foot (9.75 metre) wall. Ludovico tried such
a barrage against Novara in 1500; the drawing was done *c* 1503-4.
The high-explosive artillery catapulted shell (2) was designed for
Ludovico. The gunpowder-packed fins ignited on impact. It had
previously been supposed that a trajectory formed two straight lines
connected by a short curve. (3) is part of a page of Leonardo's
experiments showing the parabolic curve deformed by air resistance.

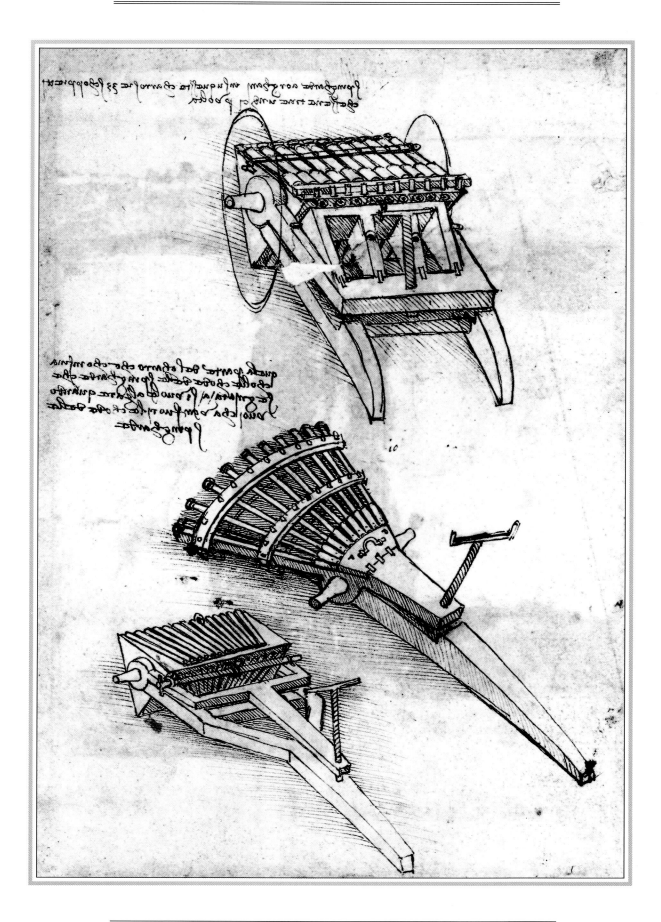

DESIGNS FOR CANNON

Renaissance firearms suffered from inaccuracy and a slow rate of fire, yet Leonardo's drawings show the use of the mid-19th-century techniques – the use of shrapnel, breech instead of muzzle loading, multiple fire, water-cooled gun barrels and advanced gun-construction methods. His *fulminaria* breech-loading gun, firing iron-tipped bolts, was set in a water-filled copper casing 'in order that once fired, the copper soon abandons its heat'. In those days large cannons were built by combining forged tapered sections together to form the barrel, then binding the segments together with metal rings, rather like hoops on barrel staves. Leonardo designed one such method of cannon construction. His water-powered mill fashioned smooth, even segments for barrels, which were too large for traditional forging methods. The segments were then welded and banded together. Like other mechanisms, this one depended on roller- and ball-bearings to reduce friction.

About 1481, he designed his *Gun with Array of Horizontal Barrels* and his *Gun with Three Racks of Barrels*. The former's barrels were canted to allow for a wide scattering of shot. He called the latter *a organi* as it resembled an organ's pipes, with its thirty-three barrels in three ranks of eleven. With each row forming the side of a triangle, it could maintain a continuous saturation of fire power. Leonardo's designs allowed for the cooling and re-loading of one rack while another was being fired. His *architronito* was a cannon dependent on the sudden generation of steam to propel its shot. The breech contained a basket-like brazier of burning coals. A little water was injected into the 'powder' chamber, which, on becoming steam, fired the shot. Steam cannons were, in fact, used during the American Civil War and in World War II for Holman projectors.

Leonardo helped develop firing mechanisms for handguns, then at the threshold of their popularity. His matchlock drawings of 1495 or thereabouts show three mechanisms using a complex system of levers and springs to uncover the pan holding the priming powder while simultaneously applying the lighted wick-match held in 'serpent' jaws. Five years later he produced the earliest form of wheel-lock, in which a chain-activated wheel rubs a flint to produce a spark as in a modern cigarette lighter. The recent discovery of this design overthrows the long-accepted view that the wheel-lock was invented by a Nuremberg watchmaker in 1515.

GUN WITH ARRAY OF HORIZONTAL BARRELS AND GUN
WITH THREE RACKS OF BARRELS
c 1481

Both had screw-jack handles for elevating. They foreshadowed both
Puckle's 1718 rotating-magazine 'Defence' gun, and Gatling's 1862
multi-barrelled gun.

MAPMAKING AND CANAL PROJECTS

In his military capacity as chief inspector of military buildings to Cesare Borgia, son of Pope Alexander VI, Leonardo accompanied his employer on military expeditions to secure his lands. The three aims of his mapwork were military, navigational (and drainage development) and geological. Geologically he hoped to prove his theory that the earth had grown out of the sea, leaving inland seas and lakes to eventually find their way back to the great oceans by means of narrow gorges developing into rivers. One outcome was his *Map of Imola, c*1502-3, a landmark in the art of mapmaking. It involved the use of a magnetic compass on a surveyor's table, a surveying disc marked in degrees and an astrolabe, to arrive at the radial angles of the town's main features. From the centre point he drew 64 radiating lines, besides measuring distances on the ground. He designed hodometers to measure the distances with their wheels rotating every 10 braccia (20ft/6m) and a 'sound of a little stone falling into a basin made to receive it' each mile. What was new was the co-ordination of the bearings with precisely measured distances so as to produce an accurately proportioned plan. He correlated the traditional 'wind rose' of radial angles, indicating the eight main wind directions, e.g. N, NE, E etc, with the major distances he had paced out, so producing the finest town map of his time. It was a marked improvement on the more medieval-style sketch plan of Milan he had produced a decade earlier. Martin Kemp has declared it the most magnificent surveying product of the Renaissance revolution in cartographic techniques. It stirs with life – the river waters surge dynamically in a series of parabolas from bend to bend as they cut into the bank. In the margins of his preliminary map Leonardo also noted the distances to nearby towns.

Military engineering involved Leonardo in considering the defensive use of water. He fully appreciated the importance of water, being particularly fascinated by its erosive powers. It was essential to curb its destructive force, and use it positively for irrigation and transport, as well as for driving machinery. 'Master of Water' was a recognized specialist status in those days.

While working for Pier Soderini, head of Florentine judicial affairs, in 1503, Leonardo planned a canal to ruin Pisa, then at war with Florence, by diverting seven miles of the strongly currented River Arno from Pisa, making the sea flood the city. Leonardo certainly drew plans of the area, but it is difficult to know just how involved he became as he was highly critical of the project. He was more interested in the development of a long-planned commercial waterway to open up Florence to the sea, which would also provide further agricultural land, with irrigation and toll rights. He considered the construction of a canal to bypass a section of the Arno, or, failing that, altering the river bed itself above and below Florence. On a map covering Florence to Pisa, he marked two possible northern canal routes. One necessitated tunnel-

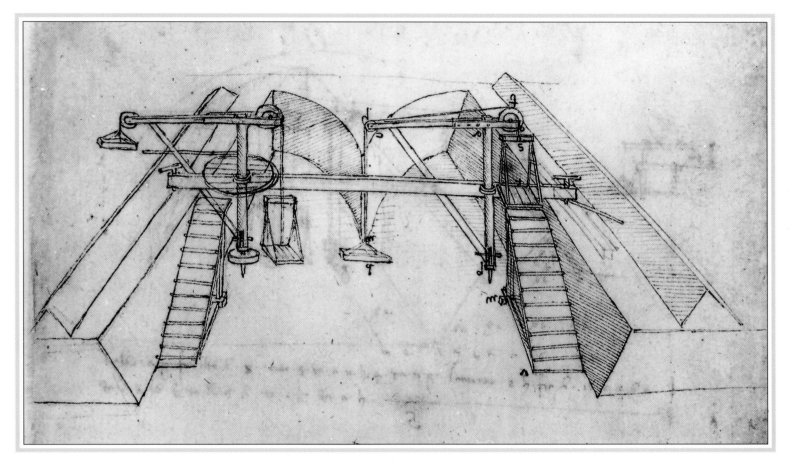

CANAL CONSTRUCTION MACHINE

Huge buckets hanging from pivoted arms conveyed the excavated
soil to the sides, counterbalanced by men who climbed up to the
cradles.

ling through Serraville to avoid a 263ft (80m) flight of locks – the
modern *autostrada* does just that. He designed a measuring device
which enabled calculations to be made to ensure the tunnelling, begun
at either end, met in the middle. His maps used colours to differentiate
heights and an amazing relief method of depicting topography in which
he produced an 'aerial view' effect. On one he noted, 'they do not know
that the Arno will never remain in a canal, because the rivers that feed
into it deposit earth where they enter, and on the opposite side erode
and bend the course of the river'. To ensure the Arno did not dry up in
summer, he marked a possible tunnel to partially divert the River Tiber
into Lake Trasimene, on an 'aerial-like' map of the swampy Chiana
Valley, with hills shaded as on Ordnance Survey maps, and faint
measurement lines on it.

LEONARDO THE CARTOGRAPHER

Leonardo made several maps when he was employed as Cesare Borgia's military architect in Romagna during 1502-3, and when he returned to Florence he became involved with plans to divert the River Arno around Pisa, with which Florence was currently at war. A further scheme concerned the idea of linking Florence directly to the sea by means of a waterway, and yet another with the building of a curved canal to bypass the less accessible reaches of the river. Some of his maps appear very freely drawn, but include precise measured scales and were clearly intended as professional surveys. One is even pricked for transfer, suggesting that a "clean copy" was to be made.

1 Map of the breakwaters and eroded embankment on the River Arno, *c* 1504. This drawing relates to the question of managing the river flow. It shows a section just downstream of the chain ferry, where the merciless vortex had destroyed over 120 feet (36 metres) of the wall.

2 Map of the Arno and Mungone, west of Florence, *c* 1504. 'Three little ditches are to be made, extending from 9 to the bend of the Arno below' to improve the management of the existing river.

3 Map for the Arno canal opening Florence to the sea, *c* 1503-4. Florence is on the right, Pisa on the left. Two possible northern canal routes are marked, one involving a tunnel to avoid a 263-foot (80.2 metre) flight of locks – which is just what the modern autostrada does.

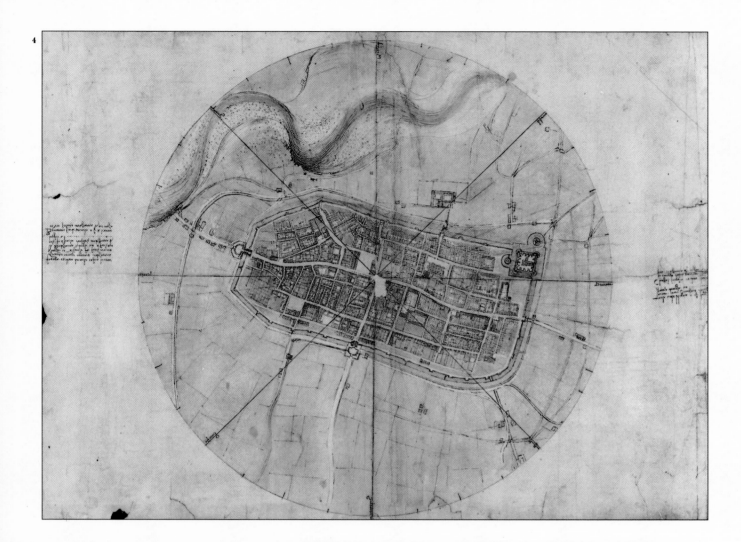

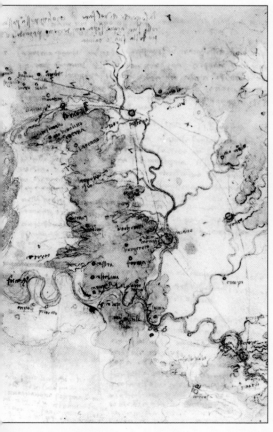

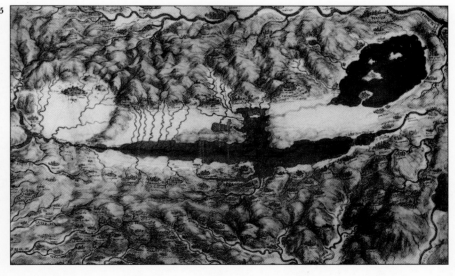

4 The map of Imola, *c* 1502-3, was made when Leonardo was employed by Cesare Borgia, for whom the town was strategically important. It is a marvellous example of Renaissance map-making, with each street and square drawn in with incredible skill and care.

5 Map of the Arezzo and Chiana valley, 1502. A tunnel (top right) would divert water from the Tiber to Lake Trasimene, expanding it to fill the Chiana Valley so that the Arno would not dry up in summer.

153

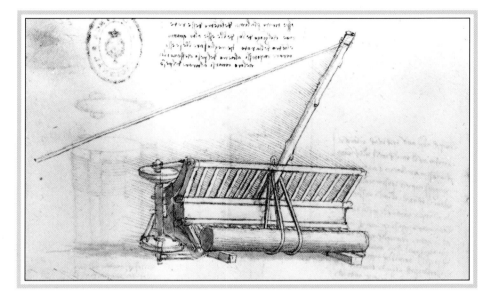

LOG LIFTING AND MOVING DEVICE

The logs were to be lifted onto cradles which could then be moved
on wheels.

Considering the problems, he advised that 'the river, which has to be diverted to another place, must be tempted away and not treated harshly with violence.' This striking comment underlines his feeling of the river having a life of its own, and hence is a reference to his view of the world, with its 'ramifications of the veins of water all joined together' like 'those of the blood of other animals; they are in continual revolution for its vivification, always consuming the places in which they move, both within the earth and outside it'. His *Map of Breakwaters and Eroded Embankment on the River Arno* shows the problems to be overcome. It is not known what Leonardo's solution to these was.

Following optimistic reports by other engineers, digging began in August 1504, while Leonardo was occupied painting the *Battle of Anghiari*. For some while 2000 workmen concentrated on the two Machiavelli canals, 60ft (18m) wide and 21ft deep (6.5m), which he said they could complete in 200 days. But the Arno would fill the new ditches only when it was itself in flood. Before they began, Leonardo had already designed new types of spade, a method of waterproofing wood and a new process for erecting scaffolding. Aware of the limitations of the shovel, he designed two digging machines. A tread-wheel one ran on wooden 'rails' with men counterbalancing earth-filled buckets, but it was never built. The plan was abandoned when a completed section collapsed as the water was let into it. Ironically, he later concluded from his studies that water's corkscrew vortices could be used to divert the river by means of skilfully placed stones. The Milanese cleric, Giovanni Ambrogio Mazenta (1565-1635), wrote of 'Leonardo's invention of machines and gates to level, intercommunicate and make navigable' the waterways of the Lombard lakes.

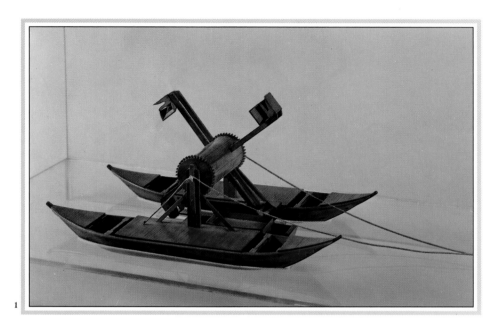

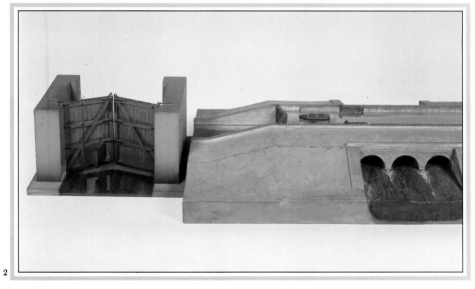

1 DREDGER

The dredger's buckets were designed not only to scoop out the sludge, but also to deposit it on the barge between the floats of the dredger. Both these models have been based on Leonardo's designs.

2 LOCK GATES TO CONTROL WATER LEVELS

An ingeniously simple trapdoor which, when opened by a latch, let water in to equalize the pressure on both sides so that the main gates could be opened. The right-hand section of the model shows Leonardo's idea for sluice gates to control the level of canal water.

THE CIVIL ENGINEER AND INVENTOR

POWER TRANSMITTING DEVICE
MATCHLOCK MECHANISM

In the transmitting device (top), the turning of the two screws moves an arm (rather like a clock hand) around the circle formed by the concave screws. The matchlock mechanism (below) was still a novelty in 1495. Leonardo was working on improving it, using a serpentine jaw to grip the match. Later he turned to the wheel lock.

I n *The Flight of Birds,* Leonardo wrote that: 'Instrumental and mechanical science is the noblest and above all others the most useful, seeing that by means of it all animated bodies which have movement perform all their action; and the origin of these movements is at the centre of their gravity'. Bern Dibner's comment, in 1974, was that 'Leonardo had a magpie mind that picked up ideas everywhere ... The muscle power of the peasant, horse, and ox were replaced, under his pen, by wind and water, gunpowder and steam. [His] notebooks often read like a modern mail-order catalogue that offers an ingenious tool or gadget for every conceivable purpose'. Despite his fascination with inventions, Leonardo could still write, 'Although human ingenuity makes various inventions, corresponding by various machines to the same end, it will never discover any inventions more beautiful, more appropriate or more direct than nature, because in her inventions nothing is lacking and nothing is superfluous.'

Leonardo the engineer and technologist aimed to create a 'second world of nature' by developing machines along anatomical lines. He sought to simplify routine tasks by introducing semi-automation. It should not be thought that he was the sole inventor of his day, for credit must also go to Mariano Taccola and Buonaccorso Ghiberti. As an inventor, Leonardo had a sound grasp of the basics of engineering, but he reached out from the feasible to the fantastic, from the viable to the visionary. While some of his drawings are simply quick sketches, others are so carefully finished and arranged that he seemed near to publishing a treatise, as for example, On the Elements of Machines. Two of his notebooks (Codex Madrid I, II) containing 700 pages of technical drawings 'lost' in 1830 due to misfiling were found in Madrid in 1965.

His treatise was on the 'anatomical' elements of mechanical devices – - levers, pulleys, joints, gears, springs, screws, bearings, and so on. The laws of motion were powerfully implicit in his mechanisms. All his mechanical devices sprang to life when activated by force in response to the universal laws of dynamics. Though he could not claim that screws and gears were to be found in the human body, he stressed that the invented bodies of machines and the created bodies of humans were comparable when both were seen as working in harmony with the universal laws of dynamics.

INDUSTRIAL INVENTIONS

Leonardo sought practical mechanical ways of improving industrial production in an urban society – hammering, shaping stone, wood or metal, casting metal, drawing strip and wire, coining, winding, lifting, moving, digging and weaving. He began by devising new ways of producing cutting tools, making metal plates and wire, bending and

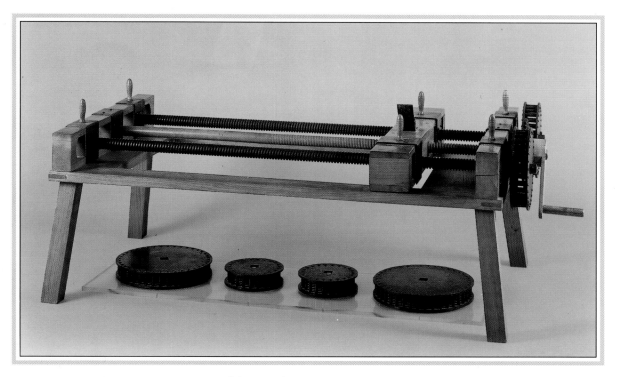

SCREW-CUTTING DEVICE

Model based on Leonardo's designs. This is the forerunner of
modern machine-shop practices. Its interchangeable operating
wheels and double screw rods ensured stability and precision.

twisting metal, casting odd shapes, and then grinding, smoothing and
polishing the parts. He realized that standardization of metal parts for
machinery was essential if semi-automation was to be introduced —
something which classical machinery had never achieved. Such
machines do not have to be complex, as long as one mechanical action
leads to another without the need for human intervention. Much
depended on his knowledge of gears, pulleys and ratchets and so on.

He considered the screw the key to his mechanical studies,
describing it as 'an inclined plane wrapped around a cylinder'. An
examination of the geometry of screws showed they could act as levers.
He tried many thread variations for different uses. He mastered the
usages of V-shaped and square-threaded screws, as well as left- and
right-handed ones. He constructed 'fast' threads by putting a number
of left- and right-handed ones on the same spindle. He introduced the
first differential screw — a spindle with two screw threads of different
pitch. (This invention, used in astronomical telescopes, was, until
recently, credited to Hunter in 1781.) Leonardo's screwcutter, with its
interchangeable operating wheels and stability rods proved the fore-
runner of modern ones.

His filemaker involved a sequence of co-ordinated and inter-
dependent actions which worked automatically once set going. He

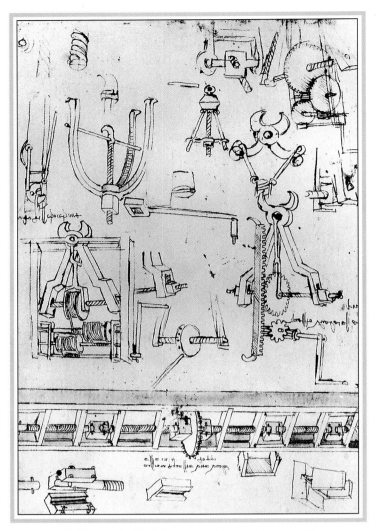

2 RIGHT- AND LEFT-HANDED SCREWS

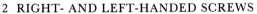

The two opposing screw-threads are combined through the use of
multiple threads on a single shaft.

used the same technique to stamp gold foil automatically for decorative
purposes. In or around 1497 he produced the first metalrolling
machine, guaranteed to turn out smooth, flat tin sheets by means of
two small pressure rollers, which prevented the main rollers from
bowing at the centre. He developed a machine for boring holes through
logs to make water conduits. It featured automatically adjustable
chucks to clamp the log whatever its thickness.

His wire-making machine mechanized the primitive techniques of
his day by pulling it through adjustable dies. Another advanced
mechanism ground and polished the insides of cylinders, using adjust-
able wing nuts to hold the cylinder in hollow jaws as a toothed disc
regularly descended to do the cutting, before a spring reversed it to do
the polishing. Such boring devices were needed for pumps and cylin-
ders in mills, locks, hydraulic fittings and in cannons.

'No coins can be considered good which do not have the rim perfect;
and in order to ensure the rim being perfect it is necessary first that the
coins be absolutely round.' Having stated the problem, Leonardo
solved it by designing a blank-punching device which produced blanks
that were perfect in weight, breadth and thickness. Spoked wheels were
turned to wind up a rope that pulled a weight to the top of a high
column. Once at the top, the weight was released and descended to
activate a long cutting rod which cut into a metal strip from which the
blanks were punched.

1 WIRE-MAKING MACHINE

This mechanized contemporary techniques by pulling wire through
adjustable dies. The stronger the pull, the tighter the tongs grasped
the wire, as ball-bearings reduced the friction.

FAST-THREAD SCREWS AND OTHER MECHANICAL DEVICES

'Fast' threads, produced by combining right- and left-handed screws
on a single shaft, are used in many modern mechanisms. Grappling
devices are also shown.

161

GEARS, BEARINGS AND SPRINGS

Leonardo was alert to the need for lubrication for machines, then done by pouring oil or spreading tallow between moving surfaces. He discovered that the amount of wear on a bearing is related to the load, and that the direction of the wear follows that of the load. He admitted clogging caused his automatic oiling attempts to fail and tried different materials to reduce friction. To minimize axle friction, he suggested a bearing block with an anti-friction metal 'bushing' of copper and tin alloy – two centuries before Robert Hooke proposed such a metal to the Royal Society. His notebooks show how his experiments progressed, with *'falsa'* written against any that proved unworkable.

Renaissance materials did not produce the long-lasting teeth needed for gears. With heavy weights Leonardo noted, 'do not use iron teeth, because one of the teeth may easily break off; so use the screw, where one tooth is bound to the other'. What he called his 'endless screw' was a revolutionary design, now known as the Hindley worm gear, after the English clockmaker Henry Hindley, who claimed to have invented it in the 18th century.

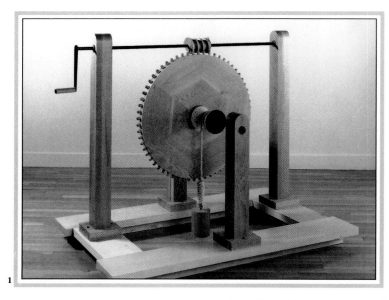

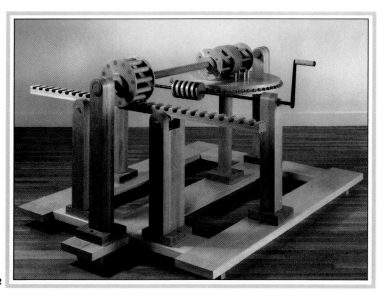

1 THE TRANSMISSION OF ROTARY MOTION INTO ALTERNATE RECTILINEAR MOTION

Model based on Leonardo's design, shown opposite. He considered a number of schemes for the generation of back-and-forth motion.

2 HELICOIDAL OR WORM GEAR

Model after Leonardo's designs (see opposite). With its concave profile, this gear is designed to reduce the likelihood of the teeth snapping.

1 WORM GEAR

Leonardo's drawing of the traditional worm gear.

2 DESIGN FOR THE TRANSMISSION OF ROTARY MOTION
INTO ALTERNATE RECTILINEAR MOTION

A number of designs from the same manuscript give alternative
ideas for back-and-forth motion.

3 IMPROVED WORM GEAR

Leonardo's new design is the same as the Hindley worm gear.

LEONARDO THE TECHNOLOGIST

Some of Leonardo's industrial inventions, such as the worm gear, were direct responses to particular problems, but the main body of his work in this field can be seen in a wider context. To him, humankind was the reflection of nature in structure, proportion, and the universal laws of function and form, and both his inventions and his architectural designs are bound up with his studies of anatomy (God had 'built' man as the perfect machine). Thus there are analogies between, for instance, the muscles which support the neck and the armature for a lifting device, as there are between the structure of the heart and a colonnaded building. 'Science', he said, 'is the knowledge of things which are possible.'

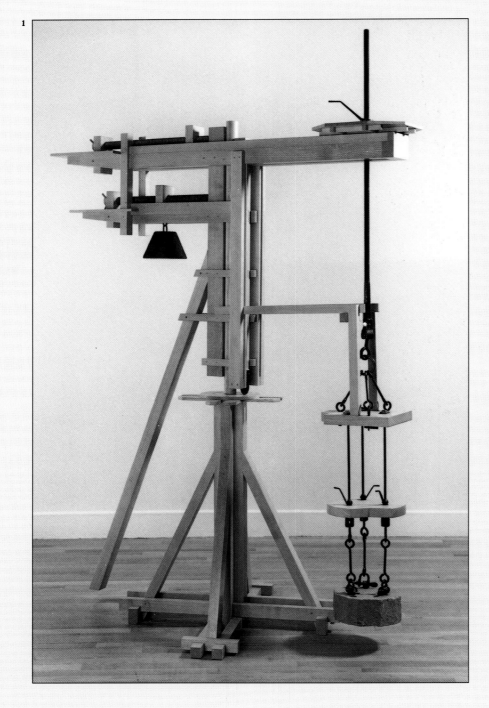

1 Revolving crane. This is a model reproducing a machine invented by Filippo Brunelleschi, who designed it to position cut stones on the dome of Florence Cathedral. It involved principles of balance, which Leonardo followed up.

2 Ball-bearings race. By placing the bearings in a ring-shaped race, Leonardo allowed them to rotate freely.

3 Double screw jack, a machine powered by the crank on the left. One worm gear turns the horizontal shaft, which is equipped with two identical worm gears. These turn the two long vertical screws at the same speed. This device was probably intended to lift cannon barrels or stone columns.

4 A screwjack designed to overcome the friction caused by a load-bearing surface. On the upper left, Leonardo noted the similarity of ball and roller bearings. He used ball-bearings to ease friction between the turning nut and the plate of his jack.

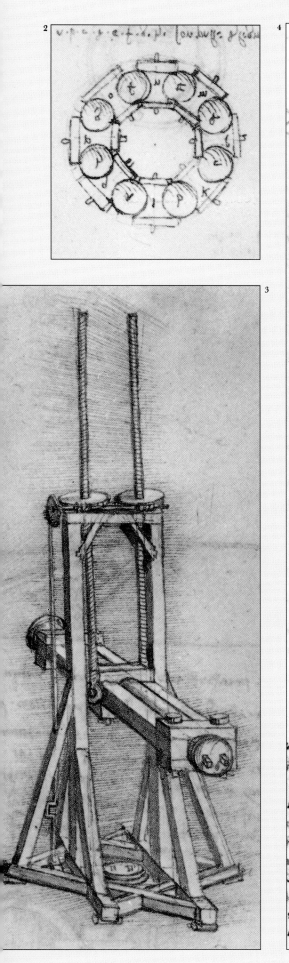

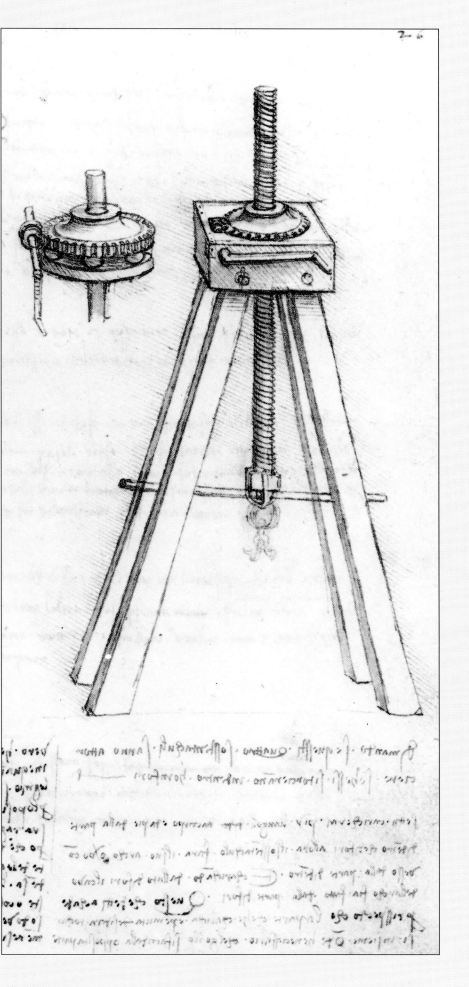

It is impossible to know if Leonardo or Brunelleschi invented the two-wheeled hoist with a caged gear. Leonardo's designs included a screw-jack with ball-bearings to reduce friction and hence wear. A sketch for his ball-bearings is identical to one made as late as the 1920s for 'blind-flying' aircraft instruments. Dr Bassett of the Sperry Gyroscope Company admitted in 1967 that he had no idea that Leonardo had already produced this solution. Leonardo himself realized that if the ball-bearings touched each other they would have a slowing effect, so he placed them in a ring-shaped race for free rotation – a solution re-invented in 1772.

From such experiments, he concluded that frictional resistance differs according to the smoothness of the surfaces in contact, that it is independent of the area of the contacting surfaces, and that it increases in direct proportion to the load carried, and can be reduced by the use of rollers or lubricating fluid. Though these laws may be obvious today, it was Leonardo who performed the experiments and proved them at least two centuries before scientists began the modern study of friction.

Leonardo developed the barrel spring as a useful source of power for clock mechanisms, as it overcame the problem of a spring losing power as it uncoiled. His compact, precisely controlled mechanism replaced the 15th-century fusée, a conical spindle which reeled out catgut thread so as to regulate the spring's motion.

For the Florentine textile industry, he designed a semi-automated spool-winding machine, with a crank turning the bobbin and flyer in opposite directions to distribute the thread evenly on the bobbin. He followed it with mechanical looms and a needle-sharpening machine, from which he dreamed of earning 60,000 ducats a year. His gig mill raised the nap on woollen cloth, while his shearing machine's spring-jointed shears cut it off, a job then done by men using enormous scissors. These two machines led to redundancies among workers – a precursor to the Industrial Revolution several centuries later.

Early on Leonardo realized the power inherent in heated air. He entered the world of gadgetry with his roasting device for meat. Methods for transferring the use of power came next. His drawing of a windlass, which translates rotary to reciprocating motion, would make a 20th-century engineer envious. He adapted the mechanism to propel a boat's vertical paddles and to operate a grain mill. Systematically he searched for ways to make machinery operate more simply and speedily. Success would mean a greater uniformity of product and a higher output per operator, and hence a lower cost per unit. A modern approach indeed.

In 1495 he invented a support system for church bells using axles resting on roller bearings – a task that had defeated Francesco Martini. The device was used for the Mutte bell in Metz Cathedral, *c*1605. Without crediting Leonardo, Jacob Leupold, in his *Theatrum Machinarum Generale* (1724), referred to the system as 'the oldest and most common'. Among Leonardo's other practical designs was a release mechanism based on tension for automatically releasing a load

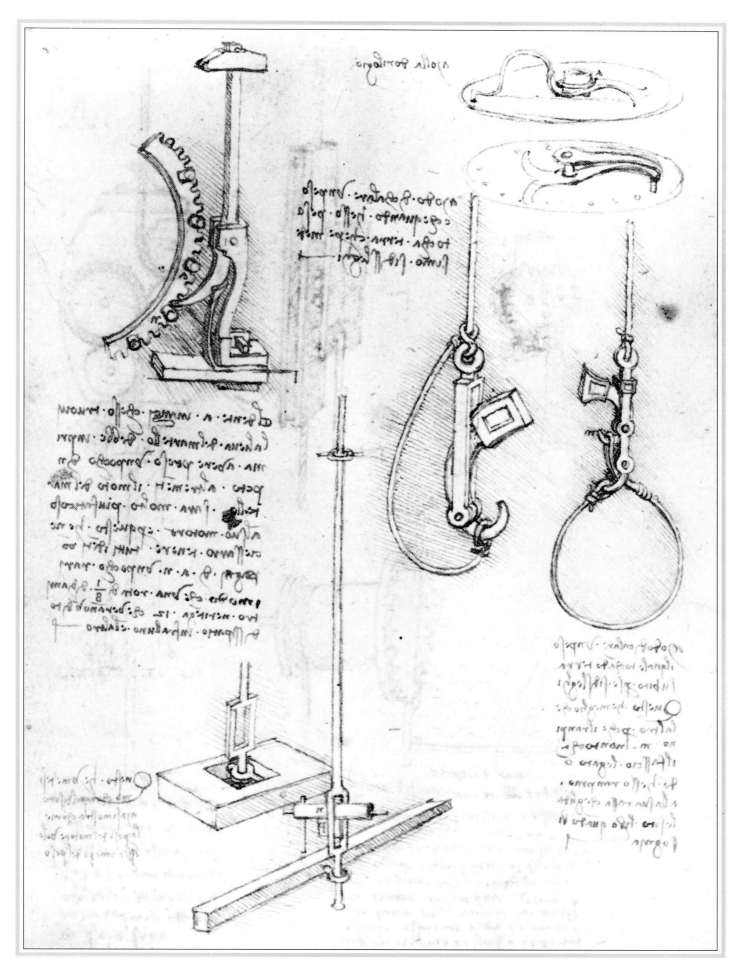

AUTOMATIC RELEASE MECHANISM

Based on tension, it automatically releases a load from a hook on
completion of its descent.

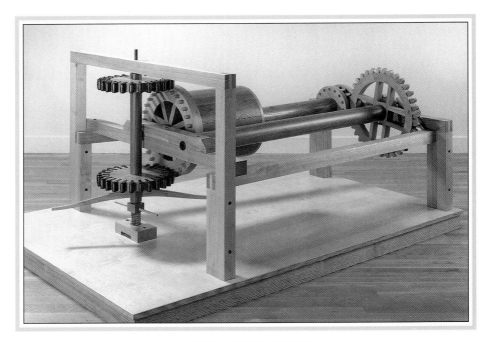

THREE-SPEED HOIST

This is a model from another of Brunelleschi's inventions used in the
building of Florence Cathedral.

from a hook. He also developed reversible hoists and revolving cranes
from inventions by Filippo Brunelleschi, which Verrocchio's workshop
used for erecting Florence Cathedral's dome between 1468 and 1472.

Brunelleschi's inventions solved the problems of transmitting motion
from one plane to another, using gears to increase lifting power and
bearings to reduce friction. Though Leonardo's drawings are in this
case of existing machines, and not his own inventions, his mind was
actively considering them as he noted the physical laws behind them.
He invented a new method of salvaging sunken ships by pumping air
into skins attached to the ship – a system the Dutch re-invented in 1688.
Similar systems are used today.

When pages of *Codex Atlanticus* were unglued this century from the
subject albums that Leoni had arranged them in, not only were
Leonardo's fortress drawings discovered on the backs of the glued-
down pages but that of a wooden bicycle too, drawn around 1493. It
had a rear-wheel chain drive with 'modern' pedals turning a wooden
cog, though the front wheel had no obvious means of directional
turning.

Recent reconstructions of his designs have shown that his drawings
were not the kind a modern machine-maker would require. Even the
most precise ones require the manufacturer to make crucial engin-
eering decisions. Perhaps he expected manufacturers to adjust them as
required. On the other hand, his drawings may only have been a
means to attract patronage or for treatise illustrations, and not working
ones at all.

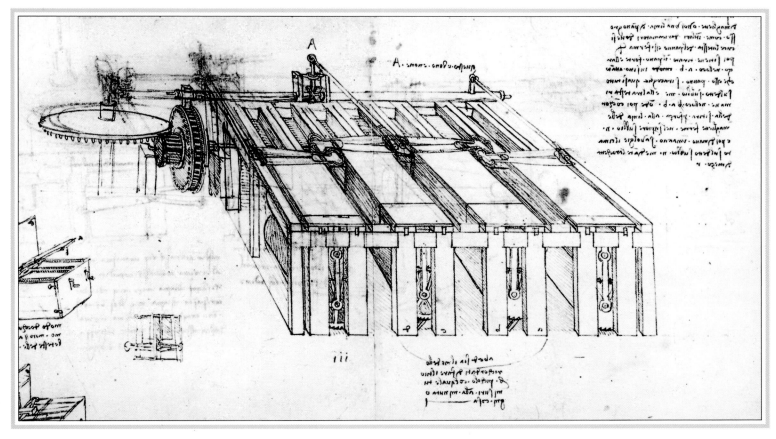

SHEARING MACHINE
c 1495

This was designed for cutting the nap off woollen cloth, and
replaced men using enormous scissors. Four strips of cloth were
steadily pulled over the frame as spring-jointed shears napped them.

TECHNOLOGY FOR THE ARTIST

Leonardo also invented the perspectograph which enabled the artist to
trace the outlines of a model onto glass, and consequently produce his
drawing in true perspective. This mechanical aid was adopted by
Albrecht Dürer. Leonardo's interest in mathematics led to his inventing
a wide range of compasses for making parabolas and ellipses, as well as
proportional compasses for copying a figure in given proportion.

'Mechanics is the paradise of the mechanical sciences, because with
it one comes to the fruits of mathematics.' Yet he was forced to come to
the conclusion that the relationship between mathematical theory and
practice was far from straightforward. Even 'the science of weights is led
into error by its practice', he conceded, referring to the ancient philos-
ophers' error in claiming nature had placed 'the axis of balances' as
'poles of a mathematical line'. His experiments led him to conclude
that 'There is an infinite difference between the mechanical point and

the mathematical point, because the mechanical is visible . . . the mathematical point on the other hand is invisible.'

Realizing that woodcuts were not fine enough for reproducing his drawings, and the new metal engravings were too costly, he devised a method of copperplate relief etching. 'Coat the iron plate with white lead and eggs and then write on it left-handed, scratching the ground. This done, you shall cover everything with a coat of varnish . . . Once dry, leave the plate to soak, and the ground of the letters, written on the white lead and eggs, will be removed . . . hollow out the ground in your own way and the letters will stay in relief . . .' This method was to be re-invented by William Blake three centuries later. Leonardo's 'modern' method could have made his drawings widely available, but the first were only to appear in 1651, thus depriving Italy of his developments within his lifetime.

HYDRAULICS AND PERPETUAL MOTION

Leonardo's Milanese notebooks show he worked hard to expand his knowledge, grappling with Latin where unavoidable. By 1495 he had a library of forty books. He made notes of things to do:

> Memorandum: Ask maestro Antonio how mortars are positioned on bastions by day and night. Ask Benedetto Portinari by what means they go on ice in Flanders. Get the master of mathematics to show you how to square a triangle. Find a master of hydraulics and get him to tell you how to repair, and the costs of repair of a lock, canal and mill in the Lombard manner.

In 1508 he designed a hydraulic well pump and a falling weight and ratchet arrangement with teeth inside wheels. He listed eleven kinds of water mill, including ones for grinding corn, spinning silk and making gunpowder. There was little call for windmills in the uncertain wind conditions of Italy, but Leonardo did sketch some, probably for the Turkish Sultan, Bajazet II.

His fascination with the vortex motion and power of water led him to consider the possibilities of achieving perpetual motion. Renaissance engineers sought such an achievement, as raising water had a consider-able economic value. About 1493, he considered the possibility of a compound system of Archimedean water screws providing sufficiently varied curvature to achieve perpetual motion. One drawing suggests that water could ascend in an inner spiral before returning downwards in a wider one ready to ascend once more, while another considers using planar and conical spirals. A perpetual pump drawing shows water passing from the spout into a container from which it can press down the pump's handle, so raising more water. A counterweight pressed the piston downwards when the water was released, but unfor-tunately it was not the solution.

*Studies of 'Perpetual Wheels', c*1495-7, show Leonardo's investigations proving it was impossible to develop a perpetually revolving wheel. He arranged weights on hinged axes so that they tumbled downwards to provide impetus. He calculated that the wheel would gradually slow down 'whatever weight shall be fastened to the wheel'. He also tried eight balls in twelve channels, four of which were on each side of the axis. They were to run down the channels and cause 'percussion' to make the channels pivot around their axis and send the balls back again. By 1550 he had to admit that any mechanical system he could devise was bound to lose too much power at every stage of its operation.

> I have found amongst the excessive and impossible beliefs of man the search for continuous motion, which is called by some the perpetual wheel, and has occupied the attention of many ages with long research and great experimentation. It has regularly employed almost all the men who take pleasure in mechanisms for water, war and other subtle contrivances. And always it finally transpired – as with the alchemists – that through a little part the whole is lost.

He also warned:

> O speculators on perpetual motion, how many vain designs you have created in the like quest! Go and join up with the seekers after gold!

BRIDGES

His grand-scale engineering projects in or around 1502 included one for Sultan Bajazet II's ambassadors, who were then in Italy looking for engineers to replace the pontoons over the Golden Horn with a bridge. 'Bridge from Pera to Constantinople 40 braccia (1 braccio = 2ft) wide, 70 braccia high above the water, and 600 braccia long; that is, 400 over the sea and 200 resting on the land, providing by itself its abutments', noted Leonardo with his sketches. Its double ramps resembled a swallow's tail. In 1952 the chance discovery of a Turkish translation of Leonardo's letter offering four projects, together with sketches, proved that the proposal was his, and not Michelangelo's, as Vasari had claimed. They included a special kind of windmill, an automatic pump for draining a ship's hull, a bridge from Pera or Galata to Constantinople and a drawbridge to reach the Anatolian coast. A modern Swiss scientist, D. F. Stussi, has calculated that Leonardo's bridge was feasible.

On the construction side, his *Device for Bending Beams, c*1488, for bridges, vaults and roofs, was viable. It may have been produced in connection with his plans for Milan Cathedral. With the apparatus firmly anchored below ground because of the strains involved, it shows how pegs were moved into lower holes as the beam was bent. In 1839, the 155ft (47m) wooden bridge at Signau, Switzerland, made use of this technique.

FLYING MACHINES

In 1487 Leonardo took the idea of a parachute from a Roman military tent, reckoning a 24ft (7.5m) broad and high 'reinforced cloth pavilion' would enable a man 'to throw himself from any great height without injuring himself'. For Leonardo, analogies between the products of the engineer and nature were almost inseparable, especially in flying machines. About 1500 he wrote, 'A bird is an instrument working according to a mathematical law. It lies within the power of man to make this instrument with all its motions, but without the full scope of its powers; but this limitation only applies with respect to balancing itself. Accordingly we may say that such an instrument fabricated by man lacks nothing but the soul of man'.

Hoping to create 'a second world of nature', from 1503 he devoted a large portion of his life to the study of flight. 'In order to give the true science of the movement of birds in the air, it is necessary first to give the science of the winds, and this we shall prove by means of movements of water.' The solution lay in understanding how birds flew. He analysed their flying techniques in minute detail, noting how they made use of the air's movements. He appreciated that a bird's aerodynamics were perfectly adjusted to exploit, with maximum economy, the impetus acquired by wing flapping, or from gravity by freefalling. He noted that birds adjusted their wing and tail angles in response to changing air currents, often using a vortex spiral motion. Birds clearly used their centre of 'natural gravity' to achieve ascent or descent. They were able to shift this centre so that it was in front of, or behind, the 'centre of resistance' made by the wings, in a way a purely geometrical body could not do. A bird's tail acted as a reciprocating lever against the air currents to ensure that it did not turn right over, as it creates a turning moment around the bird's 'centre of revolution'. Leonardo worked out the relative degrees of diagonal descent and ascent in relation to the speed of air currents. As he put it, a bird in flight is 'an instrument working according to natural law'. Flying would turn him into a 'supernatural' being by imitation. He spent years studying the structure of birds' wings, the muscles controlling them, and the function of their feathers. Bats provided his best example, as their wings were not hampered by feathers that could become heavy with rain.

The outcome, around 1504-5, was the compilation of thirty-six pages of notes and pictures on bird flight, written in the passionate conviction that manflight was possible, perhaps within his lifetime. 'The same force is made by an object encountering the air as the air against the object. See how the percussion of the wings against the air is able to support the heavy eagle in the rarefied air close to the element of fire (outer atmosphere) . . . From these demonstrations and their appropriate causes man may learn, with large wings attached to him, to draw power from the resistance of the air, being victoriously able to overcome the air, raising himself upon it.'

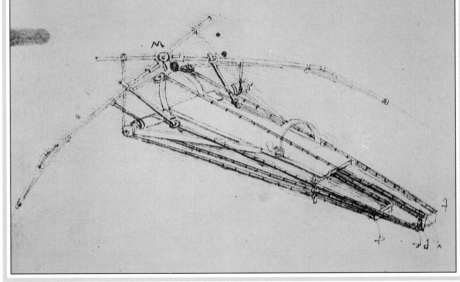

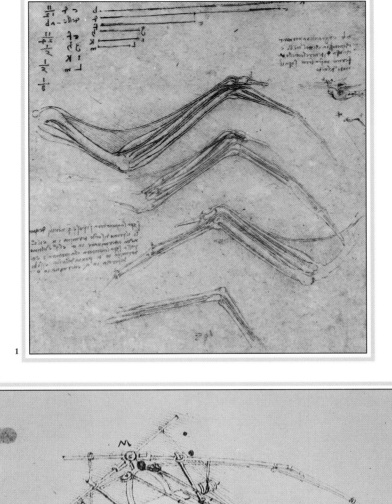

1 STUDIES OF THE ANATOMY OF A BIRD'S WING
c 1510-14

One of Leonardo's studies of bird flight.

2 DESIGN FOR A FLYING MACHINE
c 1488

The wings were made of a network of wooden nerves and a coating
of cloth, onto which was glued a layer of feathers.

In his *Codex on the Flight of Birds* (written between 14th March and 15th April, 1505, but incomplete), he forecast that 'the great birds' first flight would be from Monte Cecero (the Swan mountain) near Fiesole, just outside Florence, where he had a house. The flight would fill 'the universe with amazement, filling all writings with its fame and eternal glory.' Was this just a prophecy? Legend has it that an actual attempt was made, with the machine taking off as planned, only to crash and break the leg of the pilot, a pupil of Leonardo's. But nothing is recorded in his notebook.

In Milan he made use of an upstairs room to make secretly a model of a flying machine based on bats' flying methods. He boarded the window up so that no one could see in case it failed. Noting that flying it from the roof to the courtyard below would be an ideal test, he added, 'If you stand upon the roof at the side of the tower, the men at work upon the cathedral will not see you.' He began his design with a pair of wings attached to a man's shoulders. His *Design for a Flying Machine, c*1488, had a cane skeleton, leather tendons, muscular steel springs, starched taffeta membranes. Retractable flaps were provided, which opened when taking off and closed on landing.

One drawing shows a stooped man working a piston with his head while turning windlasses with his arms, to operate four flapping wings, each of which is almost 80ft (24.5m) long, like a kind of monstrous dragonfly. He evolved 'skin' flaps to allow air to penetrate the wings on the upstroke while closing completely with the pressure of the down-stroke. All these devices were later used in aeroplane construction. The wings were moved by the hands on take-off and by the feet on landing. A model made in 1989 weighed 650lbs (295kg), strikingly heavy when compared to the *Daedalus 88's* 72lbs (33kg), which flew 74 miles (119km) in 1988. A later, more complicated design, had the pilot upright, operating the four wings by pushing a pole with his head, turning two cranks with his hands and pressing two pedals with his feet. Steps were provided for mounting and dismounting.

Leonardo's *Studies of the Anatomy of a Bird's Wing and Bird Flight, c*1510-14, dealt with the aerodynamics of bird flight, showing that by then he had realized that direct imitation was impossible, as a comparison of a bird's anatomy with man's showed. The bird's power-to-weight ratio could not be copied by man, as a bird's muscles possess a greater weight than all the rest of the bird. No man could achieve the speed and efficacy of wing flapping which birds were capable of.

The alternative was a mechanical means of flight instead of a muscular one. He invented the helicopter, or flying screw, which anticipated the principle of a propeller on a plane, and a parachute. In his notebook he recorded, 'If a man has a tent made of linen of which the apertures have all been stopped up, and it is 12 ells (27 feet) across and 12 in depth, he will be able to throw himself down from any great height without sustaining any injury.' Of one design he noted that 'The machine should be tried over a lake, and you should carry a long wineskin as a girdle so that in case you fall in you will not be drowned.'

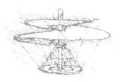

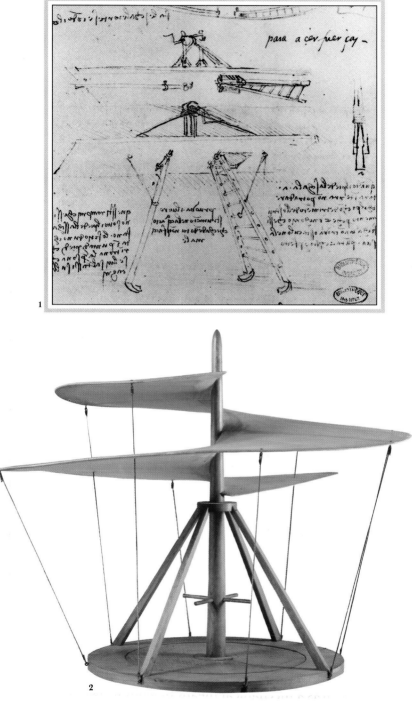

1 A FLYING DEVICE

Realizing it was impossible to simulate the movement of birds'
wings solely by muscular power, Leonardo developed the idea of
pedal manipulation and four wings.

2 LEONARDO'S 'HELICOPTER'

A model based on Leonardo's device.

THE ARCHITECT
AND
TOWN PLANNER

DESIGN FOR A MULTI-LEVEL TOWN
c 1488

Arcaded walk-ways, elevated gardens and lower levels for storage
and a service canal.

R enaissance architects used the harmonies of proportion underpinning God's design of nature as the guidelines for designing beautiful buildings. Just as there was proportion in the universe, they argued, so there must be in architecture. Furthermore, the concept was musical in nature, as the heavens moved according to a divinely orchestrated pattern – the 'music of the spheres'. The Renaissance humanist saw the body as temple-like in design. The cruciform church reflected the crucified Christ.

Leonardo was much influenced by Francesco di Giorgi, having travelled with him to Pavia and read his book on architecture. Giorgi had sometimes superimposed a human figure on ground plans of buildings. Using the navel as the central point of a man lying on his back, Giorgi argued that his fingers and toes will touch the circumference of the circle made from the navel. 'And just as the human body yields a circular outline, so too it yields a square figure.' Luca Pacioli echoed Leonardo, in saying, 'Having considered the right arrangement of the human body, the ancients proportioned all their work, particularly the temples, in accordance with it. In the human body they discovered the two main figures without which it is impossible to achieve anything, namely the perfect circle and the square'.

The proportional relationship of the parts reflected universal design. In the late 1480s the theme of the artistic *microcosm* emerged as the one great unifying principles in Leonardo's thought. Man, the *microcosm* or 'lesser world', should design his buildings to reflect the Almighty's *macrocosmic* creation. His architectural application of this principle was the beginning of a concept which had a literally universal application.

THE IDEAL CITY

In those days cities were enclosed within defensive walls, the population living in tiny houses in close alleys, which encouraged periodic plague epidemics. Such an outbreak in Milan in 1484-5 led Leonardo to sketch out a radical solution – an ideality – to the contributory factor of overcrowding. He was the first to grasp the importance of decentralizing the population. His urban planning involved segregating the rich from the poor, keeping the former inside the city and moving the latter outside.

The poor would live in healthy residential communities. The wallless city would be like a chessboard, criss-crossed by a road and canal network. There were gardens, squares and fountains in abundance. Elevated walkways for pedestrians crossed the city. At the highest of three levels, there was an arcaded walkway for gentry amidst the beautiful houses and 'hanging' gardens; in the middle, there were centrally drained roadways for deliveries by cart or canal; at the bottom, underground channels to carry away sewage. Vigorous circulation made for a healthy city. 'One needs a fast-flowing river to avoid the corrupt air produced by stagnation, and this will also be useful for regularly cleansing

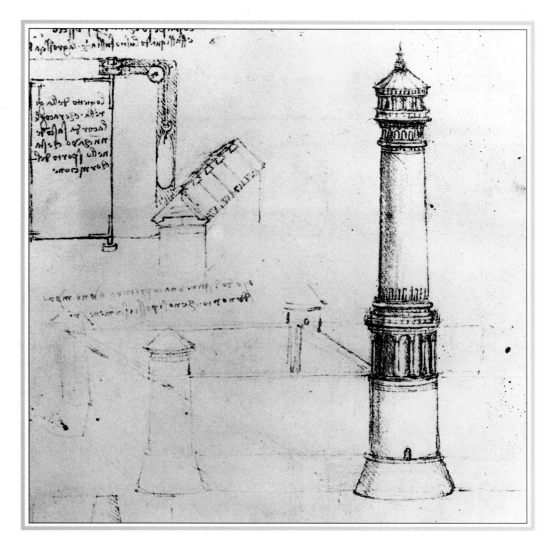

ARCHITECTURAL DRAWINGS AND A PLAN FOR A TOWER

A fine example of Leonardo's rational approach to architecture.

the city when opening the sluices.' Such street cleaning and refuse disposal were undreamed of at that time. Leonardo's drawings showed sections of a multi-storeyed palace with a bridge over a canal, and an arcaded communications system. A pilot project involved building a section centred on a square. The whole concept was a characteristically dynamic one. He used his anatomical knowledge to make metaphors for city design, talking of arteries, circulation and respiration. Even today, town planners speak of arterial roads and traffic circulation.

The nearest Leonardo actually came to planning a new town was in connection with Francis I's request in 1517 for a new palace at Romorantin, France. Caesar's military camp formed the basis, as it suited French imperial dreams. The landscaping ensured fertile surroundings by including dykes, weirs, canals and an aquatic tournament lake. Formal gardens with fountains were to surround a rectangular palace embellished with Renaissance classical motifs and French-style round towers. On a torn page of *Codex Atlanticus* Leonardo mapped the region, giving a bird's-eye view of nearby Romorantin. To increase the population he wanted to move a neighbouring village, claiming their houses could be demolished and re-assembled like prefabs. It is not known why Francis dropped the plan, though the foundations were still visible in the 18th century. Perhaps it was a mixture of Leonardo's age and the alternative attraction of Chambord in the Loire Valley as a site.

'BODY-BUILDING' DESIGNS

Leonardo gave new importance to the long-accepted parallel between the design of a building, such as a cathedral, and the structure of the human body. Both were to be ruthlessly investigated to determine the rules of nature's 'necessity'. Thus he joined in the 1487 competition for building the domed crossing tower (*tiburio*) of Milan Cathedral, withdrawing only out of respect when he heard that the great Bramante was competing too. When applying, he expanded on the old idea of the importance of the architect understanding the meaning behind such a building, just as doctors and teachers need to appreciate what life and humanity really are. 'The needs of the ailing cathedral are similar' to those of a patient, so that 'what is needed is a medical architect who knows what a building is'. Hence the significant visual comparisons in his study of churches and bodies. None had developed such a high sense of a building as a kind of natural organism before. His *tiburio* design immediately suggests words like 'skeleton' and 'ribs'.

To draw attention to the similarity between a dome and the 'dome' of a skull, he stressed his analogy of a sound building being like a healthy body. Around 1489 he drew two views of a skull to try to correlate the skull's mathematical proportions with the location of vital components of the brain: the *'senso comune'* being the gathering point of the senses, for example. Similarly the ventricles of the heart are likened to the interior of a colonnaded building. Thus his drawing of the ventricles of the heart suggests the vaulting of divinely planned architecture.

His *Centralized Temple, c*1488, is one of thirty designs for churches based on a variation of squares, polygons or combinations of both done at Milan between 1487 and 1490. Such centralized designs were typically Renaissance, as demonstrated by Brunelleschi's work in Florence. Alberti wrote of Vitruvius' definition. 'The harmony and concord of all the parts achieved in such a manner that nothing could be added or substracted except for the worse.' Such architects all argued that centralized designs (square, polygonal or, best of all, circular) were the most beautiful for worshipping in. From a liturgical standpoint, the clergy were not so keen on centralized designs, so only a few were commissioned during the 15th century.

Though Leonardo drew at the height of the Renaissance, his design foreshadowed the Baroque. His plans were all derived from putting together a number of simple geometric shapes in symmetrical patterns. Starting with a large central space – square, octagonal or circular – he added clusters of different shapes such as smaller domes. This provision for numerous mass-saying altars gave his designs a rather cluttered look. The mathematical integration of the parts somehow achieve a compelling sense of exterior organic unity in a way uniquely Leonardo's own. He moved with complete fluency between geometric abstracts and actual building elements such as walls, columns and

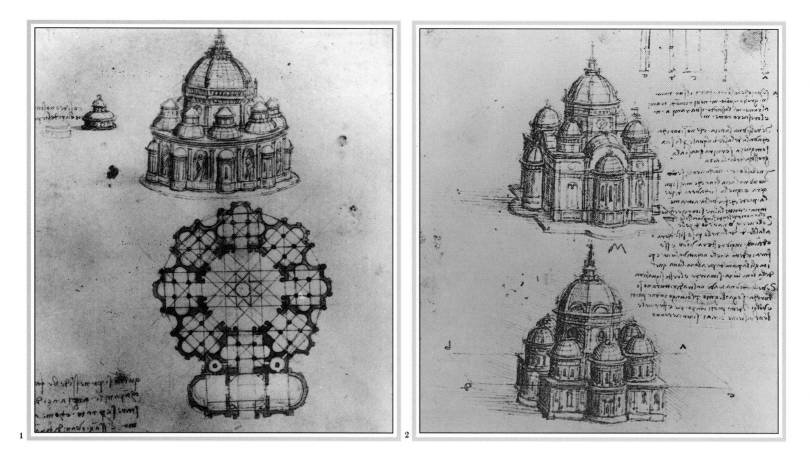

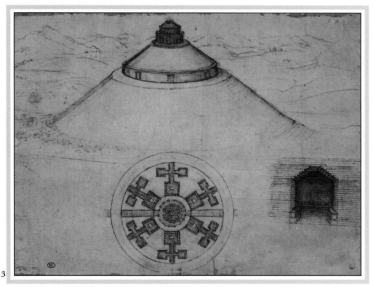

ARCHITECTURAL DRAWINGS

Centralized church (1), domed churches (2) and a mountain-top
mausoleum in the antique manner (3). The first two date from
c 1488 and the third to *c* 1507.

capitals. In one study, he effectively offered two churches for the price of
one, as either the whole structure could be built, or an 'upper storey' of
eight circular chapels could be brought down to ground level by
omitting the square base. His systematized designing foreshadowed the
computer-aided architectural designs on shapes and space layout of
today. Indeed one of Leonardo's designs appeared in W. J. Mitchell's
Computer-Aided Architectural Design in 1977. However, when a model was
made of one design in 1989, discrepancies were found between the per-
spective and the plan in relation to the side chapels.

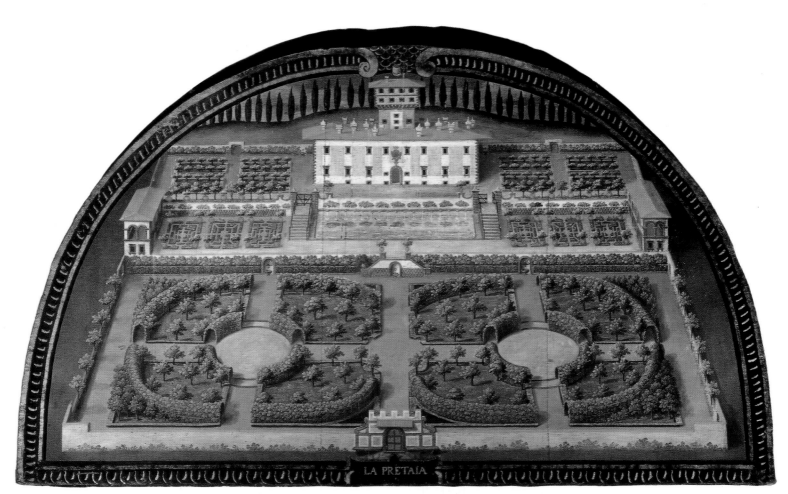

THE ORNAMENTAL GARDEN OF THE VILLA DELLA
PETRAIA

Leonardo drew inspiration from this formal garden.

GARDEN-CENTRED LUXURY

In 1508 he designed a *palais de luxe* for the French king's representative in Milan, Charles d'Amboise, which centred round an entertainments arena. Hygiene-conscious, Leonardo fitted a set of water-closets connected by flushing channels within the walls and with ventilating shafts reaching to the roof. The closet doors were automatically closed by counterweights. The rooms were water-cooled in summer. He devised a secret fountain in the garden 'where, when people walk along, the water will shoot upwards from the ground underneath so as to serve the purpose of those who want to wet the ladies, or others, from below'. The garden was to be roofed with thin copper netting to prevent the song birds from escaping. He was concerned to make the garden, plants and trees, including their shape, mirror the building's design. He drew on Pliny's plant list and Crescentis' 14th-century book on gardening, which included a section on the purpose of gardening and the use of geometric plots, trellis, climbers and summer houses. His desire for gardens with harmonious proportions echoed Vitruvius, who, like Alberti, emphasized the need for architecture and design to reflect the underlying harmonies of nature. Alberti advocated the medieval walled garden for security purposes, but suggested it should be set on a slope to enable users to see over the walls. He argued the case for topiary and

twisted, knotted forms of trees. Leonardo took up his idea of painting garden scenes indoors, as seen in the *Sala delle Asse*. Leonardo was also influenced by 15th-century herbal books.

The 1st-century writer, Lucullus, inspired Leonardo to give ingenious advice for water pumps and manure storage. Leonardo grasped the need to envisage a garden as a whole, as a place of sound, smell and sight – a refreshment for all the senses. 'By means of a mill I will make unending sounds from all kinds of instruments, which will make music as long as the mill continues to move.' Not only would the mill produce the sound of running water, but also power the fountains. Bramante's Belvedere design at the Vatican included dramatic levels and stairs, which led Leonardo to include an elaborate facade and ornamental staircase in his plans. Tragically the *palais de luxe* was never built.

Part of the new Medici palace he designed in 1515 was a 'mechanized stable' for 128 horses, which reduced labour and improved hygiene. Its triple-function vertical structure involved fodder being kept upstairs and fed through service shafts to the horses on the ground floor, where the sloping floor drained off sewage into underground tunnels. The 220 by 80ft (67 by 24.5m) ground floor was divided lengthwise into three sections, the outer two for stables and the central one for access and 'servicing'.

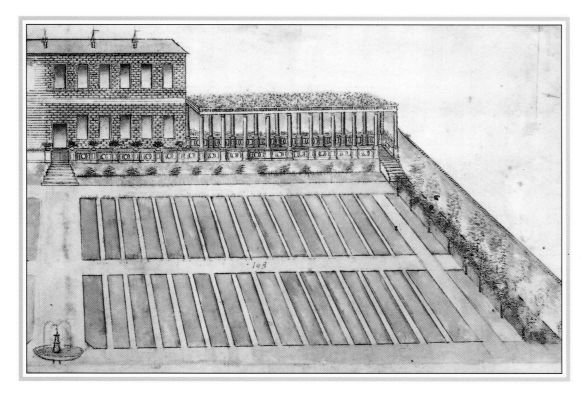

A VILLA, GARDEN AND FOUNTAIN

Professor Pedretti believes Leonardo was commissioned to duplicate this design of *c* 1500, which may be the Villa Tovalglia, for Francesco Gonzaga in Mantua.

LEONARDO AND THE THEATRE

As a master of allegory, allusion, symbolism and visual puns, Leonardo was a welcome member of the Sforza pageant industry. He loved bewilderingly intertwined allegories, heraldry, astrology and personal symbolism. Though he decried astrological forecasts, his astrologically minded employer, Ludovico, Duke of Milan liked talisman devices.

Leonardo's taste for the fantastic went hand-in-glove with his rational scientific approach to life. *Fantasia*, being an extension of rational thought, rather than a negation of it, involved inventions, monsters, and all, so he happily drew unicorns, while his notebooks refer to legendary animals taken from Pliny and medieval sources. He often drew dragons together with cats and horses; studying animal movements led him to doodle at times. Imagination, an attribute of *fantasia* in medieval psychology, permitted such expressions. Leonardo warns his readers, 'You should know that you cannot fabricate any animal that does not have parts such that each is similar to that of one of the other animals'. Of giants he wrote, 'The black face at first glance is most horrible and terrifying to look upon, especially the swollen and bloodshot eyes . . . the nose is arched upwards with gaping nostrils from which protrude many thick bristles.'

Satirical tales (*facetie*), often ribald, provided the background for some of his bizzare character drawings. For example, 'A woman washing clothes had very red feet from the cold. A priest who was passing nearby asked her with amazement where the redness came from. In answer the woman immediately replied that this result came about because she had a fire down below. Then the priest took in his hand that member which made of him more a priest than a nun, and coming close with sweet and caressing tones begged her to be so kind as to light that candle.' Leonardo's *Five Characters* is a response to some such tale. The *fessi*, the naive fools, are subjects of derision, tinged with compassion. Ribald grotesques exude a profound feeling for the inner causes of external looks, for medieval physiognomy – the science of facial expressions – was a serious subject. Linked with the soul in procreation and the four temperaments and astrological mysticism, physiognomy was a science of nature. Leonardo despised its cruder aspects, claiming they had no scientific foundation. He argued that the 'signs of faces show in part the nature of the men, their vices and their complexions'.

About 1478 he devised a self-propelled cart worked by powerful leafsprings, capable of running it across the festival arena with its load. On 13th January, 1490, the Duke of Milan gave a masque by Bernardo Bellincioni to mark the first year of Isabella of Aragon's marriage to Duke Giangaleazzo. Leonardo created the stage props and possibly the costumes. He was responsible for a small part of the proceedings, called the *Paradise Festival* by Bellincioni, 'because Maestro Leonardo Vinci, the Florentine, created a Paradise with great ingenuity and art, and all

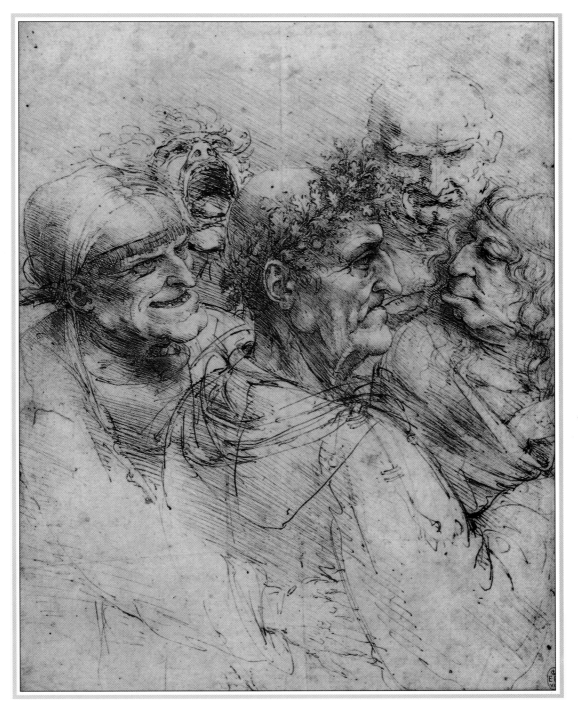

FIVE CHARACTERS IN A COMIC SCENE
c 1490

Unusually, Leonardo has portrayed his grotesque characters in a
group, and they clearly tell a story of some kind. The 'imperial'
central figure is clearly under a delusion about his status, and is the
object of derision.

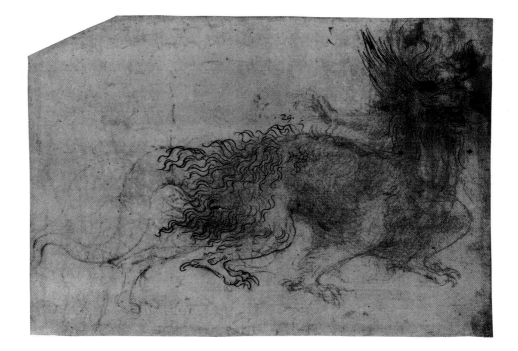

A DRAGON
c 1515-17

'Take for its head that of a mastiff . . . for its eyes those of a cat', and
add a swan's or snake's neck, a cock's wings and a lizard's tail. This
'Chinese' wingless dragon may have been for a pageant.

the seven planets were seen to revolve, and they were represented by
men who looked and were dressed up like poets, and all these planets
spoke in praise of the Duchess Isabella.' He designed a 'mountain' with
counterweights which swung back in two halves, to reveal Pluto rising
from a stage trap-door. At the climax, the gods descended to greet
Isabella. Actors dressed as ambassadors from Poland, Hungary and
Turkey spoke in her praise, to be followed by knights representing the
Holy Roman Emperor and the King of France.

In 1491 he designed the fête costumes for the marriage of lively
fifteen-year-old Beatrice d'Este to the thirty-nine-year-old Ludovico.
Milan became a fairyland of feasts, jousts and balls, while a painted
depiction of Leonardo's equestrian statue hung from the castle wall.
Leonardo choreographed parades and receptions, and designed
mythological and allegorical costumes. Included among them was a
gold uniform embroidered with peacocks' eyes for the Milanese cap-
tain, Galeazzo da Sanseverino, with a gold helmet with a half-globe and
a glorious peacock for a crest to emphasize his conquests. His shield
was covered with a large flashing mirror 'to show that he who really
wishes for favour should be mirrored in his virtues'. He rode on a horse,
with gold trappings designed by Leonardo, at the head of a force of wild
men of the forest in Leonardo's 'tattered garment' creations. He noted,
'Prudence dressed in red, and Charity sitting on a flaming throne with
a sprig of laurel . . . to signify the hope which is born of good service.'

When Isabella d'Este visited Pavia in 1496, she was greeted by a per-
formance of *Timone* staged by Bellincioni and Leonardo. The latter also
arranged the performance of Taccone's *Danae* that year, involving elab-
orate machinery to effect Danae's conversion by rising up to become a
star. Although his theatrical events were apparently much admired,
little material exists today about them.

He attempted various musical devices, particularly mechanized
drums, bells and strings. He designed a curtain-raising mechanism, a
water-regulated alarm clock which jerked the sleeper's feet vigorously

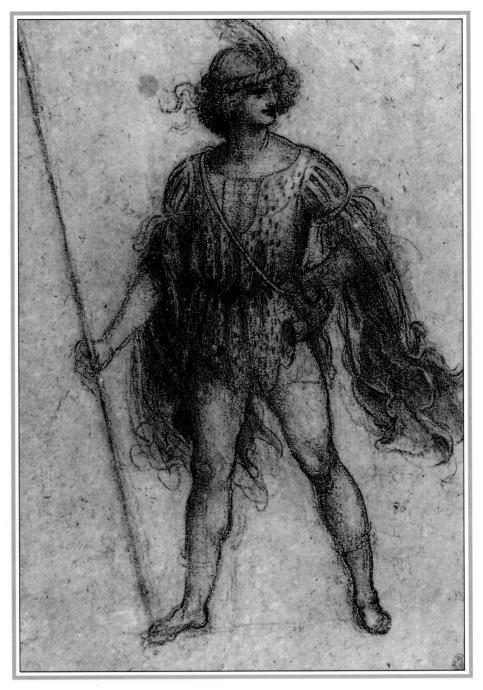

FIGURE IN A MASQUERADE COSTUME
c 1513-15

A black chalk drawing of a pageant costume for Leo X's visit to
Florence in 1515, when he was greeted by fifty youths in purple
livery and fur collars, armed with silver lances.

upwards, a chemical trick for turning white wine into red, and in-
genious fountain schemes, including 'A bath for the Duchess', a shower
system powered by a waterwheel. In 1515 he took the French king,
Francis I, by surprise when the latter entered Lyon by producing a
mechanical lion which stepped forward, opened its breast and revealed
the *fleur-de-lys*, the emblem of France and Florence. A lover of pranks,
he once used bellows to inflate the entrails of a large ram and then
floated them through the door of a room where visitors were assembled,
terrifying his unfortunate friends. Leonardo was indeed a man of many
parts.

INDEX

CREDITS